BRITISH CRAFT TEXTILES

ANN SUTTON

With photography by
David Cripps

COLLINS

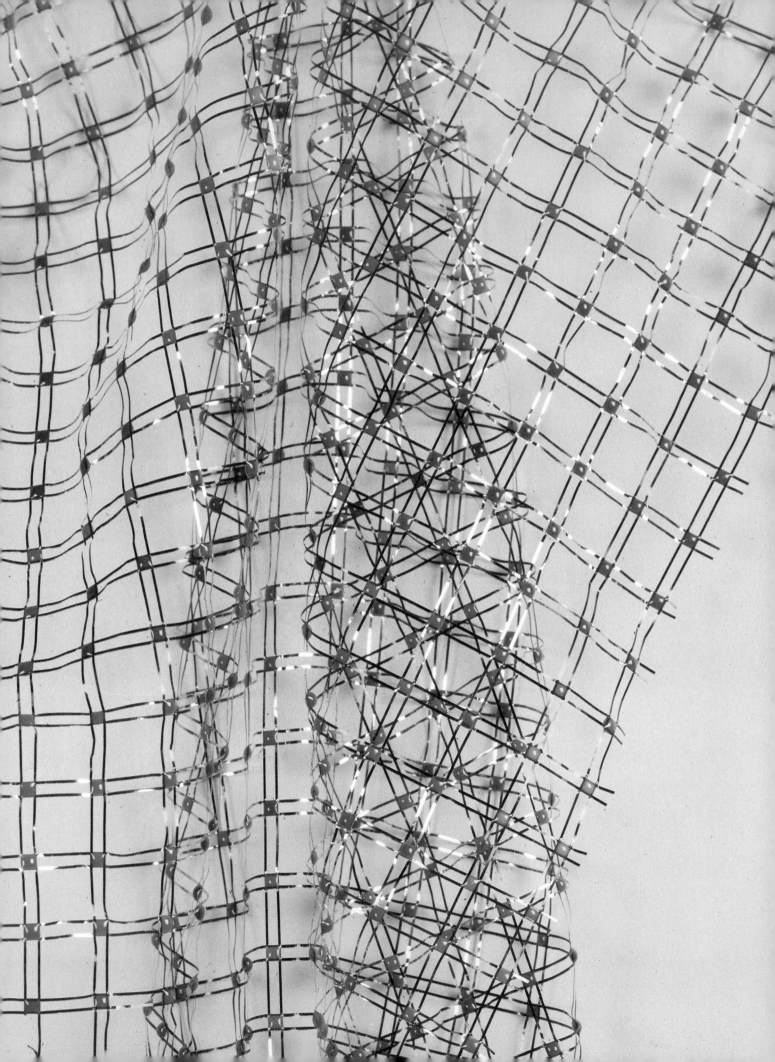

CONTENTS

The publishers wish to thank
The Crafts Council
for their invaluable contribution
to this book.

First published in 1985
by William Collins Sons & Co Ltd

London Glasgow Sydney
Auckland Johannesburg

© Ann Sutton 1985

Designed and produced by
Bellew Publishing Company Limited
7 Southampton Place, London WC1A 2DR

Designer: Bob Vickers

Printed and bound in Great Britain

Sutton, Ann, 1935-
British craft textiles.
1. Textile crafts – Great Britain
I. Title
746'.0941 TT699

ISBN 0-00-411968-1

INTRODUCTION

British textile artists are pre-eminent in their ability to link innovation, perception and craftsmanship. Textile artists from other countries produce work that is often superior in one of these aspects – for example, the Japanese are unbeatable for sheer, pristine craftsmanship, while work from the United States is highly innovative and creative – but it is the British who combine the three skills to best effect.

This is recognized by patrons abroad who commission and display British work (notably that of Peter Collingwood – see pp.142 5 – and the tapestry companies of Edinburgh and West Dean). Yet it seems that the British themselves are not fully aware of the superb work that is being done in this country, many examples of which are included in the following pages. Some British companies and private individuals choose to commission from abroad craft textiles which are no better than – and often not as good as – British artefacts.

It therefore seemed timely to compile this survey of important textile artists. Some of them have produced work that is unrivalled in the rest of the world; others have had great influence through their contribution to education; others still have acted as catalysts. All have extended the possibilities of craft textiles.

After the First World War many of the textile crafts in Britain were beginning to drift into oblivion and would have been lost were it not for the work of a small group of women working in the 1920s and 1930s. Ethel Mairet, Phyllis Barron and Dorothy Larcher were among those who saved a variety of craft-orientated skills, such as dyeing, weaving and textile printing. But it was not until after the Second World War that the crafts revival began in earnest. Britain enjoyed years of ever-increasing prosperity and people had more leisure and more opportunities for education and creative hobbies. Evening classes boomed and so also did the gift-trade outlets for the craft world. By the late 1950s you could learn to weave at night classes and later sell your output to some little shop in the Lake District or in Wales for sale to the new tourists. At the same time, the post-war baby boom soon required many more teachers, and the education industry grew, fuelling the crafts revival, because post-war education put a premium on creative subjects.

FRONTISPIECE
Resin 'jewelled' net structure by PAMELA WOODHEAD

Below left: ANNIE SHERBOURNE felt

Below right: PETER COLLINGWOOD rug shaft-switching technique

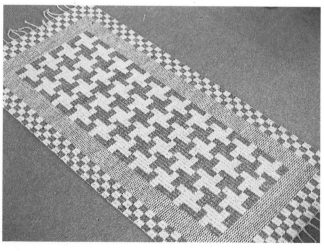

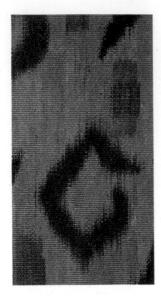

VANESSA ROBERTSON and NORMAN YOUNG ikat-dyed warp-face rug (*detail*)

MONIQUE GOETZEE painted silk scarves

MARGARET BRISTOW warp-face rug

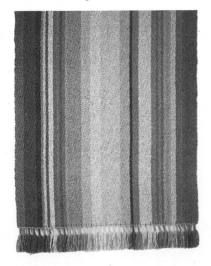

In the 1970s the most important events were the establishment of the Crafts Advisory Committee (now the Crafts Council) and the launching of *Crafts* magazine, both of which have promoted and made respectable the craft textile industry.

The committee was launched in 1973 with a seminal exhibition at the Victoria and Albert Museum in London. Entitled 'The Craftsman's Art', it included nearly seventy items of current textile work, as well as an equal number of pots, pieces of jewellery, furniture and so on. Before that date few people outside the craft world had any idea of the quality of work being produced around the country.

The strength of the textiles in that exhibition lay in the woven tapestries, closely followed by some of the embroidered hangings and panels. Some of the embroidery suffered from over-complicated techniques used at the expense of creativity, but the simpler pieces were excellent. Among the most memorable woven works from the exhibition are rug-woven cushions in the form of 'Sacks' by Roger Oates, Helena Hernmarck's large and professionally executed woven hangings based on photographic imagery, and Tadek Beutlich's pale sisal winged form. My own contribution was a 14ft square 'Floor Pad', exuberant and flashy, which was commissioned for the exhibition.

The year 1973 was also vital for textile influences from abroad: the serious and sombre woven messages of Magdalena Abakanowicz, the great Polish textile artist, were seen by many at the Arnolfini gallery in Bristol and in the Whitechapel Gallery in London. The Institute of Contemporary Arts put on an exhibition of Navajo rugs and blankets which delighted both weavers and painters with their glowing colours and inspiring images.

In spite of these important exhibitions in Britain, few British textile artists have been adequately represented overseas and there are few British jurors involved in selecting work for international exhibitions. Archie Brennan (pp.108-9), Maureen Hodge (pp.124-5), Fiona Mathison (pp.129-30) and I (pp.172-3) have exhibited at the Triennale in Lödz in Poland, and the influential Tapestry Biennale in Lausanne has consistently included tapestries from the Edinburgh Tapestry Company and West Dean.

The power of the Lausanne Biennale had one unfortunate effect on tapestry. The organisers demand a minimum of 5 square metres in area, and textile artists in this country and elsewhere produced acres of work that was more notable in size than in quality. Sometimes the world's greatest textile artists (e.g. Sheila Hicks, Peter and Ritzi Jacobi, Claire Zeisler and Wilhelmina Fruytier) made initial explorations of ideas on very much smaller pieces, which tended to be submerged in general exhibitions, while their studio assistants worked on the large tapestries. For this reason I persuaded the British Crafts Centre to organize 'The First International Exhibition of Miniature Textiles' in 1974. The maximum size of any exhibit was 8 (British) inches in any direction. The response from invited artists to the first exhibition was excellent, and a jury was set up for the following year, when open entry was encouraged. By the third exhibition 4000 entries were coming in from all over the world and there were scores of imitative exhibitions organized on both sides of the Iron Curtain. After the fourth show, the idea had to be stopped: just as Lausanne had encouraged needlessly large, derivative pieces, the antidote was provoking equally derivative and unnecessarily miniature pieces.

During the past decade, the textile crafts have benefited immensely from the grants and bursaries awarded by the Crafts Council and, through them, the regional art associations; and of course, the textile departments of British art colleges which I have come to see are among the best in the world. For this reason many textile craftsmen from other countries come here to train: some return to their own countries to work, while still maintaining strong links with their British counterparts;

others remain, enriching our culture. This is in the best of British textile tradition. Ever since the Huguenot silk weavers fled here from religious persecution in France, we have welcomed and absorbed the fresh views and expertise of immigrant textile craftsmen and craftswomen. The weaving industry, for example, would have been the poorer without Miki Sekers, Tibor Reich and Bernat Klein.

Another point which has become clear is that the textile craftsmen and craftswomen who are making strong contributions (except for production weavers and printers) have had, almost without exception, fine art training. In this category, I include those who have graduated from the embroidery and textile course at Goldsmiths, which is run on a fine art basis. There seems to be a stronger sense of personal resource in craftsmen with this training, and a concern with concept.

In the 1950s and 1960s, before the Crafts Council-backed revival of the last decade, there was more common ground between professional and amateur craftsmen. With fewer people practising the crafts, both the amateurs and the professionals sat together and learned from each other (for example, at meetings of the Weavers' Guilds). One area of cooperation today is in the exhibitions mounted by the Crafts Study Centre, but the gulf seems to widen yearly. It is as though the amateurs are at the mercy of technique, while textile artists such as those described in the following pages transcend technique with innovation, perception and sensitivity.

I have also discovered a few people who are being quietly yet very strongly influential through their inspired teaching and writing. These people are rarely heard of outside the textile world, but within it they are well known and gratefully respected. They include (for no such list could be complete): Audrey Walker, Audrey Levy, Peter Collingwood, Ella MacLeod, Marianne Straub, Kaffe Fassett, Anne Butler (now Morrell), Archie Brennan and many more. A more unusual benefactor of textiles is the photographer David Cripps, who manages in his photographs to make textiles seem more tactile even than in reality. His legendary cover photograph for *Crafts* magazine of Sue Rangeley's embroidered blouse, for instance, was inspirational in itself and, as Sue Rangeley agrees, transcended the piece in importance and influence.

The increasing interest in, and respect paid to, the crafts in Britain has combined with the unrivalled education in textiles to inspire increasingly confident and innovative textiles. Fashion designers, interior designers and retailers are coming alive to new possibilities and links with the craft world, and more organizations are considering the benefits of commissioning individually produced textiles, but it is not yet enough. The photographs in the following pages show the quality of work now being done in Britain, and it is our hope that this directory of textile artists will awaken broader interest. Almost all the people included here welcome individual commissions and it is for this reason that we have compiled the address book on pages 188-192.

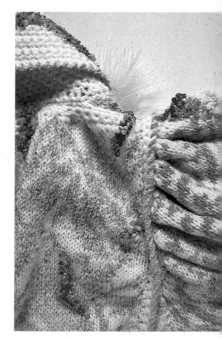

ANNE FEWLASS detail of knitted/crochet jacket

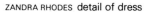

ZANDRA RHODES detail of dress

PRINTING, PAINTING AND DYEING

The phrase 'printed textiles' is misleading. For while it does refer to block, screen and roller printing, it can also be used for more immediate techniques – sticking your fingers into a pot of dye and painting directly on to cloth or waxing or tie-dyeing, all of which are traditional methods.

The printed textiles trade is a broad one. At one end of the scale are the large companies using high-technology equipment to make long runs for clothing manufacturers and similar bulk-purchase clients. At the other end of the range are the craft-orientated studios that design and produce limited lengths of printed cloth for specialist or private clients. The large companies buy in a lot of the designs they use from outside, autonomous design studios whereas the impetus for running a craft-orientated workshop is to design *and* produce.

Whatever the scale of operation, printed textiles is a genuine applied art – it has a craft component, a strong design core and it also demands a brio of creativity usually assumed to be the preserve of fine art. Designing for printed textiles has always attracted creative young people, some of whom might have been expected to opt for fine art. The appeal of printed textiles is in its combination of personal statement and utility. Equally attractive are the creative possibilities offered by a medium which combines colour, graphic imagery and the textures and finishes of cloth.

The professional printed textile world can be divided into the industrial and the craft orientated. The design studios which service industry are mostly staffed by graduates from art and design colleges. Traditionally the majority of printed textile graduates seldom work with cloth, but on paper – an international practice. These paper designs are adapted and interpreted by the textile printing companies' own skilled artisans. These artisans are a vital link between the designer and the machine, and their skill can make or marr a designer's work.

A craft workshop operation does not, of course, have an intermediary between design and production and so the craftsman textile printer has the advantage of controlling the production of the design first hand. There are disadvantages. It is difficult to make a small operation commercially successful because good basic equipment is expensive and there is the major problem of fixing the dyes economically – this is the reason why so many small printers have to rely on pigment printing. The craft workshop must make do with time-consuming, labour-intensive (hence costly) methods or beg the use of someone else's equipment (which is, as often as not, that of the local art school). Setting up a commercially viable small craft printed textile workshop is much more difficult than setting up a weaving workshop. But, of course, the reward for the small operator is the freedom to innovate, and some of the more enterprising fashion designers have found the small workshops a source of inspiration. In addition there is a growing trend for some printed textile designer-makers to make up their own cloth into garments or soft furnishings. A prime example of this is Zandra Rhodes who started out as a printed textile designer.

Financially the craft-based end of the printed textiles trade is of small importance but its impact on design is much greater. The fact that the small workshop production is more flexible and innovative – the fact that it gains its energy through the hands-on immediacy of design-and-make – has enabled it to become something of a design powerhouse. British mass-produced printed textiles, with a few notable exceptions such as the Liberty prints and others, are not especially regarded by European fashion and design houses. But these same Europeans show great interest in the one-off craft designers, and British textile designers generally are highly thought of. Ambitious, creative young designers are frequently offered employment abroad rather than at home. The industrial world of printed textiles has been (or will be) moved by the work of small workshops such as Timney Fowler and Bodymap, making their mark through designer-collections.

As a consequence of the developing craft-based aspect of printed textile design we have also seen more applied artists producing fabrics which rival contemporary painting in terms of imaginative, virtuoso image-making. Sometimes the craft designer is indeed painting on the cloth, and such work is indebted to fine art for its inspiration. But there has also been a strong revival in good pattern-making and a re-evaluation of textile printing's own history which has resulted in a greater respect for the applied art's own achievements.

The craft skills involved include learning how to make separations for the silk screens, how to mix and apply dyes, and there is a body of knowledge to learn about textiles. More important still are the skills of drawing and painting. Finally there is the skill of designing – making good pattern demands a certain innate talent but the basic scaffolding of how to devise strategies for good repeat patterns can be taught. As in all disciplines, there are techniques to be learned and mastered in order that they may be broken. At one time, for example, diagonal patterns were outlawed but now the rule forbidding them, and other similar rules, seems odd and arbitrary; design fashion in pattern also evolves and there is currently a move away from the small all-over patterns to bolder, larger geometrical abstractions. The important feature of any training is to encourage the student to acquire a thorough craft and technical foundation but not to cramp creativity.

Today the level of endeavour in an applied art such as printed textiles is as high as that for any other art, notwithstanding the fact that each medium has aims that are specific to it. What we see in Britain at the moment is not only a considerable variety of printed textile design – from the painterly to the most traditional of repeat patterning – but a sustained quality of invention and manufacture across that variety.

AUDREY LEVY

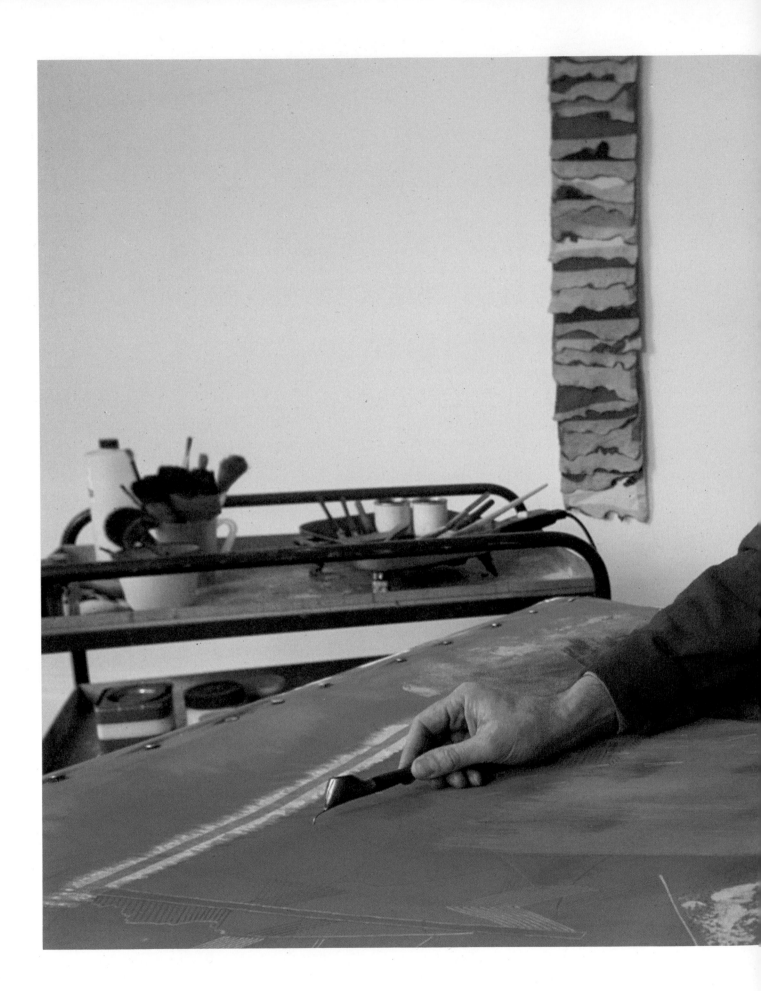

NOEL DYRENFORTH

b. 1936 (at seventeen, was Boy Boxing Champion of England)

Training
Central School of Art, London; Goldsmiths' College, London; Sir John Cass School of Art, London (drawing, textiles, ceramics)

Awards, etc.
1977 Crafts Council Bursary (study/travel in USA, Indonesia and India)
1978 Craftsman-in-residence, Toorak State College, Melbourne, Australia
1982 Study/travel in Japan

Exhibitions
1965-84 Twenty-eight one-man shows in Britain, Australia, Germany, USA and Japan. He has also participated in mixed shows throughout the world.

Noel Dyrenforth is Britain's leading exponent of batik. His original studies of painting and drawing ensure the content of his work in the textile medium in which he has worked since 1962. As well as expanding the traditional methods of applying colour in this craft, he has recently begun to manipulate the cloth into rolls, pleats and flaps. His control of the medium enables the imagery to dominate – the subject matter is abstract but often evocative of landscape, trees and birds.

'I start my work always in a well-planned symmetrical process, and events change this. I often introduce chaos for its own sake. Craftsmanship is important in my work only up to a point. It is the potential and not the preconceived that matters. I follow the rules, then break them, redefine, take risks to arrive at new concepts. This is one of the lures of batik – exciting things happen when the dyes have their own way, and one is for ever led in new directions...The structural discipline is in being able to have the power to retain the hard edge structure against the promiscuous ebb of the dyes.'

Previous page: NOEL DYRENFORTH batik artist, in his London studio

NOEL DYRENFORTH batik

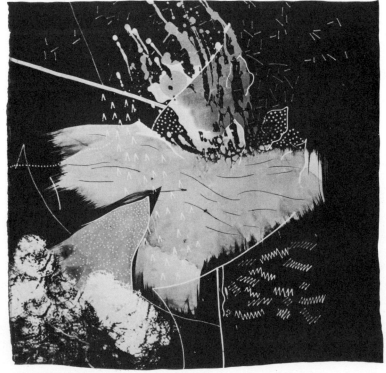

David Cripps

12

JANET ANDERSON

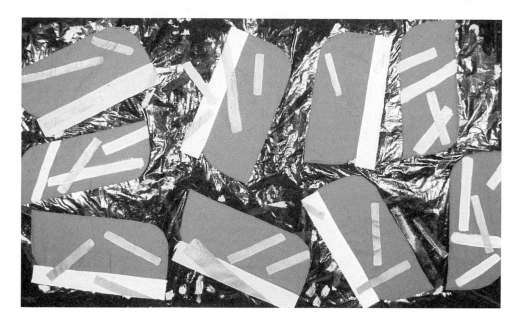

JANET ANDERSON untitled
43 inch × 71 inch polythene
and fabric, painted, 1981

b. 1946

Training
1962-8 Hornsey College of Art, London (now Middlesex Polytechnic) (painting and textiles)

Employment
1971-9 Maidstone College of Art (Fine Art Department)
1978- Goldsmiths' College, London (Textile Department)

Awards, etc.
1968-9 British Council Travel Scholarship (to India)
1975-8 British Council Costume/Textile Research Programmes (Romania and Bulgaria)

Since 1973, Janet Anderson has worked as assistant and photographer with the performance artist Stuart Brisley in Europe and Canada. One of the resulting works is 'Beneath Dignity' by Stuart Brisley, in the Tate Gallery, London.

Working in the medium of tapestry-weaving until 1980, she now works in collage and paint.

'Some of my earlier works in tapestry were based on traditional modes of peasant dress still worn in parts of Romania and Bulgaria, two of several countries I have made studies in. Although these works closely resembled the original models they did not function as clothes, but commented upon the declining folk tradition and played on the relationship between function and image. In the last five years or so I have used mass-produced clothing and discarded off-cuts. This phase of work evolved freely, being assembled in ways which directly relate to my experience as a painter, and my response to the work of other painters. It is the visual power of the off-cuts and parts of garments that I find valuable, and also the fact that they function to some extent as found objects.

'Although the work has been "opened up" and is not easily categorized in terms of painting or textile, the central issue continues to revolve around the nature and use of fabric.'

STEPHANIE BERGMAN

b. 1946

Training
1963-7 St Martin's School of Art, London (Fine Art)

Employment
1969-71 Federal Penitentiary for Women, West Virginia, USA

Award
1975 Gulbenkian Award

Exhibitions – Solo
1973 and 1975 Garage Art Ltd, London
1976 Midland Group, Nottingham
1977 Kettle's Yard, Cambridge
1978 Chester Art Gallery, Chester
1978 and 1980 Anthony Stokes, London
1980 Riverside Studios, London
1984 Crafts Council Gallery, London; Kilkenny Design Workshop, Ireland

Exhibitions – Group
1975 Southampton Art Gallery and Mappin Gallery, Sheffield (with Nicholas Pope)
1976 '25 years of Painting', Royal Academy, London
1977 IX Festival Internationale de la Peinture, Cagnes-sur-Mer, France
1978 Tolly Cobbold II; 'Certain Traditions', touring Canada
1979 'British Art Show'; 'Style in the Seventies'
1980 Tolly Cobbold III; XI Biennale de Paris; Selection from XI Biennale de Paris, Belgrade
1982 'The Maker's Eye', Crafts Council Gallery, London; 'Fabric and Form', Crafts Council, London, Australia, New Zealand, Zimbabwe, Hong Kong

STEPHANIE BERGMAN two
hangings

David Cripps

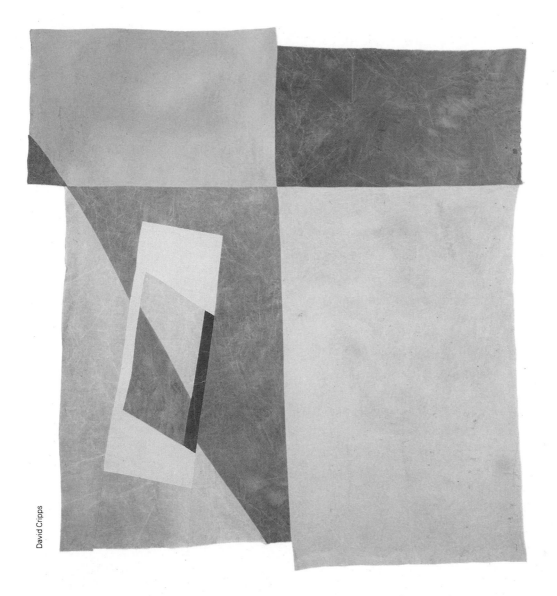

David Cripps

'There are two distinct processes in my work. The first is preparing material and the second is making something with it.

'I buy 9oz cotton duck by the roll and cut off long pieces which I put on the floor and paint with acrylic paint and when it's dry, I wash it. Other pieces I dye in a boiler or spray with dye. I end up with a large stock of prepared canvas of different colours, tones and textures.

'The second stage is sewing the canvas together into large flat abstract compositions. The main source of inspiration is dealing with the material itself; placing large sheets of coloured canvas on the floor, playing with torn strips of different colours, overlapping, scissoring shapes, moving shapes around. I start with an idea of what each piece will consist of. I have developed a way of thinking about the material (or talking to it) which identifies specific parts, such as backgrounds, middles, invented structures, etc. It is the colour that is always uncertain in each piece, as the appearance of two pieces of coloured canvas in a pile on a shelf is never the same as their appearance when sewn together.

'The way I sew, unlike collage, butts the seams together and provides an integrated surface. The seams are apparent and provide a clue to the structure. I like the irreversibility of the sewing and the fact that it can alter a pile of cloth into a skin with an inscribed image.'

SUSAN BOSENCE

Training
with Phyllis Barron and Dorothy Larcher

Employment
1962 taught short courses, especially at Dartington, Devon; also at Camberwell School of Art, London, and West Surrey College of Art and Design, Farnham

Awards, etc.
1975 Crafts Council Bursary

Exhibitions
1959 First showed work at Primavera, London
1961 Major exhibition (with Annette Kok) at Tea Centre, London

Susan Bosence works on, and into, cloth by block-printing and resist-dyeing by paste, wax and stitch, with traditional dyes (indigo, tannic, rust) and more modern dyes (Soledon, Procion).

She does not design on paper and then put the design on cloth, but works directly, often labour-intensively, in a build-up of dye and print to achieve these results. The cloths are sometimes sold in lengths, sometimes as simple garments.

'I am not a cerebral person, but a simple doer, relating what I see to what I do, and vice versa...I hope my work moves in a direction that is true to itself. One questions all the time...The final piece of cloth should be a whole piece of cloth – the quality of cloth, the colour, and the patterns of equal standard – lovely to look at, handle and use.'

SUSAN BOSENCE two scarves, block-printed in indigo and red

Craft Study Centre, Bath

NORMA STARSZAKOWNA

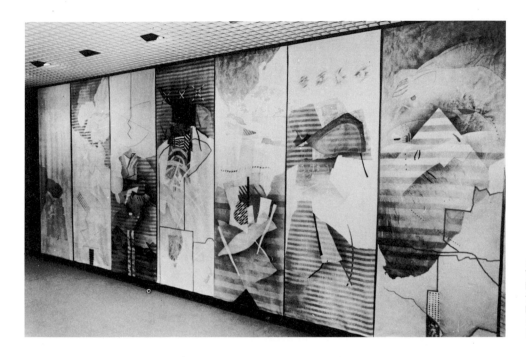

NORMA STARSZAKOWNA 'Silk Wall', 9 ft × 30 ft, batiked/dyed silk (various types), 1983. Commissioned by General Accident Insurance Co. for their headquarters in Perth, Scotland

b. 1945

Employment
Duncan of Jordanstone College of Art, Dundee

Awards, etc.
1977 Scottish Arts Council
Saltire Society Biennial 'Art in Architecture' Award

Selected Exhibitions
1973 'The Craftsman's Art', Victoria and Albert Museum, London
1974 Scottish Craft Centre, Edinburgh
1977 'New Acquisitions', Scottish Arts Council Gallery, Edinburgh
1978 '*Sunday Telegraph* Craft Awards', Somerset House, London
1981 'Batiks', British Crafts Centre, London
1983 'Contemporary British Crafts' (from the British Craft Centre), Houston, USA
1983-4 Anatol Orient Gallery, London
1984 Aspects Gallery, London

Collections
Scottish Arts Council; Scottish Crafts Council; IBM; Leeds City Art Gallery

Commissions
Crest Hotel, Antwerp; Royal Lyceum Theatre, Edinburgh; General Accident Insurance Co., Perth

'I was drawn to batik by the immediacy of the medium and the translucency of the dyes – these seemed to be the perfect vehicle for expressing certain inherent qualities of cloth: its strength and fragility, perhaps its omnipresence. Most earlier work depicts folded and layered cloth, sometimes with a burned edge, often image layered upon image. Recent work becomes three-dimensional: bowls in treated/stiffened silk, sometimes combined with acetate film.'

HELEN COWIE

b. 1948

Training
1966-72 BA and MA Royal College of Art, London (Interior Design School)

Employment
1973-5 Bournemouth and Poole College of Art (Interior Design)
1975-6 Kingston Polytechnic (Interior Design)

Selected Exhibitions
1979 Portsmouth City Museum and Art Gallery (with Nigel Shelley)
1982 'Making It', Crafts Council Gallery, London
1983 Aspects Gallery, London
1984 'Maker/Designers Today', Camden Arts Centre, London

Opposite: HELEN COWIE detail of printed, air-brushed and pleated curtains to fit window 7 ft 6 inches × 10 ft

Below left: HELEN COWIE printed cotton pleated curtains to fit window 3 ft 6 inches × 2 ft

Below right: HELEN COWIE air-brushed cotton roman blind, 5 ft × 3 ft 6 inches

Helen Cowie's earlier textiles for interiors were highly realistic in imagery, whether huge curtains laden with jungle growth, or cushions with life-like three-dimensional snakes emerging. More recent work has involved the rethinking of the structure of blinds or curtains and the relationship of folds and pleats to the surface patterning. During the last year she has concentrated on furniture-making.

'My textiles have as much to do with the space they occupy, and their effect on that space, as with being fine objects in themselves.'

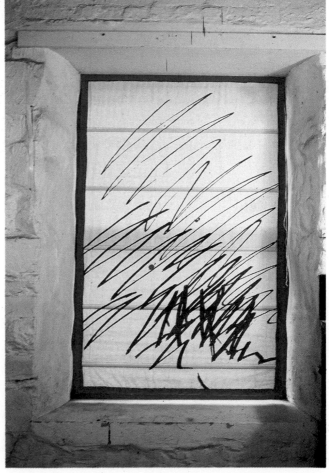

David Cripps

DIANA HARRISON

DIANA HARRISON, stitched, sprayed and dyed textiles (details)

Training
1967-71 Goldsmiths' College, London (Embroidery School)
1971-3 Royal College of Art (Printed Textiles)

Employment
1973-5 Mid-Warwickshire College of Further Education, Leamington Spa
1974- West Surrey College of Art and Design, Farnham

Awards
1972 Sandersons Travel Scholarship
1973 Courtaulds Textile Prize (RCA)

Selected Exhibitions
1977 Victoria and Albert Museum, London
1980 'Approaches to Metal and Cloth', British Crafts Centre, London
1982 'Fabric and Form', Crafts Council, London, Australia, New Zealand, Zimbabwe, Hong Kong; 'British Needlework', National Museums of Modern Art, Tokyo and Kyoto, Japan
1983 'Designer's Choice', Westminster Gallery, Boston, USA; 'Quilting, Patchwork and Appliqué 1700-1982'. Minories, Colchester, and Crafts Council, London

Collections
Brunel University; Southern Arts Association; Crafts Council, London; Museum of Modern Art, Kyoto, Japan

Diana Harrison masks the cloth (sometimes satin, sometimes cotton) and sprays it with dye. When this has been fixed, the fabric is worked upon by quilting, pleating and tucking. This comparatively simple technical process becomes the medium for the precise stitchery and dye control for which this artist is known.

The resulting sophisticated textiles may be bed-quilts, cushions or wall-hangings.

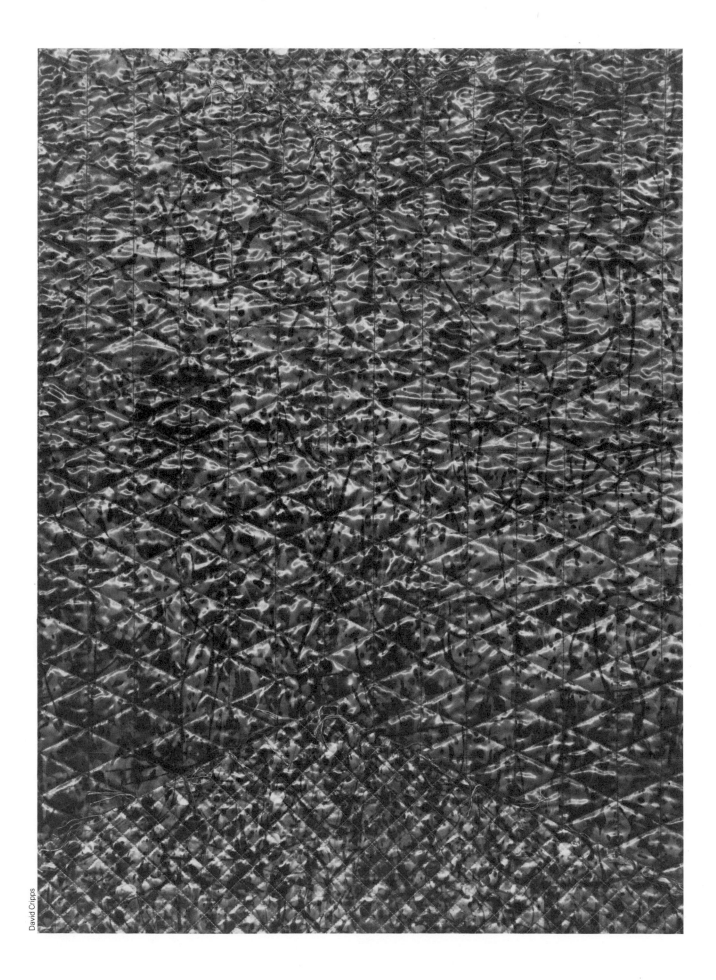

MONIQUE GOETZEE

b. 1958, Holland (moved to the UK in 1968)

Training
1976-80 West Surrey College of Art and Design, Farnham (Textile Design)

Awards
1979 Royal Society of Arts Bursary (studying paper-making in Japan)

Selected Exhibitions
1982 'One-off Wearables', British Crafts Centre, London; '100% Silk', Rufford Crafts Centre, Notts

1983 'Makers '83', British Crafts Centre, London; 'Printed and Painted Textiles', British Crafts Centre, London; 'Made to Measure', Rufford Crafts Centre, Notts

Opposite: MONIQUE GOETZEE three scarves in painted silk

MONIQUE GOETZEE detail of two scarves, painted silk

Monique Goetzee's work involves resist-dyeing (using hot wax) and hand-painting on to translucent and other silk fabrics, to make scarves and bed-covers. The geometric patterning on the scarves is accentuated by the inevitable folding and overlapping of layers in use.

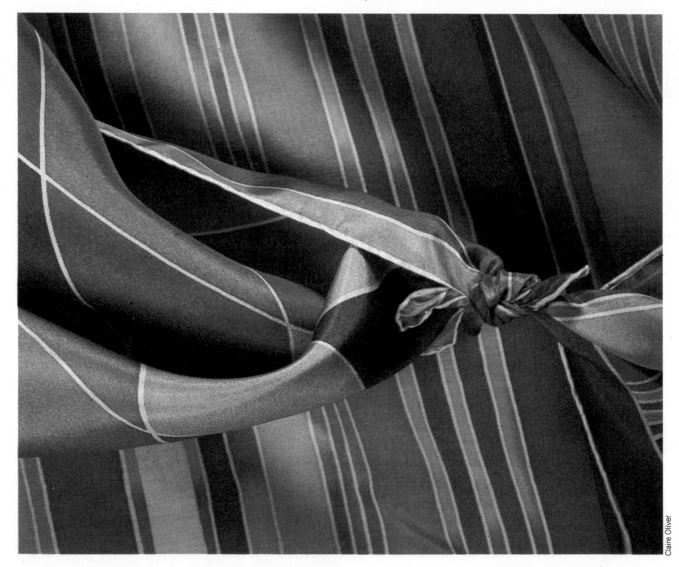

Claire Oliver

22

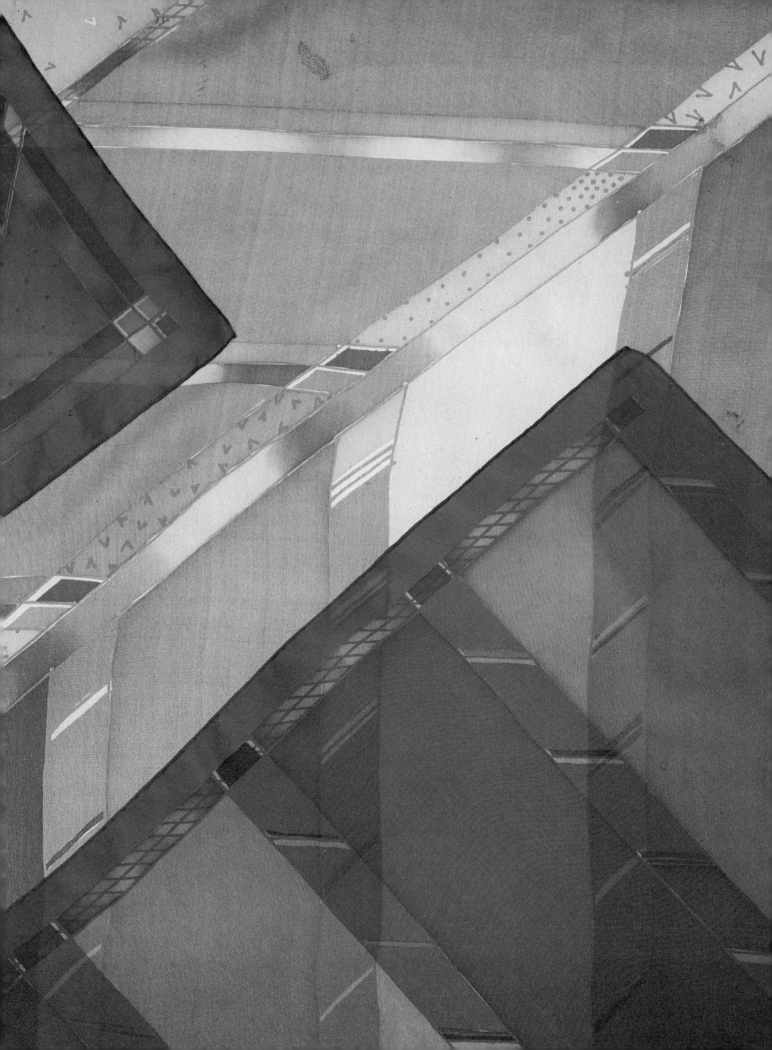

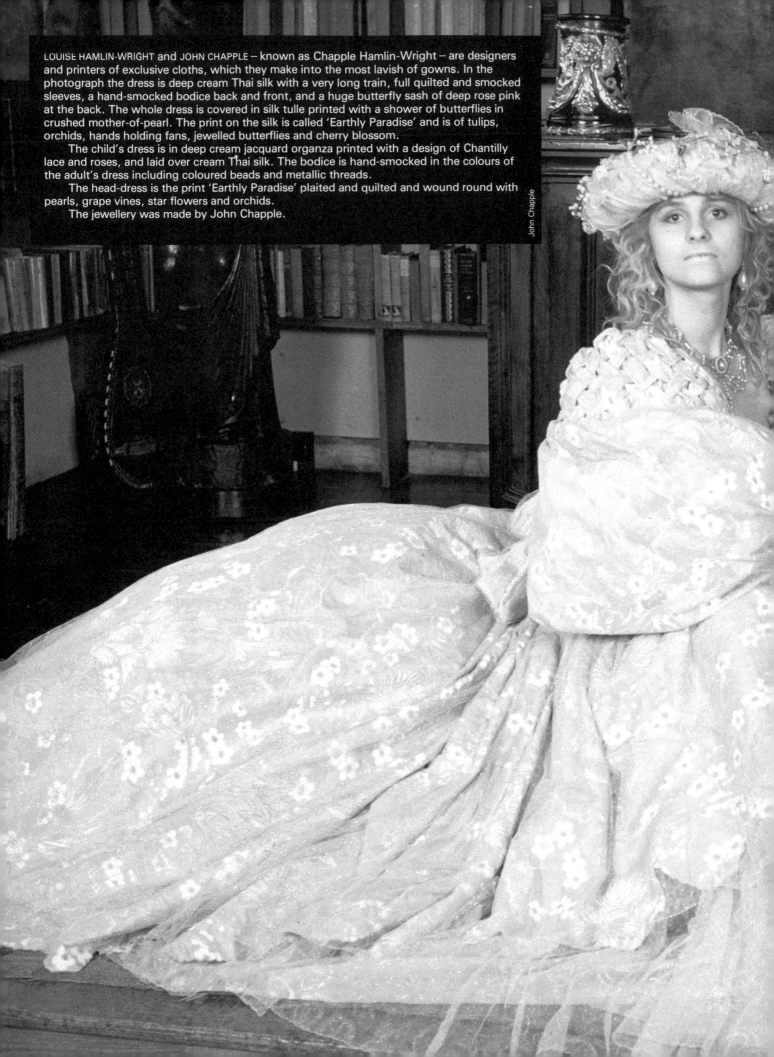

LOUISE HAMLIN-WRIGHT and JOHN CHAPPLE — known as Chapple Hamlin-Wright — are designers and printers of exclusive cloths, which they make into the most lavish of gowns. In the photograph the dress is deep cream Thai silk with a very long train, full quilted and smocked sleeves, a hand-smocked bodice back and front, and a huge butterfly sash of deep rose pink at the back. The whole dress is covered in silk tulle printed with a shower of butterflies in crushed mother-of-pearl. The print on the silk is called 'Earthly Paradise' and is of tulips, orchids, hands holding fans, jewelled butterflies and cherry blossom.

The child's dress is in deep cream jacquard organza printed with a design of Chantilly lace and roses, and laid over cream Thai silk. The bodice is hand-smocked in the colours of the adult's dress including coloured beads and metallic threads.

The head-dress is the print 'Earthly Paradise' plaited and quilted and wound round with pearls, grape vines, star flowers and orchids.

The jewellery was made by John Chapple.

John Chapple

SIAN TUCKER

b. 1958

Training
1976-80 Middlesex Polytechnic, London (Textile School)
1980-82 Royal College of Art, London

Awards
1983 Prize, Jugend Gestaltet Exhibition, Munich

Exhibitions
1983 'Young Blood', Barbican Arts Centre, London
1984 'Maker/Designers Today', Camden Arts Centre, London; 'Black and White', British Crafts

SIAN TUCKER four panels,
120 inches × 54 inches, acid
dyes painted on to wool
delaine

Centre, London; 'Three Rooms' Aspects Gallery at Barbican Arts Centre, London; 'The Exhibitionists', Five Dials Gallery, London; Craft Shop, Victoria and Albert Museum

Commissions
Habitat: designs for fabric and paper goods
1983 Conran: Christmas decorations and hangings for the shop; Mind, Body and Spirit Exhibition, Olympia, London: painted backdrop 11m×6m (with Alison Wotten); Rosenthal Porcelain, Germany: patterning for products

Sian Tucker works mainly in acid dyes, which she paints with assurance on to thin wool fabric. These lengths of cloth are often used as free-hanging banners; the light coming through the cloth enhances the brilliance of the colours used. Recently she has been making clothes – big blanket-cloth coats, dye-painted brightly and lined with patterned silk. She feels that her work is becoming more theatrical, and future work will probably include a complete set, with costumes.

SALLY GREAVES-LORD

b. 1957

Training
1977-80 West Surrey College of Art and Design, Farnham (Textile Design)
1980-82 Royal College of Art, London (Textile Design)

Employment
1982 West Surrey College of Art and Design, Farnham
1983 Royal College of Art, London; Birmingham Polytechnic, MA course

Exhibitions
1980 'Class of '80', Design Centre, London
1982 'Recent Work', South Hill Park Arts Centre, Bracknel, Berks
1984 'Jugend Gestaltet', Munich; British Crafts Centre, London; 'Sideshow', Crafts Council at ICA, London; 'Tables and Chairs', John Hansard Gallery, University of Southampton

Commissions
1981 Conran Associates
1982 Bass, Mitchell and Butlers Ltd: two hangings
1983 Royal College of Art fashion show: flags; Powell-Tuck and Associates: painted interior and fabric for Research Recordings Ltd
1984 Powell-Tuck and Associates: painted house interior; Powell-Tuck and Associates: surface decoration for Wardour Street restaurant

Opposite: SALLY GREAVES-LORD with two silk lengths and a painted and varnished cotton floor-covering

SALLY GREAVES-LORD upholstery for chair by Powell-Tuck and Associates, Research Recordings Ltd, Camden Town, 1983

Sally Greaves-Lord produces distinctive boldly designed interiors, often comprising curtaining, upholstery, murals, painted furniture and floor coverings.

A palette of black, white and neutrals is enlivened with sharp areas of brilliant colour, especially in the silk hangings where the intensity of colour obtained from the use of acid dye is fully exploited.

28

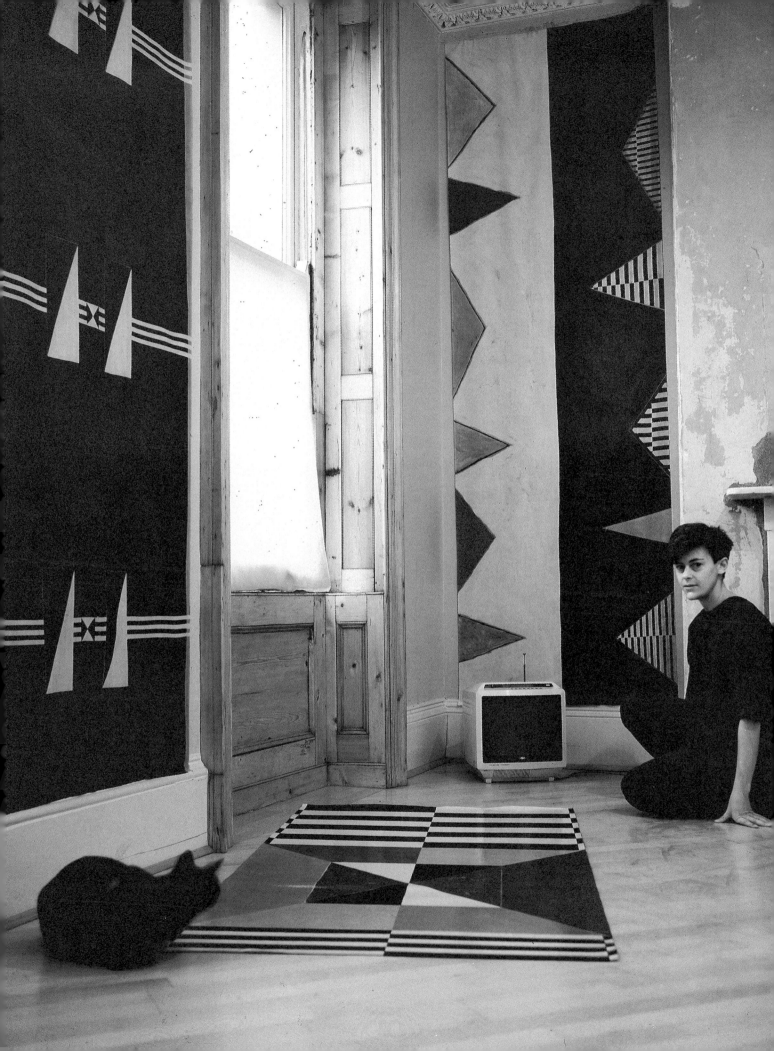

ANNE SICHER

b. in Paris (moved to the UK in 1973)

Training
L'Ecole Nationale de Beaux Arts, Paris

Exhibitions
1974-5 'Shopping in Britain', Design Centre, London
1977 'Masterpiece', British Craft Centre, London; Jubilee Exhibition, Victoria and Albert Museum, London
1978 'Five with Fabrics', Woburn Abbey, Bedfordshire; 'Craftsmanship', Trelowarren, Cornwall
1979 Spink Modern Collections, Mall Galleries, London; 'Craftsmen of Distinction', Galerie J. Kraus, Paris; 'Silk', Charles de Temple, London
1980 'Craft South West', South West Arts, touring
1982 British Craft Exhibition, New Jersey, USA
1983 'Printed and Painted Textiles', British Crafts Centre, London

Opposite: ANNE SICHER 'Jug with Sweet Peas', silk scarf

ANNE SICHER in her workshop

'I try to work in the most direct way: painting freehand directly on to the silk, using diluted aniline dyes – they let the light come in through the silk. Once the fabric is painted it is fixed by steaming – it is colour-fast. The silk is made into scarves, kimonos, Turkish coats. It can be used in interiors: anything from a light-diffuser to a folding screen.'

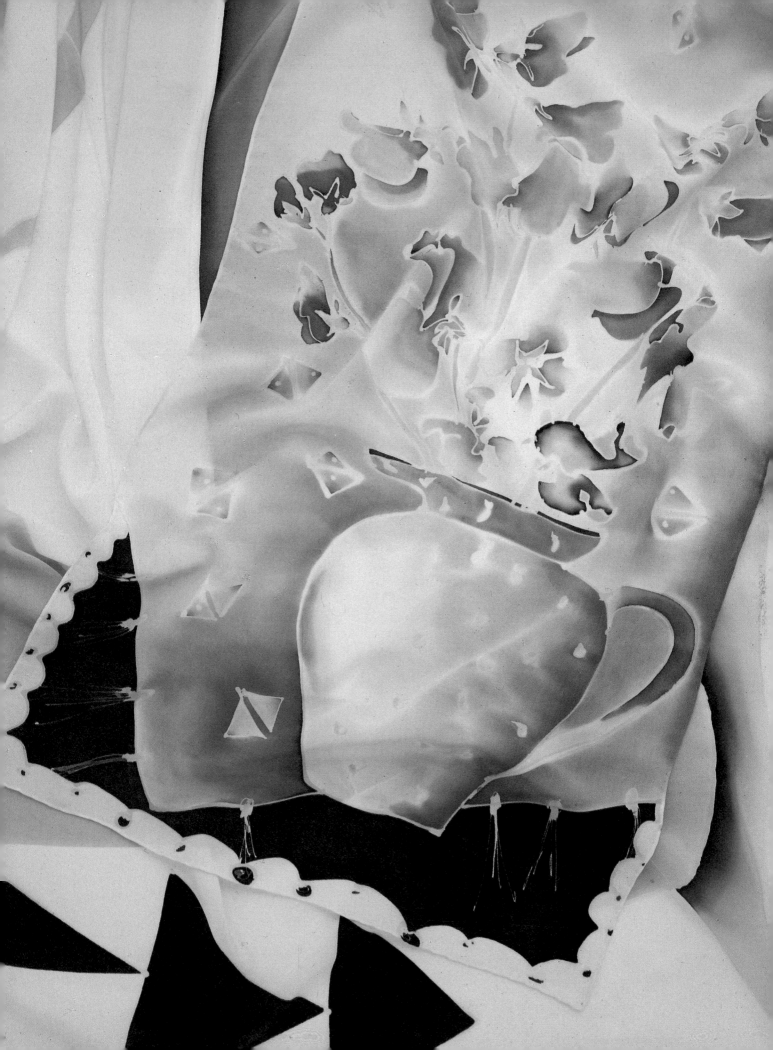

KNITTING

The art of knitting has had a renaissance this century. Even before the craft revival of a decade ago, knitting would not have been considered an art, merely a skill possessed mainly by women in order to make warm clothing.

Many women (and a few men) knit by hand; 6 million of them in Great Britain. But the reinterpretation of knitting traditions was made by a handful of designers who unpicked the time-honoured patterns and reworked them in different shapes and colours.

Colour was perhaps the most important change in the knitwear revolution, with Kaffe Fassett casting a painter's eye over the conventional colourings. Classic Fair-Isle patterns, each design filled with rich symbols of folklore and religion, have now been interpreted in the modern idiom, both by introducing alien strands of colour and by using blocks of pattern and motif purely as decoration.

Texture is a crucial part of modern knitting, and the three-dimensional effect of Aran is echoed also in the bobbles and bas-relief used by Patricia Roberts, often for images from nature, like bunches of grapes, or for novelties such as boiled sweets. Stitchcraft is the stuff that fine knitting is made of, even though the magic carpet knits can rely for effect on shading of colour. Contrasting textures are produced from stitches, from the bobbly blackberry stitch or the smoother open-work lacy patterns which look almost like crochet. Surface interest and texture comes also from the yarns themselves with deep-pile angora, crunchy cotton, fluffy mohair, fine silk, thick linen and tweedy and marled wool all making a contribution to the final effect.

The current trend among craft knitters is to mix textures and incorporate a variety of yarns in one garment. Dishcloth cotton, nylon mesh and even electric flex have all been used to create interesting surfaces.

The growth of inventive yarn companies, founded by designers or set up in conjunction with a mill like Rowan Yarns, has contributed to the craft revival in knitting. The variety of materials commercially available and the dramatic widening of the colour range, has enabled knitters to experiment. In many cases, demand from craft knitters stimulated a response from the suppliers, who are already turning silk and cotton ribbons into part of the yarn business, even if they have not yet come up with over-the-counter packs of leather strips or coloured fuse wire.

The original designer picture knits had a dimension which made them much more than pictures on the chest. Sandy Black, who is a mathematician by training, produced designs worked out in stitches to the shape of the body, so that an animal's tail curved down one arm or a *trompe l'oeil* window opened across the chest in proportion to the body size of the garment. At a time when craftsmen sometimes take themselves very seriously, witty knits, featuring one black sheep among the white or a surreal torso picked out in stitches, are a light relief from homespun chic. Craft packs, sold with the yarns and pattern directly from the knitwear designer, offer a craft service to the general public.

Decorative details worked into knitting is a strong craft trend, and one which can never be copied by mass production. Artwork have incorporated metal coils, leather pieces, studs, pearls and beads into their designs. Decoration on the surface, such as ribbons slotted into an open-work pattern or pearls scattered on the surface or following the line of a knitted motif, is a feature of the work of Sarah Dallas.

Anne Fewlass is the most original of these knitters because she includes the work of other craftsmen and craftswomen, like ceramic pieces and wooden sculptures. She also uses fur tails, beading and tassels to make a multi-media effect in one single jacket – often knitted to a medieval shape.

Craft knitters have concentrated more on texture, surface interest and Fair-Isle patterns than they have on the shape of the garment. In fact, designs are often left deliberately simple to allow the unusual colourings or materials to make the statement. Yet through their experiments with new yarns, the knitters have created a minor revolution.

Fair Isles, in flowers and picture motifs as well as the traditional patterns, have now been translated into cotton, hand-framed as well as worked by hand. By contrast, simple open-work sweaters, as loose in stitch as an old-fashioned dishcloth, but now worked with ribbon thread, are made up into simple shapes. Intricate lacy patterns emphasize the *art* of knitting; crunchy cotton cables its *craft*.

What is the future for the craft knitter? The danger is that the hand-crafted looks that are currently in fashion will be cast off by a new generation, just as the make-do-and-mend knits of wartime Britain were swept away by a tide of brash machine-made products.

There is certainly a trend towards man-made fibres, rather than only natural materials, but the craft designers themselves are well ahead of the trend, using shiny viscose or even nylon and rubber as part of their designs. The newest patterns are graphic rather than naturalistic, abstract blocks of colour and shape making a bold statement on a simple knit. Student knitters are experimenting in this area, using shape or texture for effect, and eschewing the multi-colour and multi-pattern Fair Isles.

The greatest strength of craft knitting lies in its versatility. Just because designers are creating one-off designs, they are able to incorporate new materials, to work in appliqués of fabric or to introduce changes of texture that would be technically difficult and commercially impossible in a factory-made product.

The vigorous design element and the bold, experimental energy of British craft knitters ensures them long life – and a place in twentieth-century fashion history.

SUZY MENKES

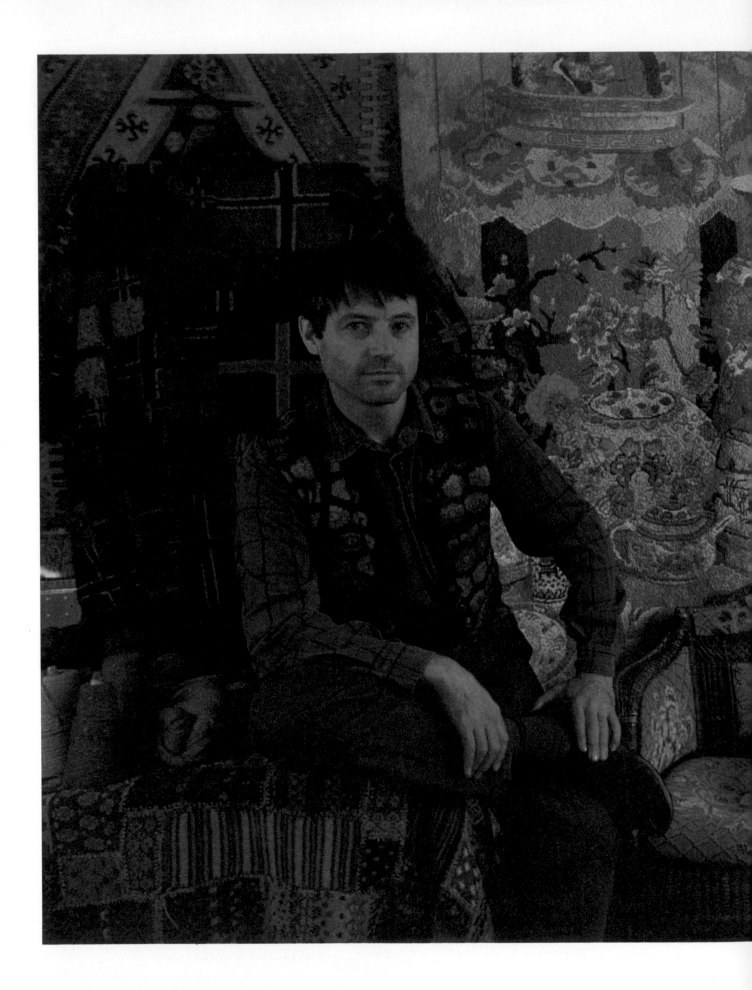

KAFFE FASSETT

Previous page: KAFFE FASSETT in his London studio

b. 1937, San Francisco, USA (moved to the UK in 1964)

Training
Short time at Museum of Fine Arts School, Boston, USA (painting)

Employment
Teaching workshops throughout Britain

Award
Salamagundi Prize for Painting, New York

Exhibitions
pre-1964 Drawings and paintings, Coast Gallery, Big Sur, California; Pantechnicon Gallery, San Francisco; Larcada Gallery, New York (three solo shows)
since 1964 Hazlitt, Gooden and Fox Gallery, London (drawings and paintings)
since 1968 Knitted pieces exhibited in group and solo shows in Britain, Switzerland and Germany
1985 Textile Museum, Washington DC

Collections
Aberdeen City Art Gallery; Royal Scottish Museum, Edinburgh; City of Leeds Museum; Victoria and Albert Museum, London; Melbourne Museum, Australia

Commissions
Drawings and articles for *Vogue*, *The Times*, *Transatlantic Review*, *House and Garden*, *Daily Telegraph*, and magazines in Japan; Knitting packs for Rowan Yarns and the National Trust; Private commissions for knitwear and furnishings

Kaffe Fassett's work was the starting point for the strong upsurge of interest in knitting in Britain; his poetic use of colours and patterning, combined with a relaxed and creative attitude to technicalities, reached British knitting through his inspiring teaching and knitwear. Coming to Britain to paint and draw, he was moved by the colour of yarns in Scotland, and began to teach himself knitting in 1968. He teamed up with Richard Womersley, the weaver (see page 182) and designed machine knits for Bill Gibb. He now concentrates on hand-knit commissions, but also paints murals and does needlepoint, including chair covers, to order.

Perhaps best known for his hand-knitted garments, he is the first to eschew the importance of technique, or elaborate stitches, concentrating instead on colour and texture; often using up to fourteen colours in one row, and always working on circular needles (in order to be able to make large and heavy garments without taking the weight on the needles) he knits instinctively, without charts and without 'weaving in' on the reverse side. Shaping and patterning are dealt with during the making. 'You just,' he says, when teaching, 'knit'.

SUSIE FREEMAN

b. 1956

Training
1974-8 Manchester Polytechnic (School of Fashion/Textiles)
1978-80 Royal College of Art, London (School of Textiles)

Award
1984 Churchill Memorial Trust Fellowship (travel to India)

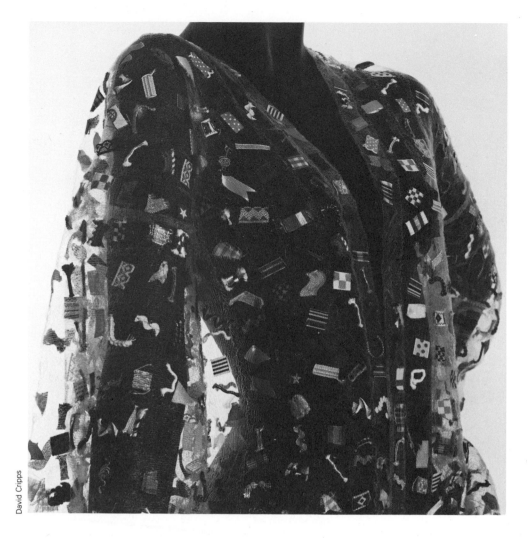

David Cripps

SUSIE FREEMAN machine-knitted monofilament jacket with fabric fragments inserted in the pockets of the structure

Selected Exhibitions
1979 'Tapestries for Today', Contemporary Art Society and Crown Wallpapers, London
1980 Courtaulds Textile Competition, Leeds Art Gallery
1981 Greene Spring Gallery, So Ho, New York
1982 'Making It', Crafts Council Gallery, London; '3 Artists working in Plastic', Aspects Gallery, London; 'Hat Show', Aspects Gallery, London
1983 'The Knitwear Review', British Crafts Centre, London and touring; 'Body British', Edinburgh Festival; 'Sideshow', Crafts Council at the ICA, London; 'Paper Round', British Crafts Centre, London and touring
1984 'Makers '84', British Crafts Centre, London; 'The Complete Works', Aspects Gallery, London and touring; 'Crafts in the Tent', Edinburgh Festival

Collections
The Contemporary Art Society; The Crafts Council, London

Susie Freeman is best known for her transparent knitted work, in which she knits small pockets into the structure, to be filled with a fragment or bauble before being sealed by the next row of stitches.

'I started the pocket idea while studying at the RCA. With the help of a 'setting-up' grant from the Crafts Council I bought a Dubied machine, which meant I could develop the idea. I have been working on this for four years now, and the knitting becomes hats, shirts, collars, cowls, skirts, etc. A lot of the clothes and accessories are more like jewellery than garments. I like knitting which does not look like knitting. I try to construct fabrics that make the viewer take a second look, and then more looks.'

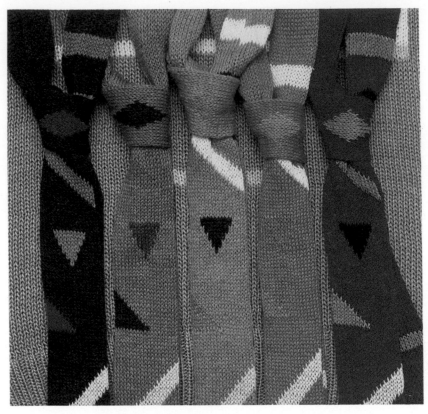

Crafts magazine / David Cripps

VICTOR STUART GRAHAM

VICTOR STUART GRAHAM ties, knitted in cotton, showing the hand-intarsia technique

b. 1949

Training
1967-9 Eastbourne School of Art
1969-72 London College of Printing
1972-4 Royal College of Art, London

Employment
Gloucestershire College of Art and Design; Central School of Art, London

Exhibitions
1980 'Golden Fleece', Rufford Craft Centre, Notts
1981 Galerie Het Kapelhuis, Holland
1982 'The Maker's Eye', Crafts Council Gallery, London
1983 'The Knitwear Review', British Crafts Centre, London and touring
1984 'The Body British', Edinburgh Festival; 'Crafts in the Tent', Edinburgh Festival; 'The Craftsman Today', Hove Museum, Sussex

'I use the technique of hand intarsia, with yarns in natural fibres: wool, cotton, silk. This involves laying the yarn over the needles of the knitting machine (which is producing stocking stitch), and linking the yarns of adjacent colour areas so that a single layer fabric is produced, with no floats at the back. This process gives the freedom to use many colours per row, and to create any pattern on the surface of the knitting. I use the technique to make individual fully-fashioned garments.'

SUE BLACK

Training
1965-8 Hornsey College of Art, London (now Middlesex Polytechnic) (Printed Textiles)

Employment
1973-7 Teaching art in a secondary school
1979- Goldsmiths' College, London; Various short courses
1984 Hounslow College (foundation course)

Award
1982 Southern Arts Bursary

Selected Exhibitions
1982 'Makers '82', British Crafts Centre, London; 'One-off Wearables', British Crafts Centre, London; 'The Maker's Eye', Crafts Council Gallery, London
1983 'The Knitwear Review', British Crafts Centre, London and touring
1984 'Black and White', British Crafts Centre, London

Collections
Leicester Museum; Private collections in USA

Commissions
1984 Designers' Guild

'I use hand-knitting as an expressive medium, developing ideas from drawings, straight on to the needles. This organic process allows me to make spontaneous decisions about details. Occasionally I use other textile techniques such as embroidery, or hand-painting, in conjunction with knitting.

'Each piece made is different and worked in a broad variety of colour and texture—I am concerned with construction, form and surface pattern. Most of my work is made to commission, but some is made for sale through exhibitions.'

SUE BLACK hand-knitted shawl with deep fringe

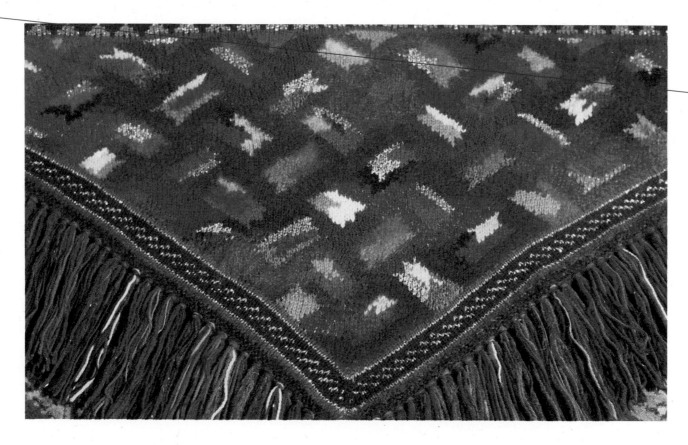

SANDY BLACK

Training
University College, London (mathematics)

Sandy Black is a self-trained knitter and designer of garments. After a period in the unreliable ready-to-wear market with individual clothing items, she started to work via seasonal collections, and now shows regularly at the Individual Clothes Show, selling mainly to Europe and the USA, Australia and Japan. Since 1982, her own ranges of specially developed yarns, with patterns for the home-knitter, have been on sale by mail order and through fifty stockists in the UK.

Originally a machine-knitter, the majority of Sandy Black's designs have been designed for hand-knitting, but future plans include machine-knitting for both ready-made garments and kits.

SANDY BLACK 'Vase of Flowers', coat in mohair

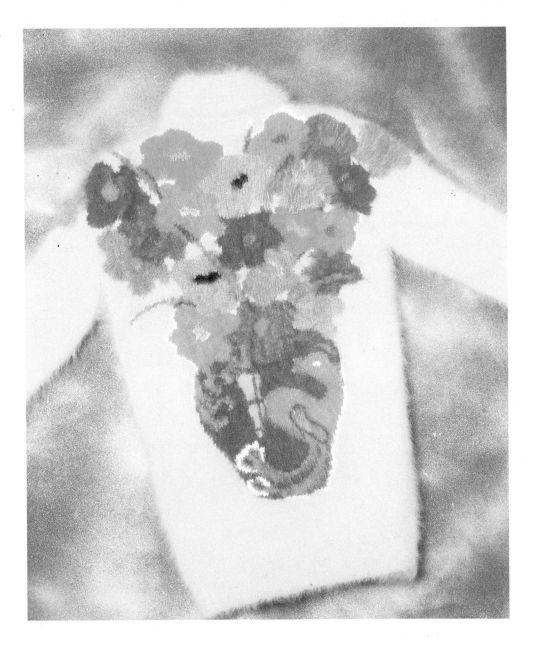

PATRICIA ROBERTS

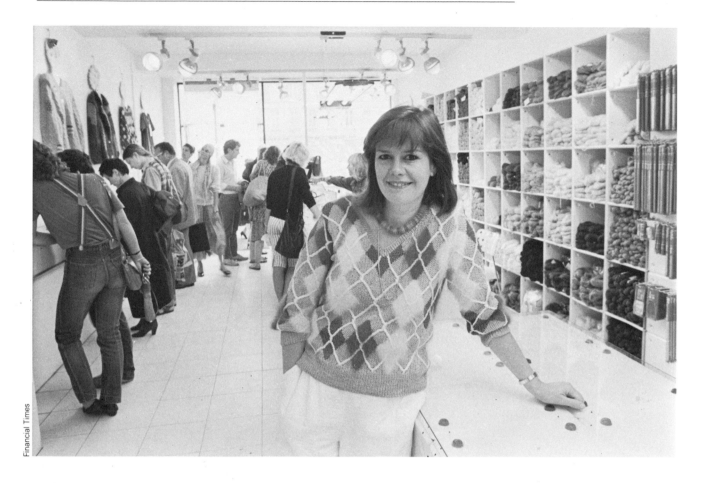

Financial Times

Training
Leicester College of Art (School of Fashion)

On leaving college as an enthusiastic hand-knitter in the early 1960s, Patricia Roberts worked for a group of women's magazines where she realized the value of technical accuracy. She then set up her own knitwear design studio, and organized the production of ready-made hand knits, which sold in London and the USA. Today, she shows two collections each year, to buyers in Paris, Milan and London.

1974
She began to design and supply, by mail order, her own range of knitting yarns
1975
The first of the annual pattern books was produced (since then, eight have been published in paperback and three in hardback)
1976
She opened her first retail shop and was joined by her brother Keith Roberts who now manages the business and wholesales the range of yarns
1982
The second shop was opened. There are franchise shops in Hong Kong and Melbourne, Australia

Patricia Roberts is the most 'commercial' of Britain's hand-knitters. Without any loss of originality and quality, her ready-made collections, patterns and yarns are available to a very wide international public. She, more than any other hand-knitter, has enabled the general public to make their own replicas of her very original designs, which range from textured, simple-colour garments to multi-coloured highly patterned sweaters.

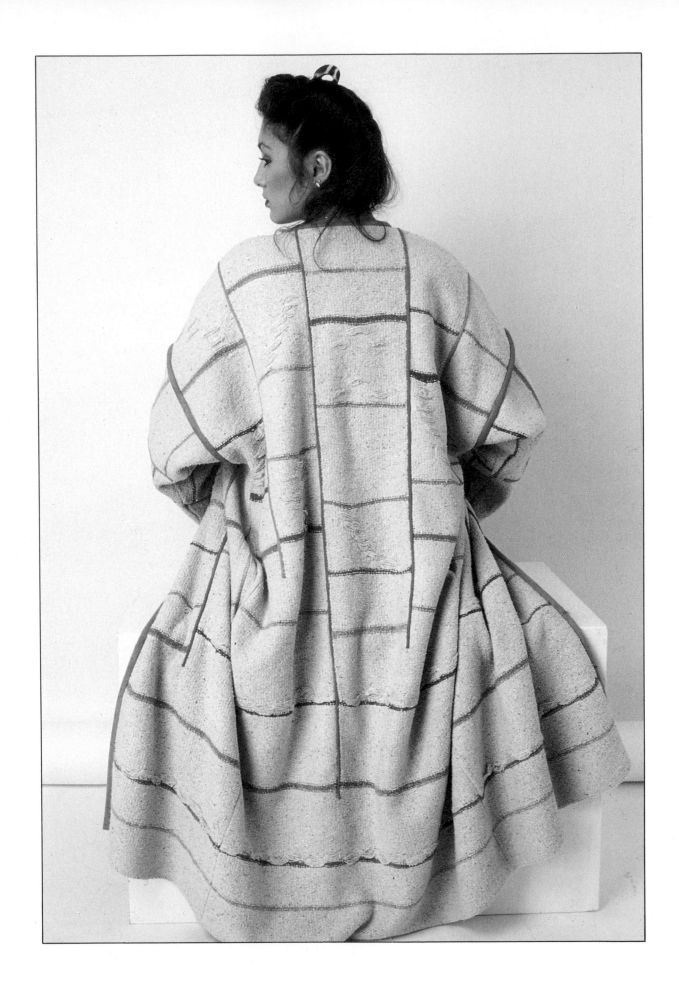

PURY SHARIFI

Training
1970-74 Middlesex Polytechnic (Printed Textiles and Knitting)

Exhibitions
1975 Whitechapel Art Gallery, London
1982 Rufford Crafts Centre, Notts
1982-3 Hand and Spirit Crafts Gallery, Scottsdale, Arizona, USA
1983 'The Knitwear Review', British Crafts Centre, London and touring
1984 'Texstyles', Crafts Council Gallery, London and touring

Pury Sharifi's one-off work has been notable for its sophisticated use of subtle colours, the placing of areas of those colours, flat and textural patterning. These garments are highly original and distinctive – essentially works of art made by a craftsman.

'Until recently I have been designing and producing only "one-off" garments for commissions and exhibitions. I have been interested in developing textural and three-dimensional effects, using textured yarns dyed to my own specifications. In designing a garment I develop and experiment with yarns on a domestic knitting-machine, creating fabric structures which often look more like weaving than knitting. The shape of the garment is then designed with that fabric in mind. (Or it may be the other way round: I may have a strong idea about a garment shape, and design the fabric to suit it.)

 'Although continuing to make one-off garments, I am now designing knitwear for small production runs. From two collections each year, these are sold to buyers in London and abroad.'

Opposite: PURY SHARIFI coat knitted in rough silk with suede piping (one-off)

PURY SHARIFI jacket and top in cotton crêpe yarn (production run)

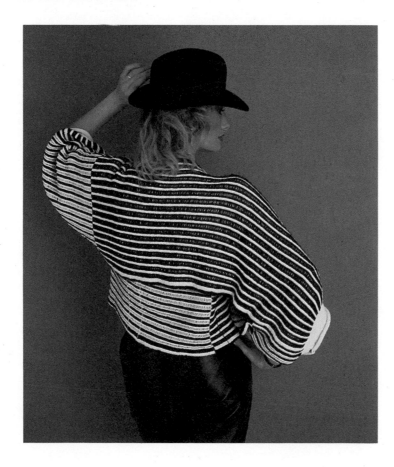

43

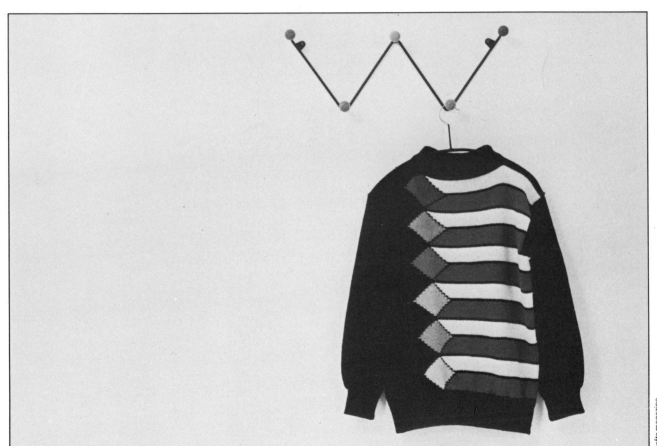

CONNIE STEVENSON

(formerly Connie Cashmere)

b. 1953

Training
1972 North Staffs Polytechnic, Stoke-on-Trent
1973-4 Liverpool College of Art (painting)
1976 Self-taught in knitting

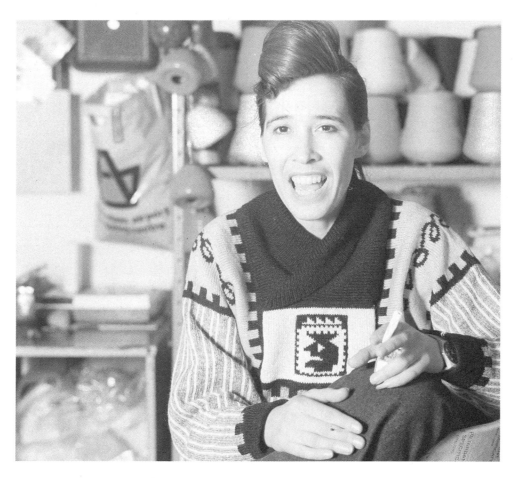

Opposite: CONNIE STEVENSON machine-knitted sweater, *c.* 1980

CONNIE STEVENSON wearing Connie Stevenson sweater, 1984

Exhibitions
1982 'The Maker's Eye' (invited selector/participator), Crafts Council Gallery, London
1983 'The Knitwear Review', British Crafts Centre, London and touring

Connie Stevenson sells work to the USA, Germany, UK, Holland, Belgium, Japan, Australia, Italy, Canada, Switzerland, Austria and France.

'I'm a machine-knitter. I can't knit by hand. I have my own method of working out my designs which, after all these years, is still mainly trial and error (I don't think I could follow a proper knitting pattern). After a time spent in discovering new techniques, new ways of using knitting machines, I've been concentrating recently on simple patterning, and using this to create bold, quite classically styled knitwear, moving more towards men's rather than women's designs. Surface patterning is the most important aspect for me now, and the challenge lies in creating knitwear which looks more complicated to make than it actually is. This is all important – my commercial survival depends on simplification.'

EMBROIDERY

Embroidery is a term now used to describe not only the craft in its traditional sense – that of embellishing a given surface with stitches – but also to cover such other stitched textile methods as appliqué, patchwork and quilting. It has always been the most popular and accessible of the textile crafts. Requiring the minimum of equipment, taught to most girls from primary school onwards and commercially available in the form of printed canvases and 'materials kits', it appears to be within the reach of anyone who can wield a needle. Surprisingly enough, it seems that this very accessibility works to its disadvantage in any bid for a recognized and valued place in the world of the visual arts. Furthermore, a curiously persistent misconception which equates embroidery with compliant female domesticity has done nothing to help those who have recognized its considerable potential (and history) as an art form and have wished to practise professionally. In one respect, however, such serious students are in a fortunate position – Britain is one of the few countries where embroidery may be studied as a specialist subject to Honours Degree and postgraduate levels. That it is accorded this status is due to the innovative work produced at Glasgow, Edinburgh and Birmingham schools of art as early as the turn of the century, and to the inspiration of a number of outstanding teachers from the 1950s on – notably Constance Howard at Goldsmiths' College, London and Kathleen Whyte at Glasgow School of Art.

In the 1950s and 1960s many young artists trained in other areas of the visual arts joined with new graduates from specialist embroidery courses to produce a wealth of innovative stitched textiles. Their work had an immediate and wide appeal. It was shown in the influential 'Pictures for Schools' exhibitions and purchased for many public collections. Nevertheless the word 'embroidery' was an inhibiting factor in securing further prestigious exhibition venues. The term 'fabric collage' was frequently substituted, and Margaret Kaye's work using collaged fabric scraps was exceptional in being shown regularly in West End galleries.

Some general trends can be discerned in the work of this period – an enthusiastic use of all kinds of materials, the stylization of natural forms as 'motifs' and the emergence of a new and successful abstraction. The format was commonly that of modestly sized framed panels or wall-hangings. By the early 1970s more fundamental changes were taking place. There was a greater variety of work, both in subject matter and scale. Originally content to work on a given base fabric, embroiderers now began to dye and print their own fabrics; they began to work three dimensionally and to increase the scale. By the mid 1970s there was a noticeable rejection of the dainty, an increasing interest in the construction of the textile and a search for more robust qualities. Michael Brennand-Wood (see pp. 62-63) was in the forefront of this

movement. Sally Freshwater, a little later, worked towards an austerity that is only now being appreciated.

The international revival of interest in papermaking prompted many artists to recognize its affinity with stitched textiles, noticeably Helyne Jennings, Susan Kinley, Stephanie Tuckwell and Katherine Virgils. Similarly, the renewed interest in feltmaking (triggered here in 1979 by Mary Burkett's seminal exhibition 'The Art of the Feltmaker') has provided a splendid medium for such artists as Annie Sherbourne and Jenny Cowern.

The innovative force of the studio quilt movement in the USA has scarcely touched Britain and although exhibitions such as 'Irish Patchwork' at Somerset House in 1980 remind us of our heritage, we rely on only a few outstanding makers such as Pauline Burbidge, Diana Harrison or Phyllis Ross to point a way forward. (Patchwork is immensely popular with amateur stitchers but suffers badly from the availability of pre-selected packages of fabric which negate that essential quality of an idiosyncratic selection by each maker.)

In the USA the strength of the Women's Movement in the 1970s was undoubtedly a catalyst in the re-presentation of sewn work, and in Britain the work of Kate Walker has a similar underlying intention.

The public face of embroidery has many sides; flags and banners, costume and, perhaps most obviously, ecclesiastical embroidery (an unbroken tradition since medieval times). Commissions for vestments and church furnishings are undertaken regularly by professional embroiderers such as Barbara Dawson, Beryl Dean, Hannah Frew-Paterson, Pat Russell, and it is still quite usual to find churches furnished with embroideries produced on a co-operative basis by amateur embroiderers.

There are few other commercial outlets for embroidery and so it exists mainly in the area between the fine and applied arts. With the sense of freedom this marginal place produces, the boundaries of 'embroidery' have now been stretched to encompass a range of work which only two decades ago would have been unthinkable. In everyday language the word embroidery has been debased to signify excessive elaboration (rather than plain truth) and today's artist-craftsmen and craftswomen often use the simpler term 'stitched textiles' to describe their work. Providing they can resist a pleasurable reliance on the processes and obvious seductive qualities of the medium, the accessibility of the stitched textile may, in the end, prove its greatest strength.

AUDREY WALKER

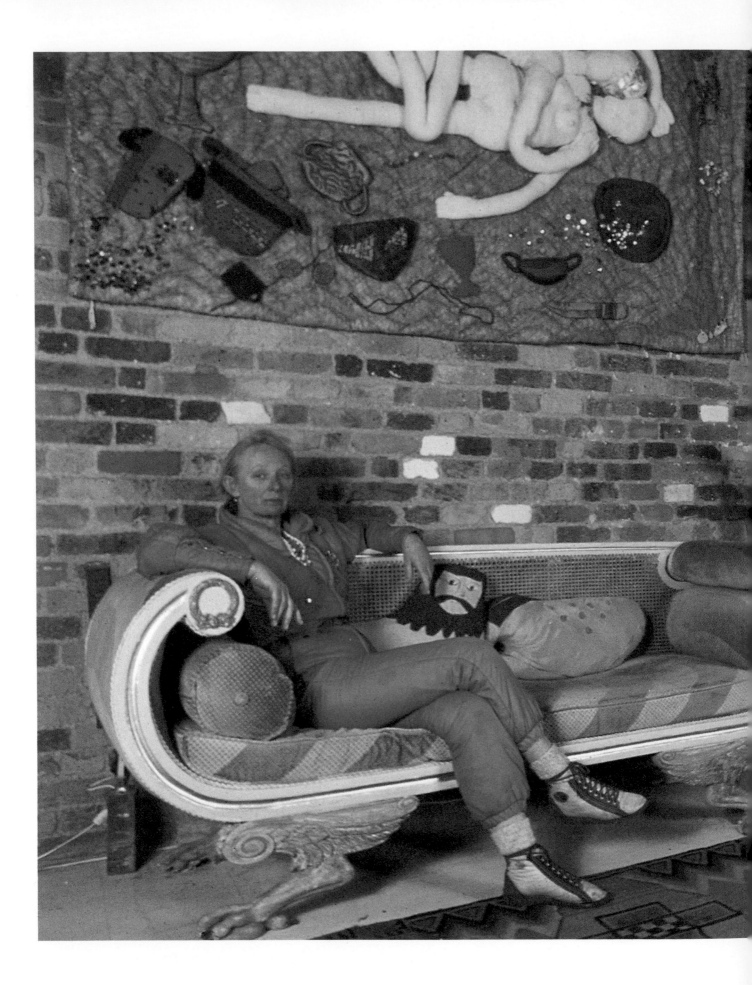

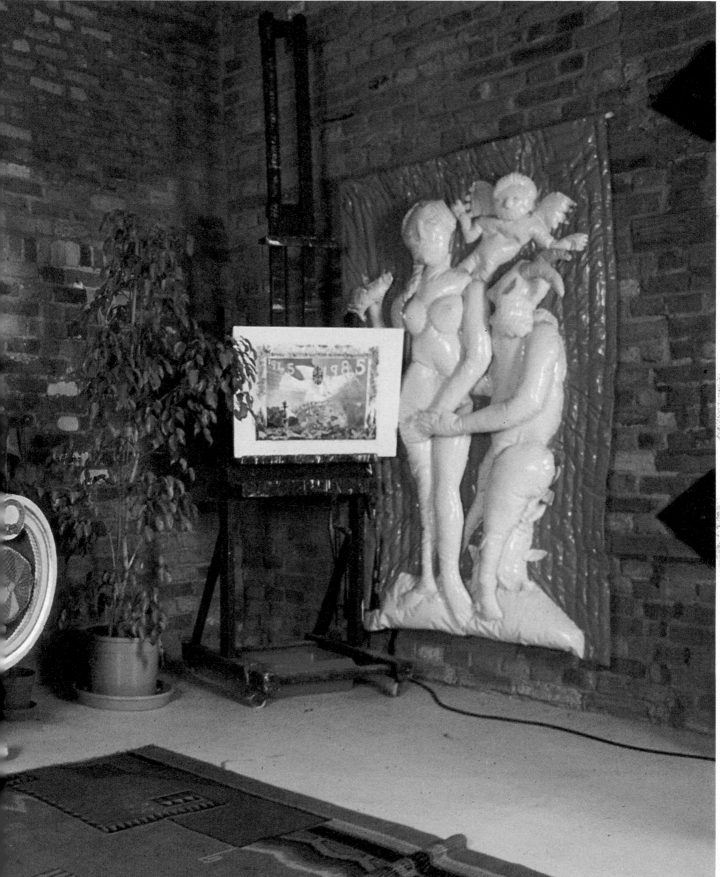

POLLY HOPE

b. 1933

Training
1942-8 Trained as a dancer; joined Festival Ballet (too tall)
1949 Heatherley's School of Art, London
1950-52 Chelsea School of Art, London (Painting)
1952 Slade School of Art, London (Painting)

Selected Exhibitions – Solo
1976 Institute of Contemporary Arts, London
1978 University Art Gallery, Albany, New York, USA; Norton Gallery, Palm Beach, Florida
1979 Redfern Gallery, London; Galerie B 14, Stuttgart; To Trito Mati Gallery, Athens
1980 National Theatre, London; Sarah Cabell Massey Gallery, Dallas, Texas; Australian Gallerie, Melbourne
1982 Warwick Arts Trust Gallery, London; Australian Galleries, Melbourne; Macquarie Gallery, Sydney

Selected Exhibitions – Group
1958 The John Moores Exhibition, Liverpool
1977 '8th International Tapestry Biennale', Lausanne
1978 Whitechapel Gallery, London
1979 'The Craft of Art', Walker Art Gallery, Liverpool

Polly Hope's richly mixed background and life is reflected in, and important to, her work: the primary family influence of architecture and the military was overlaid by a simple book of her childhood *One Hundred Paintings of the Royal Academy: 1908* showing 'romantic love scenes, sweated labour, shiny horses, shipwrecks'.

Working within the modern movement, as a student, led to large wooden sculpture, but also to an intense concern with colour. Her marriage led her to Greece, which proved to be the right working environment, full of unselfconscious regard for the figure in art, whether classical sculpture or tinsel ikon. To work using textiles as a medium seemed natural in such a place, 'where many of the important works of art for the past 500 years have been made with the needle or the loom'.

Previous page: POLLY HOPE in her London studio

Below left: POLLY HOPE 'Happy Family', 2.05m × 1.13m, padded and quilted vinyl, 1979

Below right: POLLY HOPE 'Szekassy Family', 2.6m × 3.1m, 1978

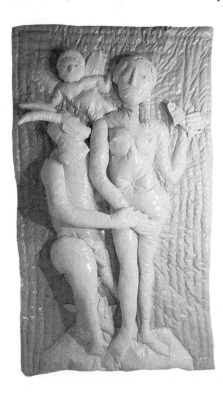

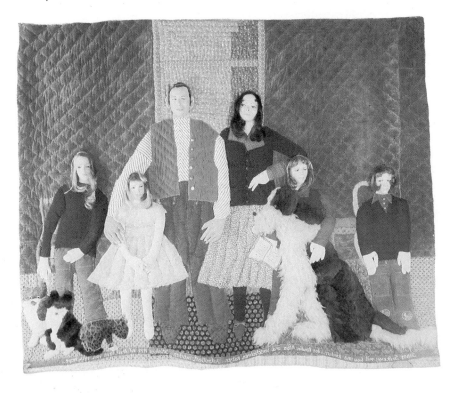

POLLY BINNS

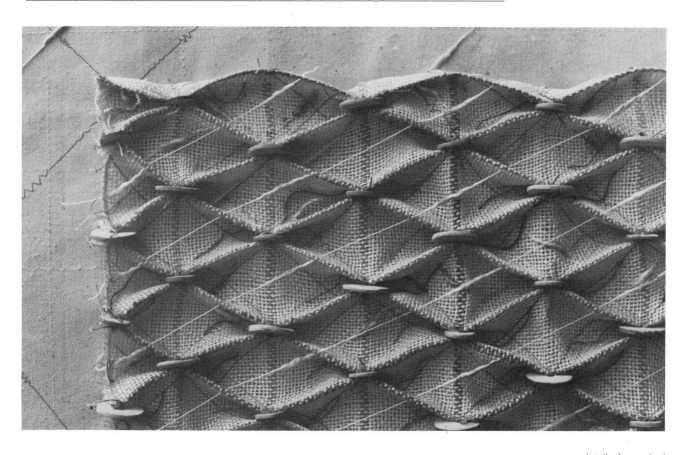

b. 1950

Training
1972-6 Kingston Polytechnic (Sculpture)
1976-7 Croydon College of Art (Ceramics research)

Employment
1977-8 Kingston Polytechnic
1981- London College of Furniture
1982- Craft Officer, Southern Arts

Selected Exhibitions – Solo
1978 Craftwork at Heals, London
1982 Rye Festival, Sussex
1984 Westminster Gallery, Boston, USA

Selected Exhibitions – Group
1980 Fibre Art I, Roundhouse Gallery, London; '62 Group, Usher Gallery, Lincoln
1981 'Porcelain and Bone China', British Crafts Centre, London; 'Stitchery', British Crafts Centre, London
1982 'British Needlework', National Museums of Modern Art, Tokyo and Kyoto, Japan
1983 'Makers '83', British Crafts Centre, London; Westminster Gallery, Boston, USA; 'Paper Round', British Crafts Centre, London
1984 'Rugs and Hangings', South West Arts, touring; 'Black and White', British Crafts Centre, London; 'Totem Show', Anatol Orient Gallery, London; 'Colour in Furniture and Textiles', Ikon Gallery, Birmingham and touring

POLLY BINNS detail of smocked panel, hand- woven, dyed and stitched, incorporating porcelain discs

'I work and experiment with the rigid and flexible qualities of fabrics and paper, relating and playing with muted colour and the qualities of light on smocked, folded and pleated surfaces.'

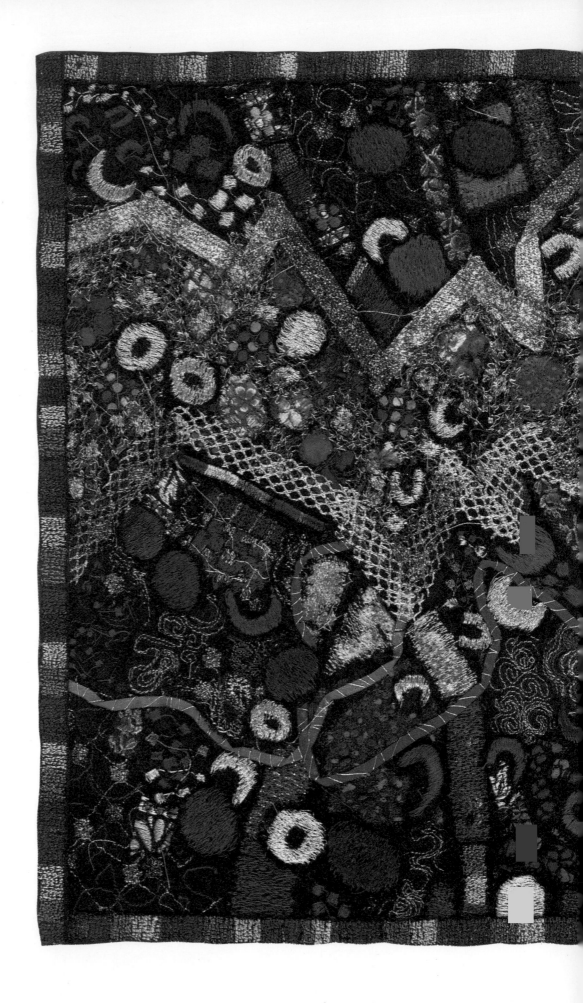

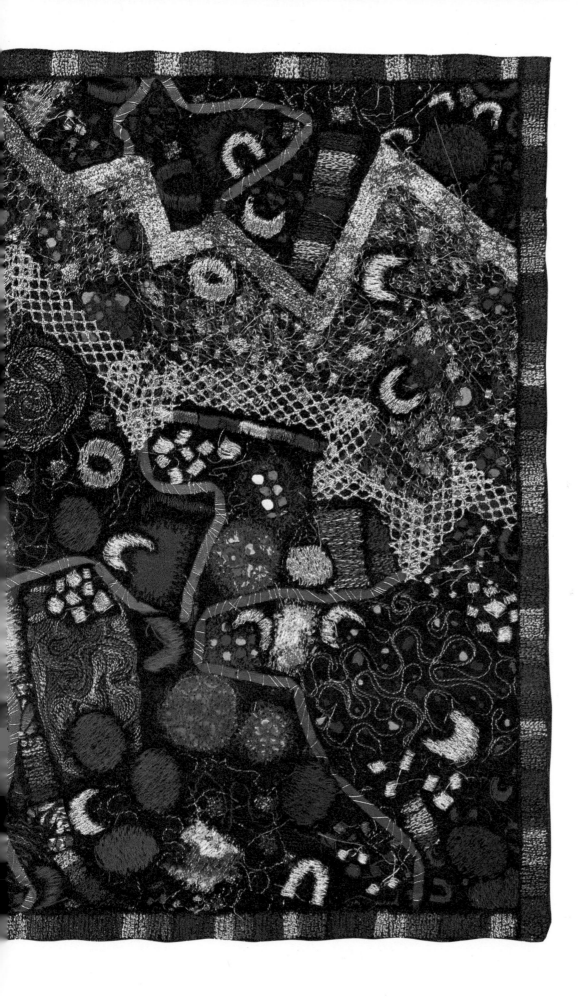

CHRISTINE RISLEY

Previous page: CHRISTINE RISLEY
'I'm flying away tomorrow',
28cm × 36cm, machine
embroidery, 1982

Employment
1949-67 St Martin's School of Art, London
1967- Goldsmiths' College, London
1978- Royal College of Art, London (visiting lecturer)
1978- Short courses and lectures in Canada
1979- External assessor for various polytechnics and colleges of art

Selected Exhibition – Solo
1954 Hanover Gallery, London

Selected Exhibitions – Group
1950-73 'Pictures for Schools', touring; British Crafts Centre, London; Society of Designer
Craftsmen; Arts Council travelling exhibitions; Victoria and Albert Museum, London
1981 London Regional Art Gallery, Ontario, Canada
1982 National Museum of Modern Art, Kyoto, Japan
1984 Bath Festival

'My work consists of richly patterned and coloured fragments that are placed closely
together to form a sumptuous, ornate and lavishly stitched and appliqued textile.

'The ingredients are an amalgamation of reality and fantasy, things seen, felt
and remembered. I would like my work to be a total expression of what I am so
that it is as near as possible to being a visual multi-faceted image of experiences
that for many reasons cannot be conveyed by words.

'My textile pieces are all machine-embroidered on a Singer 'Irish' machine
which is larger and more versatile than an ordinary domestic machine. Originally
used by embroidery manufacturers, this machine is only set for 'free' embroidery
and has become increasingly appreciated by specialist machine-embroideresses
mainly because it has a variable width of stitch up to 1 cm wide.'

ELERI MILLS four of the eight panels commissioned by the National Farmers' Union Mutual and Avon Insurance for their new headquarters in Stratford-upon-Avon, Warwickshire, 1984. Each panel measures 1.80m × 1.00m

ELERI MILLS

b. 1955

Training
1974-7 Manchester Polytechnic (School of Embroidery)

Employment
1977-8 Crew and Alsager College

Selected Exhibitions
1980 Royal Northern College of Music, Manchester
1981-2 'Textiles North', touring
1981 British Crafts Centre, London
1982 'British Needlework', National Museums of Modern Art, Kyoto and Tokyo, Japan

Collections
Rachel Kay Shuttleworth Collection, Gawthorpe Hall, Burnley, Lancs; Greater Manchester Transport; North West Arts; Private collections

Commissions
Central Toxicology Laboratory, ICI, Alderley Edge, Cheshire; Eight panels for the National Farmers' Union Mutual and Avon Insurance Headquarters, Stratford-upon-Avon, Warwickshire (architects: Robert Mathew, Johnson, Marshall, London); Private commissions

'Although my pieces are essentially textile in quality they are strongly influenced by painting styles and much of the background work takes the form of drawing and watercolours...The form that a piece of work takes is sometimes elusive but the materials used are generally very basic and uncomplicated. Cotton/linen canvas makes a good ground for acrylic paint applied both by brush and sprayed with a mouth diffuser. The threads are a mixture of cottons, linens and rayons and are worked in a range of simple hand-stitching techniques.'

MICHAEL BRENNAND-WOOD

b. 1952

Training
1972-5 Manchester Polytechnic (School of Embroidery)
1975-6 Birmingham Polytechnic (Textiles)

Employment
Goldsmiths' College, London

Award
1980 Medal, Exempla Exhibition, Munich

Fellowship
1984 Artist-in-residence, Perth, Australia

Selected Exhibitions – Solo
1980 Royal Northern College of Music, Manchester; Gardner Art Centre, University of Sussex; John Hansard Gallery, University of Southampton
1981 South Hill Park Arts Centre, Bracknell, Berks
1982 Sunderland Arts Centre, Tyne and Wear

Selected Exhibitions
1978 3rd International Exhibition of Miniature Textiles, London and world tour
1979 'Thread Collages', Crafts Council, London and UK tour; 'Approaches to Fabric and Colour', Midland Group, Nottingham
1980 Exempla Exhibition, Munich; Art Latitude, New York; 4th International Exhibition of Miniature Textiles, London and world tour
1981 'British Ceramics and Textiles', British Council/Crafts Council, Knokke-Heist, Belgium and many others
1982 'The Maker's Eye', Crafts Council Gallery, London (contributor and selector); Aspects Gallery, London; 'Fabric and Form', Crafts Council, London, Australia, New Zealand, Zimbabwe, Hong Kong (contributor, organizer and selector); 'British Needlework', National Museums of Modern Art, Kyoto and Tokyo, Japan
1984 Galerie Van Kranendonk, Den Haag, Holland

Collections
Crafts Council, London; Southern Arts, Winchester; Queensland Art Gallery, Australia; The National Museum of Modern Art, Kyoto, Japan; Private and corporate collections world-wide

Commissions
1975-6 Law Courts, Ilkeston, Derbyshire
1976-7 John Siddeley International Ltd, London
1980-82 Cheshire County Council; Meredith Arts and Sports Centre, Crewe

'In my own work my initial interest in thread structures has developed into an assemblage and layering of surfaces in which a diverse collection of materials from different sources are trapped together. I enjoy this interaction and the tension that can result from off-setting one kind of surface against another, especially those which would not be normally considered together. The grid which forms the base of my work is an ordered yet flexible ground on which it is possible to explore translucency, structure, and most importantly physical depth. The majority of my work has a strong rhythmic base, usually the thread element. Paint, fabric, paper and other materials are placed randomly between the layers of thread and act as a counterpoint.'

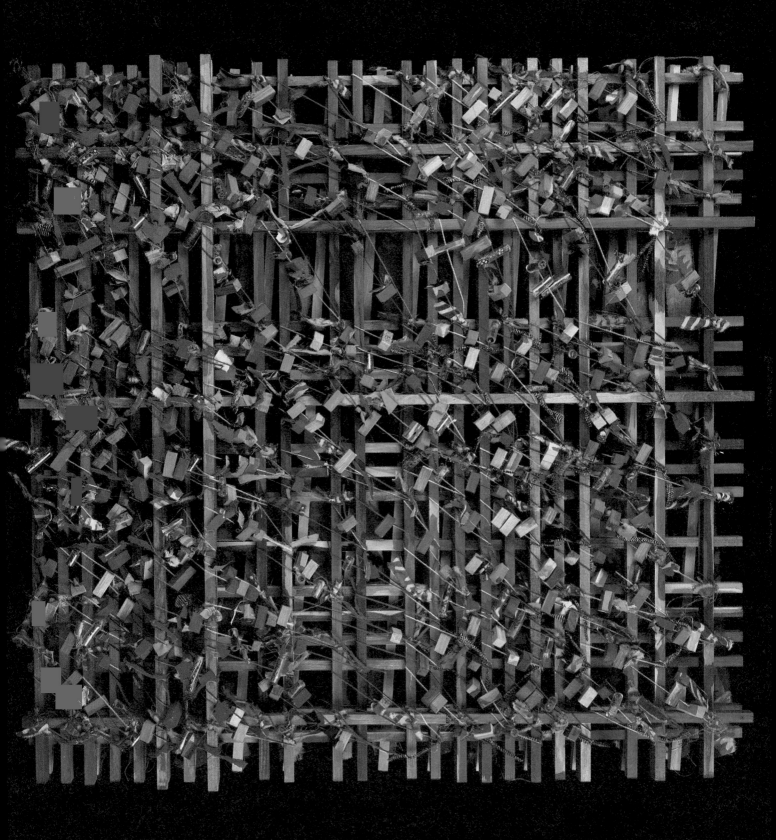

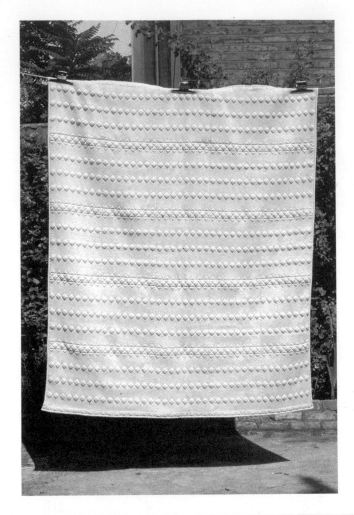

PHILIPPA BERGSON
(*above*) quilt in white cotton
(*below*) detail of above

PHILIPPA BERGSON

Training
1972-5 Manchester Polytechnic (School of Embroidery)
1975-7 Royal College of Art (Textiles)

Employment
1977-83 St Martins School of Art, London; London College of Fashion; Chelsea College of Art, London; Canterbury School of Art; Birmingham Polytechnic

Award
1976 Sanderson Travel Award (to Switzerland)

Exhibitions
1976 Prêt à Porter, Paris
1977 Texprint, London; 'New Faces', British Crafts Centre, London
1978 'Cushions', British Crafts Centre, London; Greenwich (solo exhibition)
1979 'Ten Years of 401½', Commonwealth Institute, London

Philippa Bergson's early work was intricate: quilted and tucked with tiny embroidered motifs (insects, flowers). Recently her work has become simpler, with more direct methods, often involving only one technique in each piece.

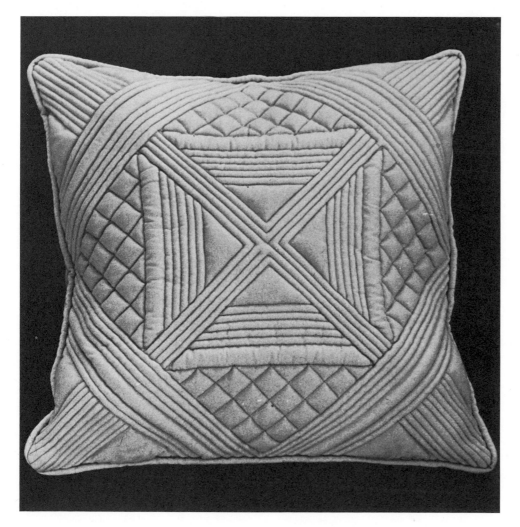

PHILIPPA BERGSON quilted cushion

ROSALIND FLOYD

b. 1937

Training
1950-57 Mansfield School of Art (Printed Textiles and Embroidery)
1958 Leicester College of Art (Teacher Training)
1974-5 Goldsmiths' College (Textiles)

Employment
1958-64 Sydenham School for Girls
1964-5 Shoreditch College (London College of Fashion)
1965-77 Rachel McMillan College
1977- Goldsmiths' College (Textiles), London

Selected Exhibitions
1962-5 'Pictures for Schools' exhibitions
1962-82 '62 Group: at Festival Hall, London; Victoria and Albert Museum, London;
Commonwealth Institute, London; Greenwich; Cardiff
1965-75 'Contemporary Hangings', Folkestone, London, Bermuda

Collections
Victoria and Albert Museum, London; Various education authorities; Private collections

'Since 1982 I have been developing the idea of the stitch and the colour producing the image, each dependent upon the other. Working with red, blue and yellow thread, laid and couched on to a printed grid, I have produced a series of geometric images on strips of cloth. These have been joined together to make an embroidered textile which has either a decorative or functional use.'

Opposite: ROSALIND FLOYD 'One Thousand and One Hours' (*details*) 1984

ROSALIND FLOYD 'One Thousand and One Hours'

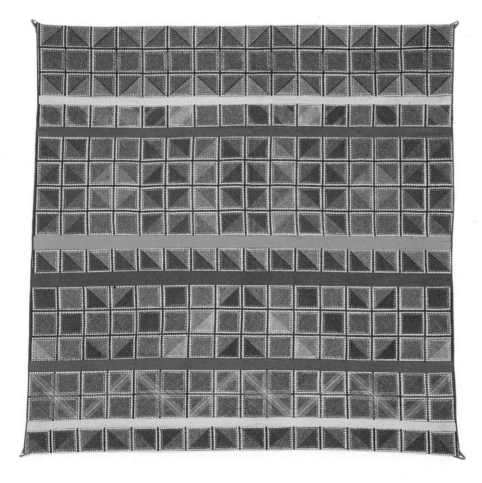

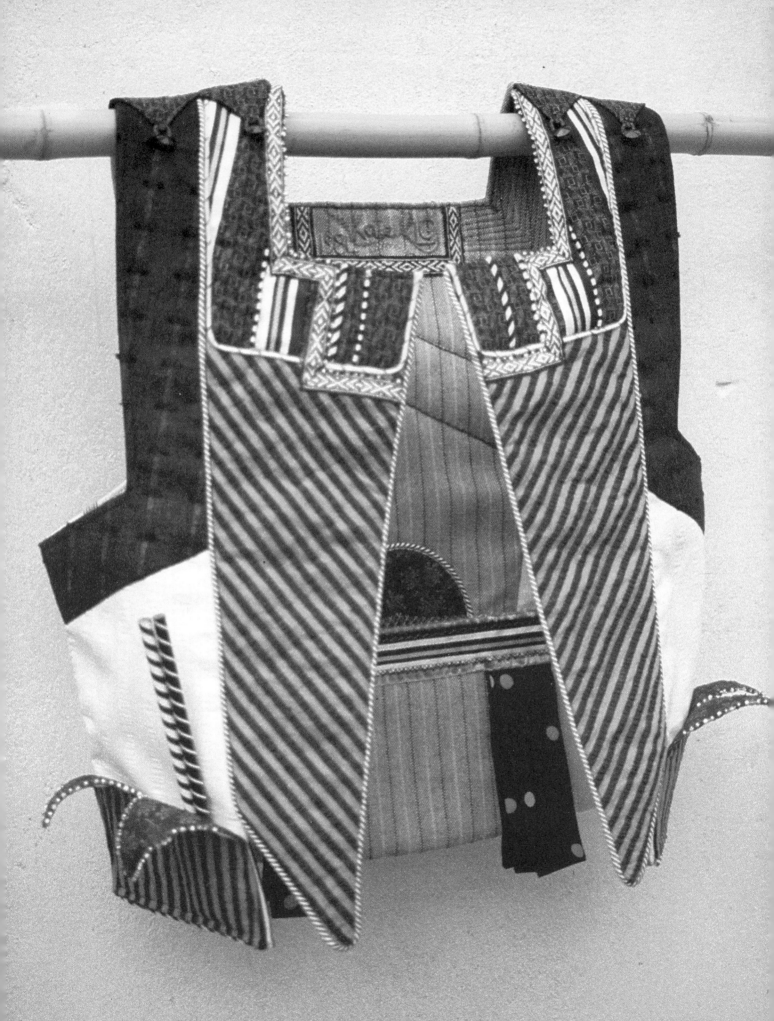

LUCY GOFFIN

Opposite: LUCY GOFFIN black and white coat, 1984

Training
1964-6 In Michael Casson's workshop (Ceramics)
1968-70 Harrow College of Art (Studio Ceramics)
1970 In Gwyn Hanssen's studio, France (Ceramics)

Employment
1971-2 Jean Lamprell Ltd, London (theatrical costumier)
1972- West Surrey College of Art and Design, Farnham; Occasional workshops at West Dean College, Sussex, and Quarry Bank Mill, Styal, Cheshire

Selected Exhibitions
1970 Ceylon Tea Centre, London
1973 'The Craftsman's Art', Victoria and Albert Museum, London; British Crafts Centre, London (with Mo Jupp)
1974 'Everyman a Patron', Crafts Council, London; 'Boxes', Casson Gallery, London
1975 Design Centre, London
1977 Schweitzer Heimatwark Gallery, Zurich; Musée des Art Decoratifs, Paris; Kantonales Gewerbernuseum, Bern; British Crafts Centre, London
1978 Brown Thomas & Co., Dublin
1979 'Silk', Charles de Temple, London; 'British Craftsmen of Distinction', Galerie Kraus, Paris
1981 'Making Good', South East Arts, touring
1982 'The Maker's Eye', Crafts Council Gallery, London; 'One-off Wearables', British Crafts Centre, London; 'British Needlework', National Museums of Modern Art, Kyoto and Tokyo, Japan; 'British Contemporary Crafts', Ohio, USA; 'In Store', Crafts Council, London
1983 'Quilting, Patchwork and Appliqué 1700-1982', Minories, Colchester, and Crafts Council, London; Quilters' Guild National Exhibition; 'British Art – New Directions', The Puck Building, New York, USA

Collections
Reading Museum; National Museum of Wales, Cardiff; South East Arts; Private collections

Commissions
1977 Department of the Environment: coat of arms for Banqueting House, Whitehall, London
1981-3 Embroidery designs for Jean Muir Collections
1984 Cheshire County Council and Crafts Council: window screen for Chester District Library

Although known for her work in stitched garments, Lucy Goffin's interest in this area is now mainly directed towards designing decoration and embroidery ideas for Jean Muir's spring and autumn collections. Her current involvement is in pieces for interiors, both public and private.

JENNY COWERN

b. 1943

Training
1959-63 Brighton College of Art (Painting)
1963-66 Royal College of Art, London (Painting)

Employment
1966-8 Sheffield College of Art
1970-72 Carlisle College of Art
Occasional short periods of teaching in workshops, etc.

Award
1981 Northern Arts Major Purchase Award

Selected Exhibitions – Solo
1980 Paintings and Felts, Abbot Hall, Kendal and Carlisle Museum
1981 Felts and Studies, Prescote Gallery, Oxon, and Wallsend Arts Centre
1982 L. G. Harris Arts Festival
1983 Shipley Art Gallery, Gateshead
1984 Gawthorpe Hall, Burnley; Stafford Art Gallery

Selected Exhibitions – Group
1978 Northern Arts
1981 'Keep in Touch', DLI Museum, Durham
1983 'Wool Gathering', Shipley Art Gallery, Gateshead
1984 Miniature Textile Biennial, Hungary

Collections
Abbot Hall Art Gallery, Kendal; Sunderland Arts Centre; Victoria and Albert Museum, London; Carlisle Art Gallery; Savaria Museum, Hungary; L. G. Harris Brush Factory

JENNY COWERN 'Sky Felt 5', 6 ft × 6 ft, 1980 (*detail*)

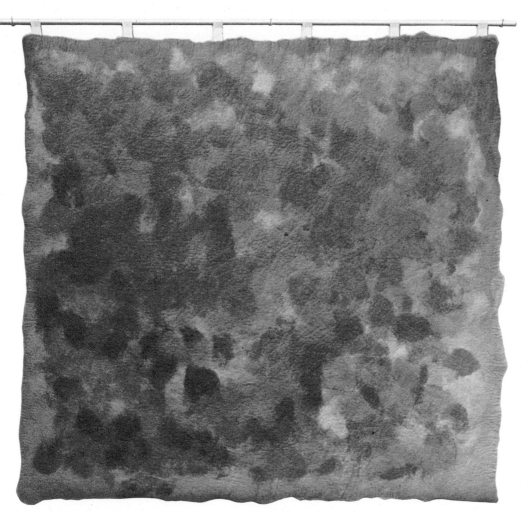

Jenny Cowern, a painter, was inspired by the exhibition 'The Art of the Feltmaker' to investigate this medium. 'It was the mural scale, the freedom, unfussiness, even crudeness, and the directness which appealed. Felt is bold, and requires bold treatment. I had to find subject-matter which would allow me the freedom that the medium promised. I began looking at skies.'

The resulting well-known series of 'Sky Felts', based on the dramatic skies of West Cumbria, occupied several working years. More recent work involves cut forms interlocked and integrated into the substance.

'I see the dyes as my pigment; the colour of the wool as my paint; the wool fibres as my line; the spaces among the fibres as the three-dimensional structure within which I work; the felted fabric as the compressed evidence of my creative activity. My only tools are my carders with which I mix colours.

'I see the felted fabric as my raw material, an area of colour. I may cut it, draw into it with scissors, positive and negative, felt the shapes with others, divide again and recombine, constructing a set of coloured levels, the origins of the once interlocking shapes being evident though permanently set apart in their new alignments.'

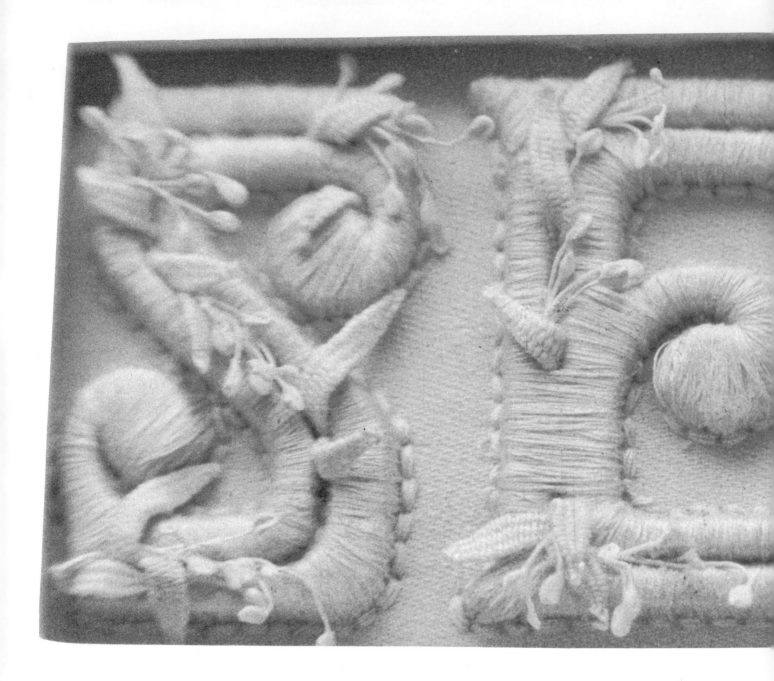

CATHERINE RILEY

Training
1971-4 Manchester Polytechnic (School of Embroidery and MA Fine Art)

Exhibitions
1974- Solo and group exhibitions nationally

Commissions
Include work purchased by the Arts Council and Granada Television

Catherine Riley is best known for the series of uncompromising three-dimensional female figures produced from 1976 to 1981. Unnerving in their life-size realism and

CATHERINE RILEY 'Sew and Sex', 35cm × 50cm, mixed media, 1980

total whiteness, they become surreal as the observer becomes aware of an alien object in the tranquil scene – a man's hand emerging from the Victorian skirt, a vacuum cleaner hose in the hands of the regal occupant of a four-poster bed.

'They convey my concern for extending and improving my technical and visual vocabulary. Technically: chiefly through the use of cloth in conjunction with other media. Visually: in trying to explore visual and emotional ambiguities, which the persistent use of the female as a "symbol" enabled me to do. (They in no way represent any personally-held views on the feminist issue!)

'Current "experiments" have moved away from the use of the female "symbol" entirely, and away from cloth as the means of exploring my central concern of using visual ambiguities as stimuli to trigger-off emotional and intellectual responses in the spectator.'

SUE RANGELEY

b. 1948

Training
1967-70 Lanchester Polytechnic, Coventry (Painting and Print-making)
1970-71 Brighton Polytechnic (Teacher Training)
1971-4 Classes with Constance Howard

Employment
Trent Polytechnic; Ulster Polytechnic, Belfast; Birmingham Polytechnic
1975-80 Craft Workshop, Fosseway House, Stow-on-the-Wold

Award
1982 Southern Arts Craft Bursary

Exhibitions
1976, 1980 Embroiderers' Guild
1978 Prescote Gallery, Oxfordshire
1980 Prescote Gallery, Edinburgh Festival
1978-79 'Silk', Charles de Temple, London and Paris
1980 'Crafts Southwest', South West Arts, touring
1982-3 Westminster Gallery, Boston, USA
1982 'Patchwork and Quilting', touring

Commissions
Worked with Bill Gibb, designing and making embroidered silk evening jackets

Sue Rangeley was the originator of a much-copied style: her embroidered clothes and accessories with three-dimensional appliqué details combine spray-dyeing and hand-painting with machine-quilting and appliqué.

'I work in a range of silks: organza, chiffon, crêpe de chine, shantungs, tussah, etc. Colour palettes vary from soft pastels into rich layers of darker silks combined with metallics. The designs are inspired by a wide range of imagery: botanical, architectural ornamentation, personal collections, studies in museums.'

SUE RANGELEY detail of three-dimensional appliqué on quilted ground, silk, painted and beaded

Opposite: SUE RANGELEY blouse neck detail: painted silk crêpe de chine, embroidered and beaded

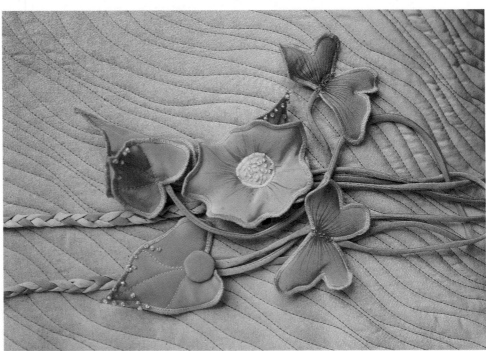

David Cripps

74

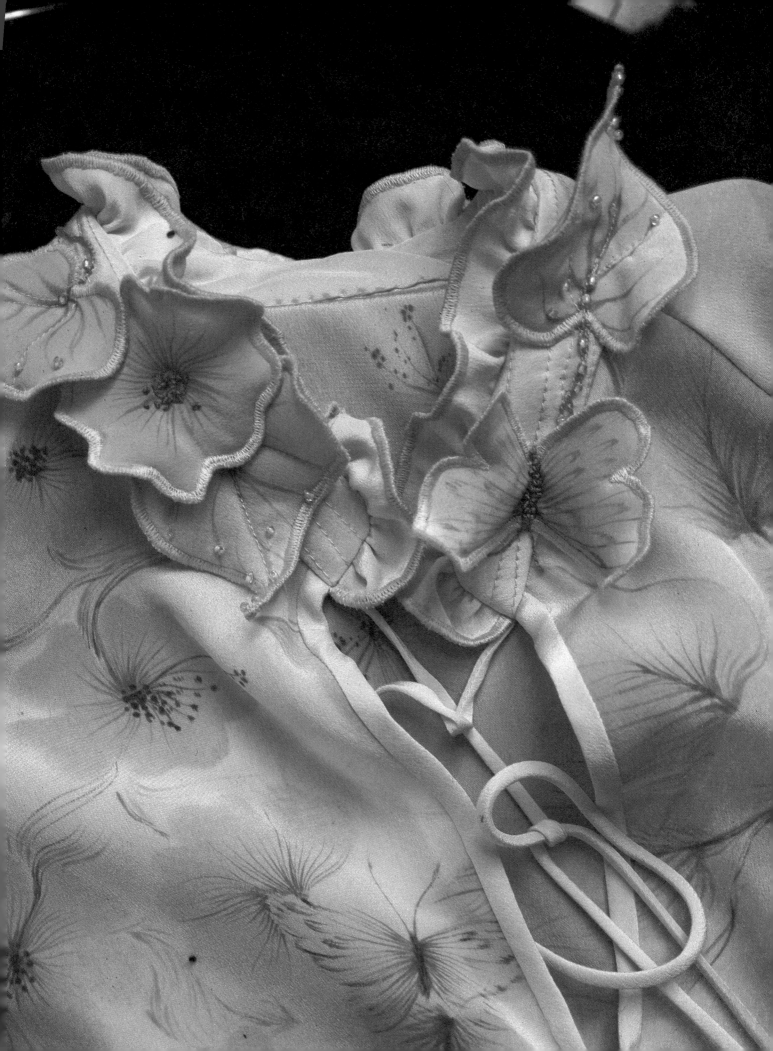

ANNE MORRELL

(formerly Butler)

b. 1938

Training
Bradford College of Art; Goldsmiths' College, London (Teacher Training)

Employment
Part-time teaching at several schools and colleges in the London area; Goldsmiths' College, London
1968 Manchester Polytechnic – currently Principal Lecturer, Embroidery BA (Hons.)

Award
1984 Pasold Research Fund grant

Selected Exhibitions
Group and two-man exhibitions in UK, USA, Australia and Japan
1971 Tapestry Biennale, Lausanne
1981 'Stitchery', British Crafts Centre, London

Anne Morrell is widely known as an influential educator and writer about embroidery, particularly the area of stitchery. Under the name Anne Butler she has written several books on the subject (published by Batsford), and since 1968 has been responsible for the rise to success of the School of Embroidery at Manchester Polytechnic – arguably the best general embroidery school in the country.

'My approach to embroidery is very personal. My concern is with an art form which is purely about embroidery, neither cloth painting nor demonstration of needlepower. All the usual considerations of two-dimensional composition are employed. I am interested in hand-embroidery stitches, in what they can do – suggest movement, for instance – and in what I can do with them.

'My present pieces are worked on felt fabric with a thread which has a surface contrast. With this contrast of materials the warp and weft of fabric does not get in the way of stitch direction, and the matt quality of felt acts against the shiny thread.'

ANNE MORRELL 'Pink Square', hand-embroidery on felt

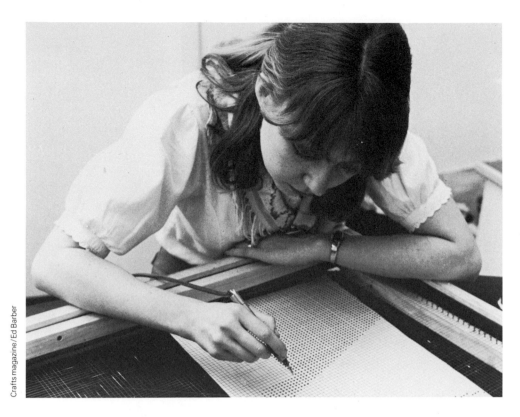

Crafts magazine/Ed Barber

PAMELA WOODHEAD working out
a design in resins and yarn on
a small frame (*see Frontispiece*)

PAMELA WOODHEAD

b. 1955

Training
1974-7 Trent Polytechnic (School of Textiles)
1977-9 Royal College of Art, London (School of Textiles)

Employment
1979-83 Derby Lonsdale College, Derby
1979-84 Brighton Polytechnic; Occasional lectures in polytechnics and colleges

Selected Exhibitions
1979-80 'Texprint', London
1981 'Wrappers', Midland Group, Nottingham; British Crafts Centre, London
1982 'All That Glistens', Rufford Craft Centre, Notts
1984 'Texstyles', Crafts Council Gallery, London and touring

Selected Commissions
Janet Reger Creations; David Hicks; Frederick Fox; David Shilling; Crystal Films (veils for the film
Excalibur); Viyella; Allans of Duke Street; Tomasz Starzewski; Adel Rootstein USA Inc.

Pamela Woodhead has invented her own technique of constructing a net and
beading it in the same operation. Fine threads (often lurex) are stretched on a frame,
and resin is applied meticulously to the intersections. The resulting veils are used for
millinery and bridal wear. Occasionally, the resin is applied to existing nets, making
'jewelled' ruffs.

'Although originally trained as a knitted textile designer, I have always been
interested in developing techniques to achieve unusual visual and tactile effects.
 'My sympathy is towards fine, intricate work, involving colour, light and
translucency. The end result is, I feel, as much a part of jewellery as it is of fabric.'

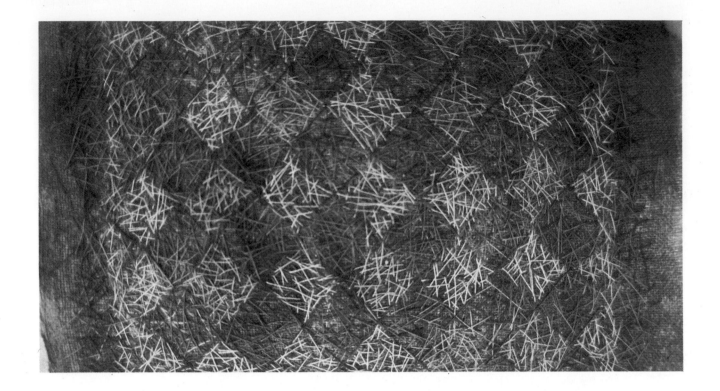

SARAH BUNGEY

SARAH BUNGEY free-stitching
on a sprayed ground.

b. 1954

Training
1973-6 Winchester School of Art (Printed Textiles)
1976-8 Royal College of Art, London (School of Textiles)
1978-81 Royal College of Art (part-time research in decorative treatments of wood)

Employment
1978-82 Chelsea School of Art, London; West Surrey college of Art and Design, Farnham
1979-80 Homeworks Ltd, London, part-time fabric consultant; Visiting lecturer: West Sussex
College of Art, Cardiff College of Art, Trent Polytechnic, Winchester School of Art, Ulster
Polytechnic, Belfast; Artist-in-residence at four venues, Eastern Arts

Awards, etc.
1978 Burton Award for development of a patented fabric
1979 Sanderson Travel Award (America)
1979 *Sunday Telegraph* Award for the most promising student to leave Royal College of Art
1980 'Indigo', France: First Prize

Selected Exhibitions
1979 National Museum of Wales; Midland Group, Nottingham
1980 'Texprint', London; 'Indigo', Lille; 4th International Exhibition of Miniature Textiles,
British Crafts Centre, London and world tour
1981 'Wood Research', Royal College of Art, London
1981 'Textiles Today', Kettle's Yard, Cambridge and touring; 'Sewing as a Woman's Art',
Minories, Colchester and Crafts Council, London and touring
1983 'British Needlework', Kyoto and Tokyo, Japan
1985 Solo exhibition at Minories, Colchester and touring

'I am interested in producing decorative surfaces, using a variety of different
techniques, some of which I have developed myself. I enjoy colour, and I aim to
produce the richness of early textiles, oriental rugs and embroideries, by using
contemporary materials and techniques.'

LESLEY SUNDERLAND

b. 1947

Training
1966-9 Chelsea School of Art (Printed Textiles)
1969-71 Royal College of Art

Employment
1972-82 Chelsea School of Art, London, (Surface Design)

Award
1984 Welsh Arts Council Travel Award (Gilbert and Ellice Islands)

Exhibitions
1975 'Gloves', Leighton House, London W14
1979 Worthing Museum, Sussex and Crafts Council 'Sideshow' at ICA London; 'The Shoe Show', Crafts Council at ICA, London
1982 'Work Together', Blue Coat Gallery, Liverpool (with Jonathan Heale); 'The Maker's Eye', Crafts Council Gallery, London and touring
1984 'Maker/Designers Today', Camden Arts Centre, London; Hereford Art Gallery and Museum

'I paint on natural fibres with Procion dyes for one-off pieces and commissions. For small editions of work I use silk-screens.'

LESLEY SUNDERLAND painted and stitched canopy, curtains and cover for four-poster bed, 1979

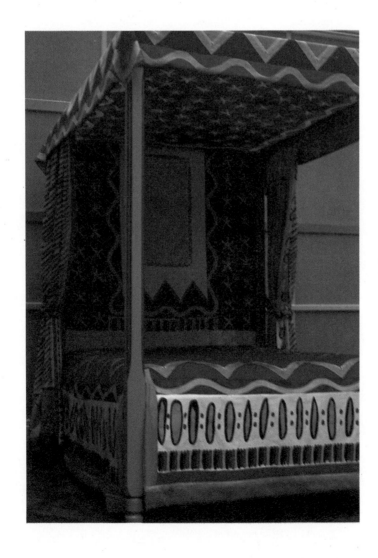

79

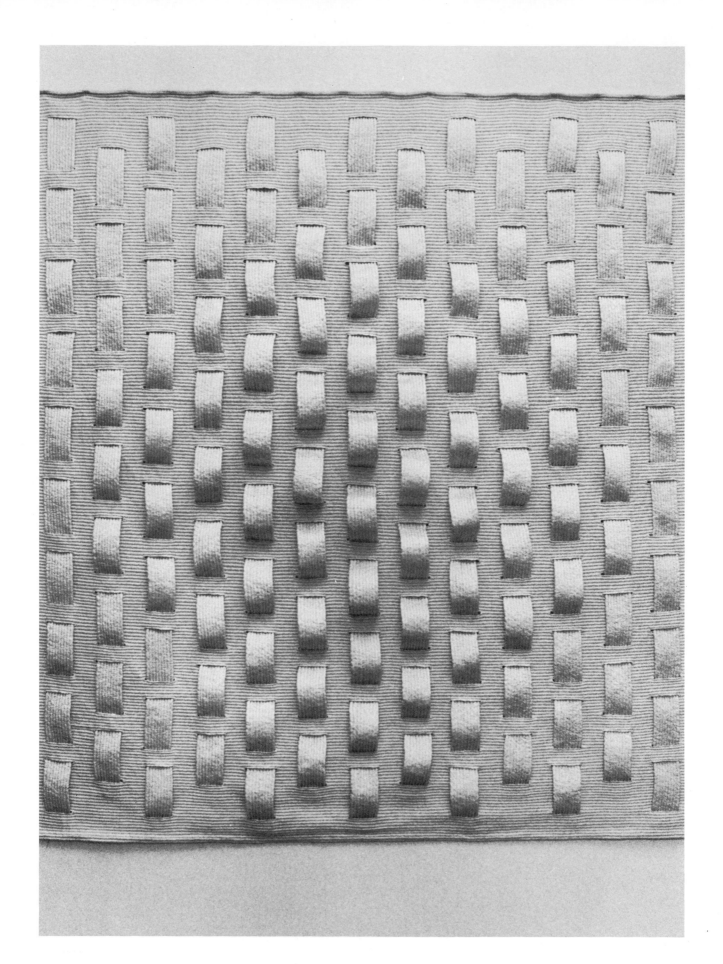

PHYLLIS ROSS

b. 1934

Training
Canterbury College, Christchurch, New Zealand
Goldsmiths' College, London (Textile School)

Exhibitions
1980 'The Fine Art of Textiles', Seven Dials Gallery, London
1981 'Textiles Today', Kettle's Yard Gallery, Cambridge and touring; 'Stitchery', British Crafts Centre, London
1982 'Textilien Aus England', Lagenbacher and Wankmiller Gallery, Lucerne, Switzerland; 'British Needlework', National Museums of Modern Art, Kyoto and Tokyo, Japan
1983 'Quilting, Patchwork and Appliqué 1700-1982' Minories, Colchester, and Crafts Council, London; 'Exposition d'art', Vancluse, France
1984 'Makers '84', British Crafts Centre, London; 'Textiles', Art for Offices, Wapping, London

Collections
The Crafts Council, London; Jon Bannenburg Collection; Mazda Cars, Tonbridge, Kent

Phyllis Ross's quilted pieces are produced in the technique of Italian quilting, where the filling is in the form of a soft thread inserted between close rows of stitches. By using a thin Habutai silk fabric, she is able to add subtle colours by changing the colour of the filling, which can then gleam through the silk.

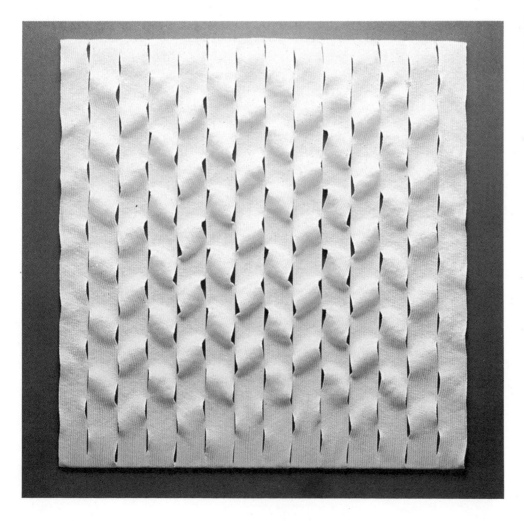

PHYLLIS ROSS 'Tortion', 48 inches × 48 inches, Italian quilted silk, 1983

Opposite: PHYLLIS ROSS 'Arches', 130cm × 130cm, Italian quilted silk

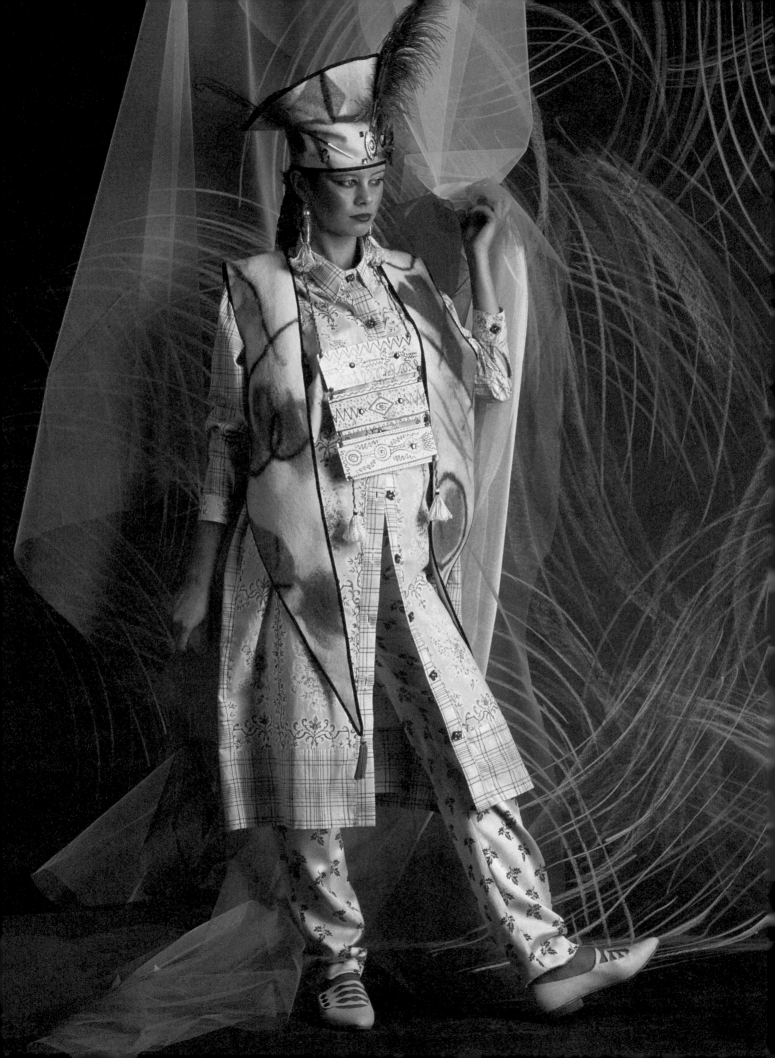

ANNIE SHERBOURNE

b. 1957

Training
1977-80 Goldsmiths' College, London (School of Textiles)

Employment
1981- Visiting lecturer (felt-making) to colleges and polytechnics

Awards, etc.
1978 Courtaulds/Leeds Museums Competition, prize for knitwear
1981 Association of British Commonwealth Universities, travel scholarship
1983 Crafts Council award to participate in 'Texstyles' project

Selected Exhibitions
1982 'Jewellery Redefined', British Crafts Centre, London; '30 Jewellers', Aspects Gallery, London; 'Hats', Aspects Gallery, London
1983 'The Knitwear Review', British Crafts Centre, London and touring; 'Fibre Art', Bury Art Gallery, Lancs
1984 'This ear thing', (earrings) Aspects Gallery, London; 'Black and Yellow Show', (wall-hangings), Aspects Gallery, London; 'Texstyles', Crafts Council Gallery, London and touring

Collections
1984 Shipley Art Gallery, Gateshead (contemporary jewellery collection)

Commissions
1982- Jewellery and felt garments for Jean Muir's collections

Annie Sherbourne's first textiles were knitted sweaters, 'But I was frustrated by the slow and laborious technique and the restriction of the linear build-up of pattern. ..It was a lecture given by Mary Burkett early in 1980 that sparked me off into felt! I work on industrial felt-making machinery with the conveyor belt turned off while I work on top of it, working directly with coloured fibres and previously made pieces of felt...I mostly relate my work to the body, and to people. I like to see it worn. Felt is the clay of textiles as it can be shrunk and stretched by steaming to encourage three-dimensional forms. I feel that there are tremendous, as yet unexplored, possibilities for moulding it round the body.'

Crafts magazine/ Ed Barber

ANNIE SHERBOURNE and workmen in the factory of Bury, Cooper and Whitehead Ltd, examining her felts

Opposite: ANNIE SHERBOURNE felt hat and waistcoat in outfit by Alison Thomas

ENG TOW

Training
1969-72 Winchester School of Art (Textiles)
1972-4 Royal College of Art, London (Textiles)

Award
1978 *Sunday Telegraph* British Crafts Award (Textiles)

Selected Exhibitions
1977 'High Standards' (Silver Jubilee exhibition), Victoria and Albert Museum, London; 'Quilted Wallhangings', 21 Antiques, London
1978 'New faces', British Crafts Centre, London; 'Contemporary Quilts', American Museum, Bath; *Sunday Telegraph* Craft Awards, Somerset House, London; 'Carousel', Crafts Council Gallery, London
1979 'Tapestries of Today', Contemporary Art Society and Crown Wallcoverings, London; 'Homespun to Highspeed', Mappin Art Gallery, Sheffield; 'Bowls', British Craft Centre, London
1980 'Approaches to Metal and Cloth', British Crafts Centre, London; 'Contemporary British Crafts', Sothebys, Torquay, London, Munich
1981 'Textilkunst 1981'
1982 'The Maker's Eye', Crafts Council Gallery, London; 'British Needlework', National Museums of Modern Art, Kyoto and Tokyo, Japan; 'Works on Cloth', Goethe-Institut, Singapore
1983 'Summer Show', British Crafts Centre, London
1984 'Singapore Art – a Decade', National Museum Gallery, Singapore; '25 years of Art in Singapore', National Museum Gallery, Singapore

Collections
Crown Wallcoverings Art Collection; Crafts Council, London; Southern Arts; City of Leeds Museums; Singapore Embassy, Washington, USA

Eng Tow was originally a textile print designer, and her interest in designing prints with an illusion of depth led to her work in cloth reliefs. White or light coloured grounds are essential to this work with light and shade, and stronger colour is applied in areas by spray dyeing, printing, hand-painting or embroidery, to activate the surface further.

ENG TOW tucked and piped quilt (*detail*)

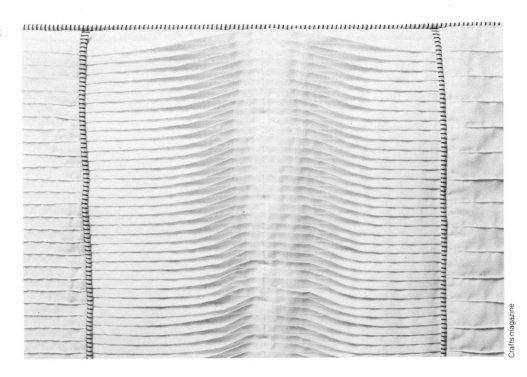

Crafts magazine

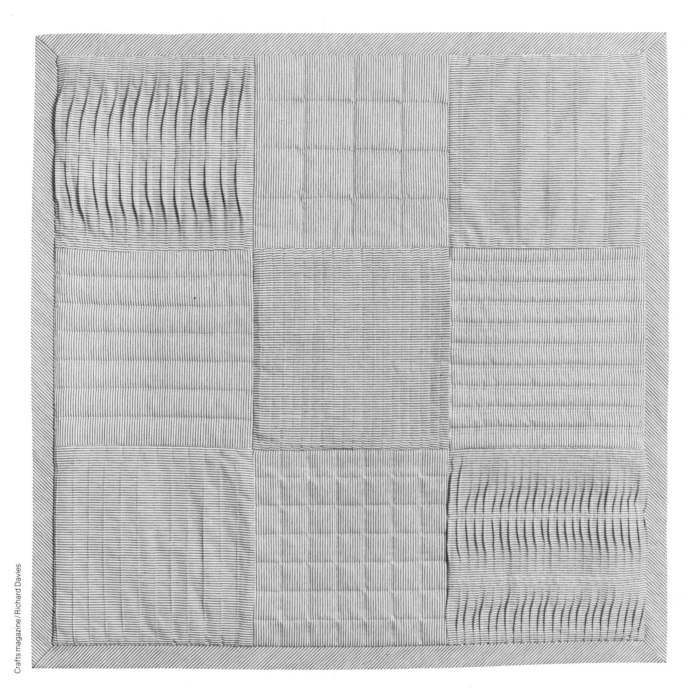

'I see cloth functioning as both the material and the medium. As a watercolourist uses paint on paper, cloth in this case is being used for its own sake – manipulated to effect a visual statement, with the natural phenomenon of light and shadow. I have worked with this "medium" since my period at the Royal College of Art, where I first began to experiment with printed and woven textiles – exploring to extend beyond their conventional states. The possibilities – I have found, to be endless; the results – unpredictable and exciting.

'I work out my basic ideas on paper, progressing later to sampling on cloth (working drawings) further to develop the concept. Using the inductive qualities of colour and optical illusion as vehicles of expression, I am able to translate visually, the metaphysical beauty of the elements, which are my reference.

'Abstract formal structures normally form the basis of my works, but recently, however, I have found the unconfined spontaneity of random form and structure both refreshing and enlightening.'

ENG TOW striped fabric, tucked and quilted panel

KATHERINE VIRGILS

b. 1954 USA

Training
1976-9 Ravensbourne College of Art, Bromley (Fine Art)
1979-81 Royal College of Art, London

Employment
1984 Artist-in-residence (Southern Arts), Oxford

Selected Exhibitions
1980 'Young Contemporaries', ICA, London
1981 Victoria and Albert Museum, London
1982 'The Maker's Eye', Crafts Council Gallery, London; 'Fabric and Form', Crafts Council, London, Australia, New Zealand, Zimbabwe, Hong Kong; 'The New Contemporaries', ICA, London; 'The Hayward Annual', Hayward Gallery, London
1983 'Eight into the Eighties', Sotto Gallery, New York; 'Paper Round', British Crafts Centre, London; 'Heads, Faces, Elevations', Camden Arts Centre, London (Solo)
1984 'New Work', British Crafts Centre, London (with Richard Slee); 'Paper', Bluecoat Gallery, Liverpool; 'Three Interiors', Barbican, London

Collections
Contemporary Art Society, London; Crafts Council, London

Commissions
Burton Group Headquarters; Sainsbury Trust; Harlech Television; Fitch and Co., Architects

Opposite: KATHERINE VIRGILS 'Mille Feuilles', mixed papers, bronze silk, 1983

KATHERINE VIRGILS with 'Silk Layer', 1983

Katherine Virgils works from a meeting point between painting and textiles. The materials (often paper and silk) are almost immaterial, being butted and layered into surfaces which are worn and patinated, folded, overlapped, bronzed.

M. Wooley

M. Wooley

EIRIAN SHORT

b. 1924

Training
1947-53 Goldsmiths' College, London (Sculpture, Embroidery)

Employment
1953-5 Gravesend School of Art, Kent
1954-67, 1969- Goldsmiths' College, London
1954-68 Middlesex Polytechnic; Occasional lecturing and short courses

Exhibitions
'Pictures for Schools', touring; '62 Group; 'Contemporary Hangings', touring
1981 Solo exhibition (retrospective) Welsh Arts Council, Oriel Gallery, Cardiff

Collections
Welsh Arts Council; National Museum of Wales; Greater London Council; Various education
authorities, etc.; Private collections, UK and abroad

EIRIAN SHORT 'Spring at Castell
Bach' (*detail*)

Commissions
Sunday Times; John Lewis Partnership; Wm Briggs & Co. ('Penelope'); British Ropes; Private clients

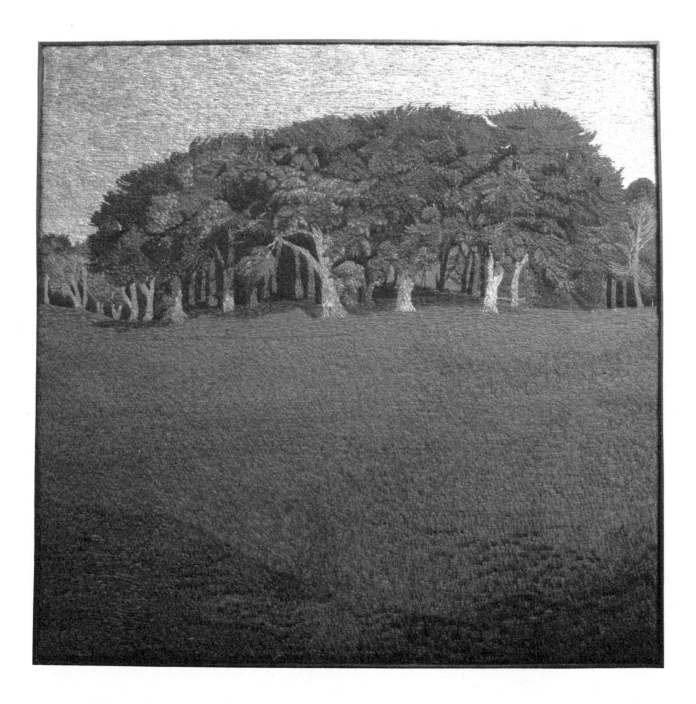

EIRIAN SHORT 'The Clump', 1980

Eirian Short's work is realistic and thematic. Earlier works were in high relief, but she has 'in recent years, worked mainly in two dimensions, depicting the Welsh landscape, in wools, on a stretched fabric ground. With the exception of French knots (which when closely massed give a pointillist effect) I rarely use specific stitches, preferring to think of stitching as mark-making, comparable to a painter's brush strokes. My only aim is to convey my feelings about the landscape and the wild-life in it. At present I am particularly trying to impart the brooding quality of rocks, but subjects of interest in the recent past include skies, crows and foxes.'

She has written several well-known books, including *Introducing Quilting* (Batsford, 1974); *Quilting: Technique, Design and Application* (Batsford, 1979); and *Introducing Macramé* (Batsford, 1970) which was responsible for the huge upsurge of interest in that technique.

KATE WELLS

(formerly Hobson)

b. 1953

Training
1973-6 Loughborough College of Art (Embroidery)
1977 Manchester Polytechnic (MA, Textiles)

Employment
1978 Part-time lecturer (Embroidery), Loughborough; College of Art, Manchester Polytechnic, Glasgow School of Art; Occasional short courses in UK and Australia

Selected Exhibitions – Solo
1979 and 1980 Jew's Court Craft Centre, Lincoln
1981 Museum and Art Gallery, Derby; Shipley Art Gallery, Gateshead
1982 '100% Pure Silk', Rufford Craft Centre, Notts

Selected Exhibitions – Group
1982 'Stitchery 1982', British Crafts Centre, London; 'British Needlework', Kyoto and Tokyo, Japan; 'Textiles North '82', touring
1983 'Contemporary Cotton', Rufford Craft Centre, Notts
1984 Gawthorpe Hall, Lancashire

Collections
National Museum of Modern Art, Kyoto, Japan

Opposite: KATE WELLS (*above*) 'Oxfordshire Triptych', three panels, each 4 ft × 3 ft (*below*) 'Oxfordshire Triptych' (*close detail*), Irish machine embroidery

KATE WELLS 'Oxfordshire Triptych' (*detail*), hand and machine embroidery

'My work is firmly rooted in drawing and painting, with strong recurring themes of landscape, free and formal pattern, and a delight in colour. Many of the stitches and techniques I use are adapted to express this painterly approach, often combining painting and stitchery. I enjoy working in quite different techniques and disciplines, changing scale from large painted and stitched panels to miniature "precious" pieces, through to quilts and soft furnishings.'

Crafts magazine

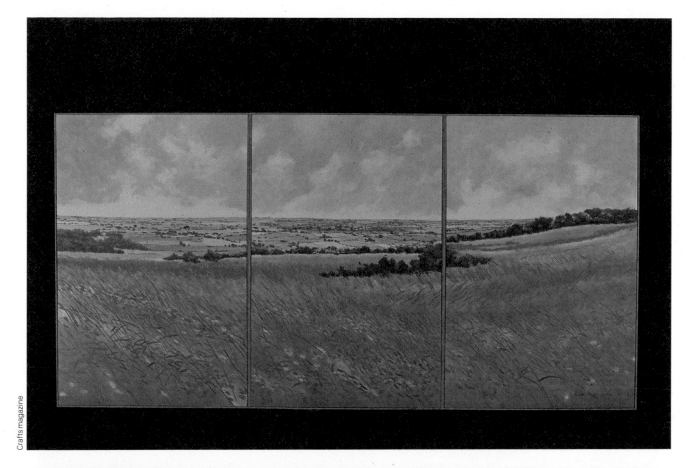

VERINA WARREN

b. 1946

Training
Goldsmiths' College, London (Textiles/Embroidery)

Employment
1969-75 Loughborough College of Art; Canterbury College of Art; Manchester Polytechnic

Award
East Midlands Arts Association

Exhibitions
Has exhibited widely in UK and USA and also in Australia, Norway, Holland and Japan

Collections
Museum of Modern Art, Kyoto, Japan; National Gallery of Victoria, Melbourne, Australia; Victoria and Albert Museum, London; Embroiderers' Guild; Regional Arts Associations in UK; Museum Services in UK

Verina Warren works in partnership with her husband, Stewart; this has enabled her meticulous work to progress through and beyond the traditional frame.

'Landscape is the overriding element of my work; I have always been particularly interested in the various facets of pattern and colour found in the countryside.
 'I use representational images within a structured design framework. The background fabric is pure silk, sprayed and painted with silk dyes. Thread wrapped borders give definition to the various separate planes, and painted mounts, usually of acrylic, extend the viewing perimeter.'

Opposite: VERINA WARREN 'Cornfield', embroidery set in painted mount

VERINA WARREN 'Estuary', embroidery set in painted mount

92

AUDREY WALKER

b. 1928

Training
1944-8 Edinburgh College of Art (Painting)
1948-51 Slade School of Fine Art, London (Painting)

Employment
1951-75 taught painting and embroidery in secondary schools and colleges of education
1975- Goldsmiths' College, London (Head of Embroidery and Textiles)

Exhibitions
Participation in group exhibitions in: Victoria and Albert Museum, London; The Commonwealth Institute, London; British Crafts Centre, London; TUC headquarters, London

Collections
Victoria and Albert Museum, London; The National Gallery of New South Wales, Australia; The Department of the Environment, London; Embroiderers' Guild; Several education authorities; Private collections in UK, Italy, Australia and Eire

Opposite: AUDREY WALKER 'Life is just a bowl of cherries' (*detail*)

AUDREY WALKER 'Eden', pieced fabric, 1978

'As a painter I worked figuratively, slowly and carefully. The subjects were portrait heads, or objects close at hand: bowls of fruit, flowers. It never occurred to me to work with needle and thread until I saw how children could work without inhibition in all materials, and at the same time (early 1960s) I saw exhibitions of modern embroidery, with its possibilities of surface richness and freedom of imagery.

'My work now is assembled and sewn, by hand and machine...When I start with the fabrics I aim to work as directly as possible – cutting, piecing, stitching, assembling, recutting, replacing, restitching, and gradually arriving at the image by a slow build-up.'

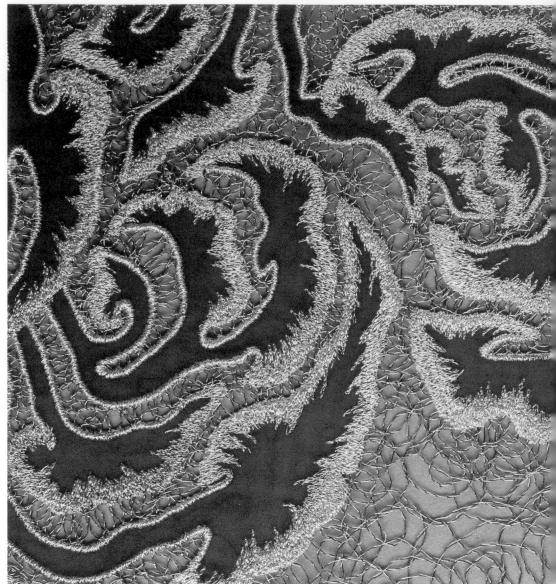

ROBIN GIDDINGS

b. 1957

Training
1976-9 Goldsmiths' College, London (Embroidery/Textiles)
1979 Manchester Polytechnic (MA, Textiles)

Exhibitions
1979 Society of Designer Craftsmen, London
1981 'Stitchery', British Crafts Centre, London; '62 Group, John Holden Gallery, Manchester
1982 Stitchery' (selected by Constance Howard), Oxford Gallery, Oxford; 'One-off Wearables', British Crafts Centre, London; '100% Pure Silk', Rufford Crafts Centre, Notts; '62 Group, Seven Dials Gallery, London
1983 'British Needlework', National Museums of Modern Art, Kyoto and Tokyo, Japan
1984 '62 Group, Tokyo and touring; 'Texstyles', Crafts Council Gallery, London and touring

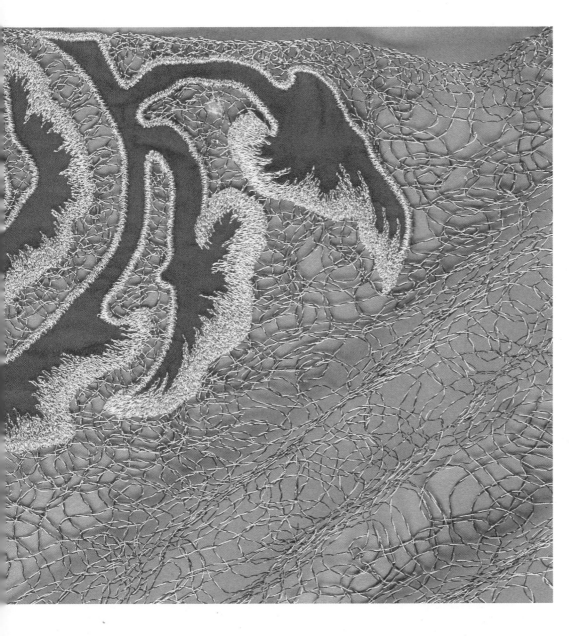

ROBIN GIDDINGS 'Guipure lace'
in gold and black thread

Collections
City of Leeds Museums (Lotherton Hall); Museum of Modern Art, Kyoto, Japan; Embroiderers'
Guild; Private collections in UK, Jersey, USA

Commissions
Thea Porter, and other fashion designers

Robin Giddings works in the basic technique of 'Guipure lace', where lines and areas
are machine-embroidered on to 'vanishing muslin', which is then removed to leave
only the stitchery. He is now experimenting with a computerized Schiffli machine in
order to be able to produce larger areas of repeated patterning, often working in the
shapes of the pattern pieces of the finished garment.

'My aim is to create a wholly personal textile surface – using the sewing-machine
to replace the warp and allowing the flowing machine line to combine elements of
a precious nature into a web-like structure: I have experimented with chemical
lace, "Guipure lace", techniques to create garments or hangings mainly of
glittering threads with fragments of precious fabrics. These have been created on
the "Irish" Singer sewing-machine.'

PAULINE BURBIDGE

b. 1950

Training
1968-9 London College of Fashion
1969-72 St Martin's School of Art, London (Fashion and Textiles)

Employment
1972-3 Designing clothes for a small London company
1973-6 Formed partnership, designing and making clothes
1976-8 Freelance pattern-cutting
1982-4 Demonstrating patchwork; lecturing and short courses

Award
1982 John Ruskin Craft Award (administered by the Crafts Council)

Selected Exhibitions – Solo
1979 Foyles Art Gallery, London
1981 John Macintosh Hall, Gibraltar
1983 Lady Lodge Arts Centre, Peterborough; The Midland Group, Nottingham
1984 Arts Centre, Sunderland; Gawthorpe Hall, Lancashire

Selected Exhibitions – Group
1979 'Contemporary Patchwork Quilts', Cirencester Workshops, Glos.
1980 'New Faces', British Crafts Centre, London
1981 'The Quilters' Guild', London and touring
1982 'The Maker's Eye', Crafts Council Gallery, London; '100% Pure Silk', Rufford Crafts Centre, Notts
1983 'Quilting, Patchwork and Appliqué 1700-1982', Minories, Colchester, and Crafts Council, London; 'Fabric Constructions: The Art Quilt', Worcester Craft Centre, Mass., USA
1984 'Maker/Designers Today', Camden Arts Centre, London; 'Black and White,' British Crafts Centre, London

PAULINE BURBIDGE assembling 'Sunray' quilt, 1984

Publication
1981 *Making Patchwork for Pleasure and Profit*, John Gifford Ltd

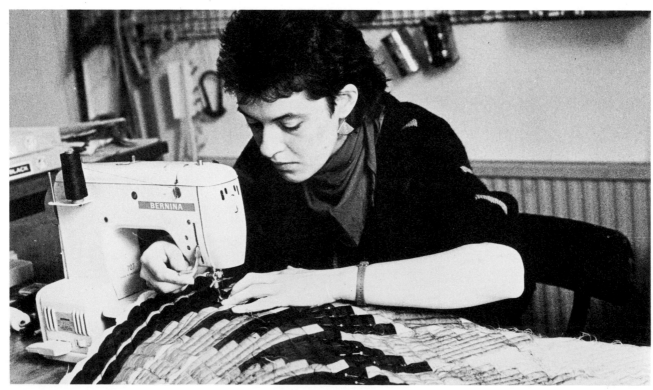

Sholeh Farnsworth

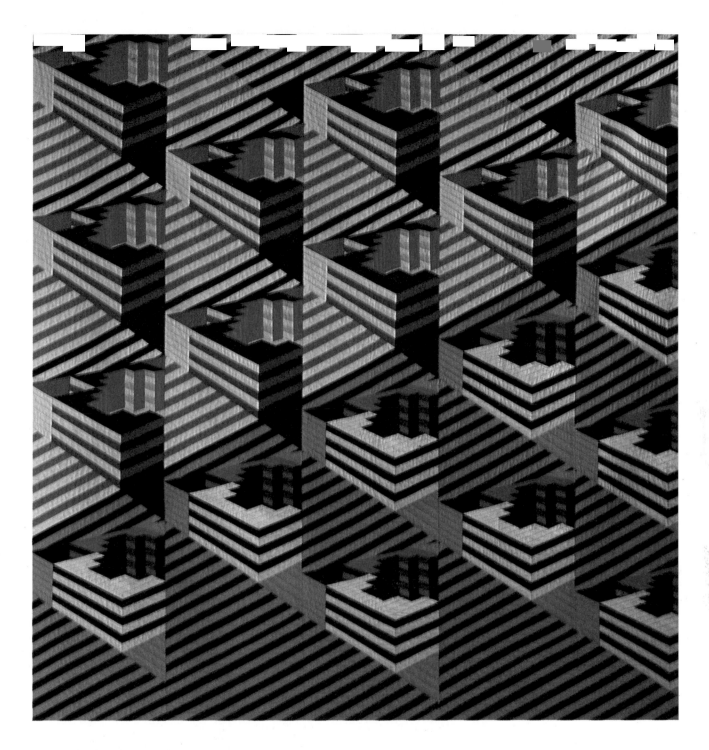

'I have been making patchwork quilts since 1975. Previously I had been designing clothes; now with only a two-dimensional surface I could use the fabrics in a "purer" way, without having to fit a body or consider the whims of fashion. Looking at traditional pieced American quilts, I liked the limitations of straight edges sewn together.

'Repeated pattern now plays a strong role in my design; I am fascinated by the way in which units can slot into each other to create a flowing rhythm, and in the variations possible within the repeat. In many of my quilts I have worked on the design in an asymmetrical way, grading the colour or shapes from one area to the next – this has been a deliberate move away from traditional quilt design, which nearly always uses symmetry.'

PAULINE BURBIDGE
'Finn', patchwork quilt, 1983

99

TAPESTRY WEAVING

'Tapestry cannot escape either the contradictions or the passions of living art'*, and this is what has led to the dichotomy which exists in tapestry today between gobelin, still a perfectly valid medium, and those forms which incorporate fibre wrapped or woven structures. One does not invalidate the other. In fact, what is or is not tapestry is not where the real problem lies but in the virtual absence of any application of critical standards. Tapestry in its various guises is constantly beset by one of two pitfalls, either it is technically incompetent or it displays dazzling virtuosity which cannot hide the lack of real aesthetic value. The happy medium of adequate technical proficiency and some purpose in its employment often seems very hard to find but if tapestry artists wish it to be considered a Fine Art, albeit a minor one, then they have to conform to the standards already accepted in painting and sculpture. Tapestry artists need to strive for the point where the art and craft merge together to produce a completeness where the 'how' becomes unimportant and something is produced which belongs uniquely to tapestry. The past decade of British tapestry has seen much debate on the subject between those who believe this and those who equally vigorously dispute it.

As twenty years ago Edinburgh, with the Edinburgh Tapestry Studios (Dovecot) and the College of Art Tapestry Department, remains the bedrock of British tapestry despite Archie Brennan's departure for Papua New Guinea in 1978. A major Dovecot retrospective, 'Masterweavers', was held at the 1980 Edinburgh Festival and this provided a comprehensive survey of the studio's work since 1912. Among the many notable Dovecot tapestries produced in the last ten years are those by Tom Phillips for St Catharine's College Oxford (1978/9), Eduardo Paolozzi's tapestry for the Stirling Building at Leicester University (1982), the Harold Cohen computer panels and those by Elizabeth Blackadder and John Houston.

Today the future of the Dovecot seems secure as the weavers begin work on a series of eleven large tapestries designed by Frank Stella for Pepsi-Cola.

Brose Patrick set up by Gerald Laing at Conon Bridge in 1970 closed six years later having produced work of a very high standard. As it closed a new tapestry workshop opened at West Dean under the direction of Eva-Louise Svensson, using horizontal looms unlike the high looms employed by the Scottish studios. West Dean is especially associated with the tapestries of Henry Moore and had an important exhibition of their work by other artists such as Howard Hodgkin and Philip Sutton.

In the mid-1970s there were numerous tapestry students spread through many colleges in Britain. Today there are far fewer, except in Edinburgh which alone has run graduate and post-graduate courses teaching the subject as a Fine Art allied to life drawing and photography rather than as part of a broader textile or painting course.

In Edinburgh specialization in the medium, in all its facets, has always been of major importance and over the years they have built up close ties abroad through many foreign students. The Royal College of Art also offers a postgraduate degree course in tapestry which has very recently been moved from within the textile school to the painting school.

In 1977 a major retrospective 'Scottish Tapestry – Loose Ends, Close Ties and Other Structures – The Way Ahead' was held at Edinburgh College of Art and, encouraged by the public response, the Scottish Tapestry Artists Group (STAG) was

*Jean-Pascal Delamaras, President of the Centre Internationale de la Tapisserie Ancienne et Moderne.

formed. STAG held three major exhibitions in Edinburgh and London in 1977, 1979 and 1980 the last ending with the theft of the bulk of the work. STAG existed purely as an exhibiting group whereas Fibre Art which began in 1980 had a much broader purpose, producing a newsheet and setting up a slide index. They have held many exhibitions in England.

In 1982 yet another group, The Edinburgh Arts Movement (TEAM) emerged in Edinburgh and held a show at the Talbot Rice Art Centre there in 1983 which combined traditional tapestry and sculpture and recalled the earlier 1977 show, 'Scottish Tapestry – Loose Ends, Close Ties and Other Structures – The Situation Now'.

The past decade has seen many other exhibitions, the most significant of these perhaps being the International Miniature Textile Biennales organized by Ann Sutton and the British Crafts Centre (I-IV, 1974-80) which toured both at home and abroad. The Scottish Arts Council toured 'Small Tapestries' to Norway in 1976 and STAG sent another miniature show to New Zealand in 1977-8. Many Scottish weavers were also included in several Australian exhibitions at this time. A few British artists were included in the Lausanne Biennales: Alan Davie 1975, Tom Phillips and the Dovecot and Polly Hope in 1977 and in 1981 Maggie Saxby. Only Archie Brennan, Fiona Mathison, Ann Sutton and myself have exhibited at the Lödz Tapestry Biennales in Poland, although Archie Brennan won the silver medal in 1980. Fiona Mathison, Eng Tow and myself exhibited in the Textilkunst Show in Vienna in 1981.

The British Crafts Centre in London held a whole series of exhibitions and in 1979 Crown Wallcovering and the Contemporary Arts Society toured a show 'Tapestries of Today' while the Sainsbury Art Centre organized 'Contemporary British Tapestry' in 1981. 'Attitudes to Tapestry' originated from the University of Southampton two years later and Goldsmiths' College put on a show called 'The Fine Art of Textiles', which was another stimulating example of work produced by fine art orientated designers.

British tapestry does appear to have consolidated its position in the last decade and the overall standard has undoubtedly improved. The breadth of the work is wide, varying from Fiona Mathison's latest wrapped white butterfly cocoons to my own all black gobelins; from Marta Rogoyska's brilliant flat expanses of tapestry to the tiny pink woven fish in Candace Bahouth's 'Ocean Swell' (with Howard Raybould).

Traditional weavers such as Lynn Curran, William Jefferies and Ingunn Skogholt produce their meticulously worked gobelins, while an ever-increasing group pursue a much more radical approach to fibre art. These include Gordon Brennan, an ex-Dovecot masterweaver with his massive cloth-wrapped and painted wooden structures, Linda Green's delicate paper pieces, Matthew Inglis's fibre and coal, and Shirley Gatt's combination of tapestry and wood in work such as 'Sea Journeys'.

How tapestry develops from here time alone will tell but the next ten years may hold many surprises.

MAUREEN HODGE

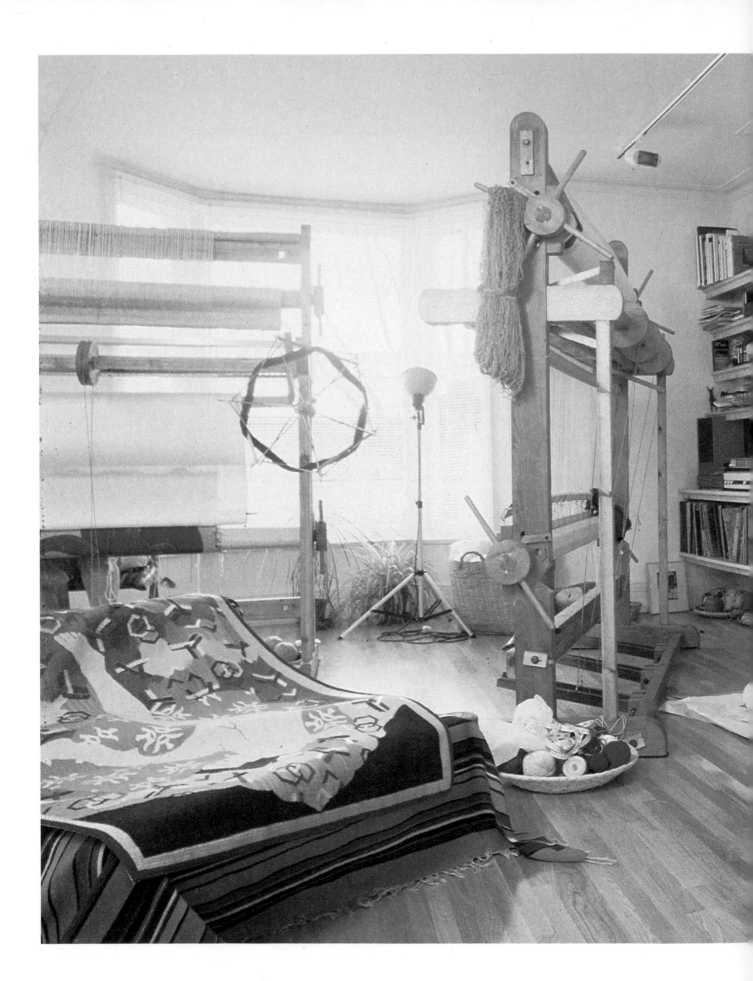

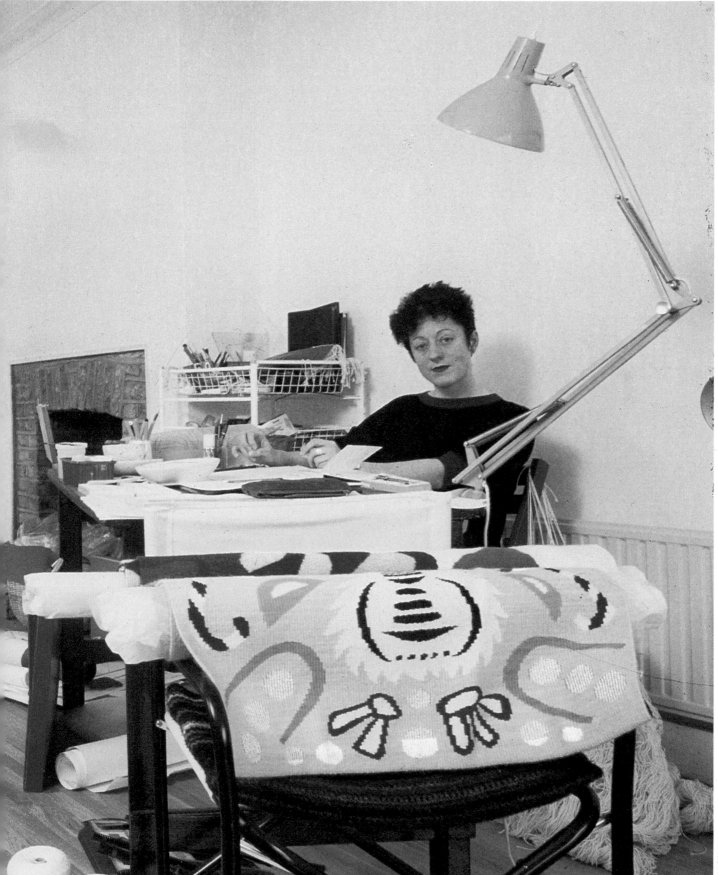

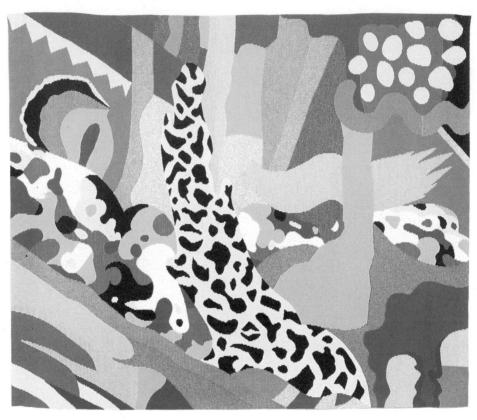

MARTA ROGOYSKA

MARTA ROGOYSKA two tapestries

Previous page: MARTA ROGOYSKA in her tapestry studio

b. 1950

Training
1970-73 Leeds Polytechnic (Fine Art)
1973-6 Royal College of Art, London (Tapestry)

Employment
Goldsmiths' College, London; Morley College, London

Awards, etc.
1975 Sanderson Scholarship (six months study of tapestry, Aubusson, France)
1978 British Council Scholarship (to study tapestry at Warsaw Academy, Poland)
1984 British Council Scholarship (travel in Germany and work at the Nuremburg Gobelins)

Selected Exhibitions – Solo
1979 Centaur Gallery, London
1980 Royal College of Art, London
1982 Ligne Roset, Paris
1983 Southampton City Art Gallery
1984 Anne Berthoud Gallery, London

Selected Exhibitions – Group
1974 Leeds City Art Gallery
1976 Whitechapel Art Gallery, London
1978 Victoria and Albert Museum, London

1980 Exemplar, Munich
1981 British Textiles, Knokke Heist, Belgium; 'Contemporary British Tapestry', Sainsbury Centre for the Visual Arts, Norwich and touring
1983 'Attitudes to Tapestry', John Hansard Gallery, Southampton; British Crafts Centre, London
1984 Air Gallery, London; Vehta Biennale, Brussels

Collections
City of Leeds Museums; The Centaur Gallery; BBC; Public and private collections

Selected Commissions
Castle Howard, Yorks, three tapestries for the restaurant

'I find it very demanding physically and intellectually. I'm pent up, tense, yet relaxed, standing back, looking at it sideways, making a shape, then unpicking it if I don't like it. If the interlocking shapes or colours don't work, out they go. All your imagination couldn't have told you they were going to have that kind of reaction. It's a terribly consuming thing. You have to be twenty times more alert, twenty times more intelligent and twenty times harder on yourself than in painting, so that you do bloody well unpick what has taken you two days to do if it's wrong. Because tapestry has to be done in a strict sequence from the bottom upwards, you have to be more visionary too, very much in the sense that you must visualize what is coming and what has been. You are committed and there is no going back. I see its affinities with life so much, balancing on this crazy tightrope, trying to be intelligent about the future, learn from the past and very much involved in the present.'

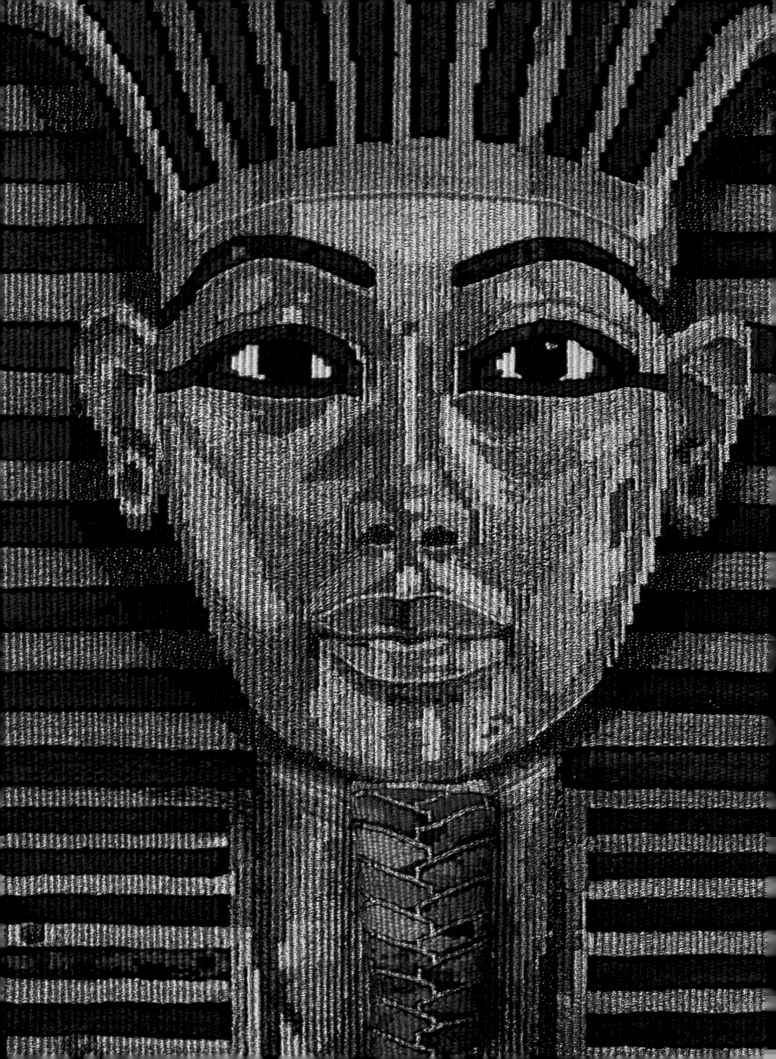

CANDACE BAHOUTH

Training
1964-8 Syracuse University School of Art, USA (Fine Art)
1971 Short course with Archie Brennan, Edinburgh (Tapestry)

Selected Exhibitions – Solo
1983 Dan Klein Ltd, London

Selected Exhibitions – Group
1979 'Softwear', Arnolfini Gallery, Bristol
1980 American Exhibition, Sothebys
1981 'Contemporary British Tapestry', Sainsbury Centre for the Visual Arts, Norwich and touring
1982 'The Maker's Eye', Crafts Council Gallery, London
1983 'Attitudes to Tapestry', John Hansard Gallery, University of Southampton
1984 Aspects Gallery, London

Collections
Southern Arts; Eastern Arts; Contemporary Art Society; Victoria and Albert Museum, London; Private collections in UK and USA

Selected Commissions
Radio Times: Jubilee cover; Northampton Shoe Museum: woven boots; Eastern Arts: 'Ocean Swell', screen (with Howard Raybould); *Playboy* magazine: woven body pieces

'I am interested in archetypal figures representative of the cultures in which costume, make-up, jewellery, hair, and expression (in other words, physical and visual self-presentation and self-expression) play an important and integral role in the society. I concentrate on one figure and then bring it out in relief with *trompe l'oeil* effects, objects and added warp-woven fabrics.'

Opposite: CANDACE BAHOUTH 'Tutan Khamun', tapestry (*detail*)

CANDACE BAHOUTH 'Punk Dolls', 1983 (purchased by the Contemporary Art Society)

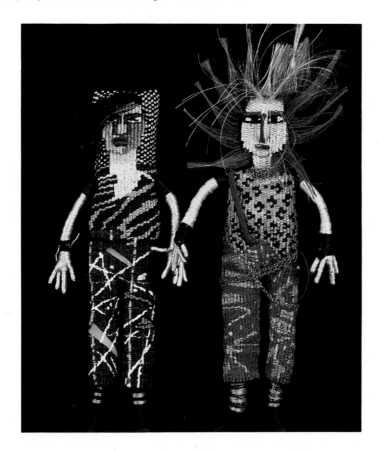

ARCHIE BRENNAN

b. 1931

Training
1947-53 Trained as a tapestry-weaver at Edinburgh Tapestry Co. (Dovecot Studios) and the Golden Targe Studio, Edinburgh
1958-62 Edinburgh College of Art (Stained Glass)

Employment
1962-73 Established and developed the Tapestry Department in Edinburgh College of Art
1962-78 Director of Edinburgh Tapestry Co.

Awards
1974 First Major Award – Scottish Arts Council, Saltire Society Art Award
1977 2nd Prize Societé des Arts et Lettres, Vevey, Switzerland
1978 Lord Mayor of London's Award to a British Artist Silver Medal, Lödz Triennale, Poland
1981 OBE

Selected Exhibitions – Solo
1972 'Archie Brennan, Tapestry', Scottish Arts Council, touring
1976 'Archie Brennan, Tapestries', British Crafts Centre, London; Narek Gallery, Canberra, Australia; Gryphon Gallery, Melbourne, Australia

Selected Collections
Aberdeen City Art Gallery*; Royal Scottish Museum, Edinburgh*; Crafts Council, London; Victoria and Albert Museum*; Shipley Art Gallery, Gateshead*; Private collections in UK, USA, Australia, France and Germany

Selected Commissions
Grampian Regional Council*; Scottish Arts Council*; Midlothian County Council*; Turnhouse Airport, Edinburgh*; Edinburgh Castle, Banqueting Hall*

Archie Brennan is arguably the founder of the strong tapestry interest in Britain. His work has been described as 'decorative, humourful and *canny*', and his attitudes towards tapestry-weaving (which he once described as being 'as sensible a process as building a life-size model of St Paul's Cathedral in matchsticks') combined with his personality have inspired many weavers. Since 1978 he has lived in Papua, New Guinea.

*designed by Archie Brennan and woven under his supervision at the Edinburgh Tapestry Co. (Dovecot Studios)

Opposite: ARCHIE BRENNAN and EDINBURGH TAPESTRY CO. 'At a Window 1' (second version), 1980. This tapestry illustrates Archie Brennan's fascination with the idea of weaving an image of a patterned textile: the curtains, carpet, spotted dress and background tapestry

ARCHIE BRENNAN 'Parcel', 1974. This was Archie Brennan's entry to the 1st International Exhibition of Miniature Textiles. The 'brown paper', 'string', and 'address label' are all tapestry-woven: it was sent through the post to the exhibition without further wrapping

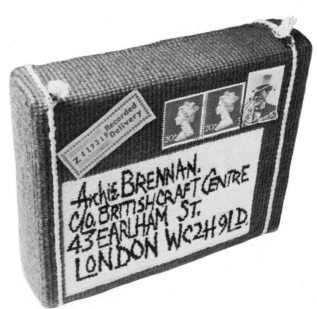

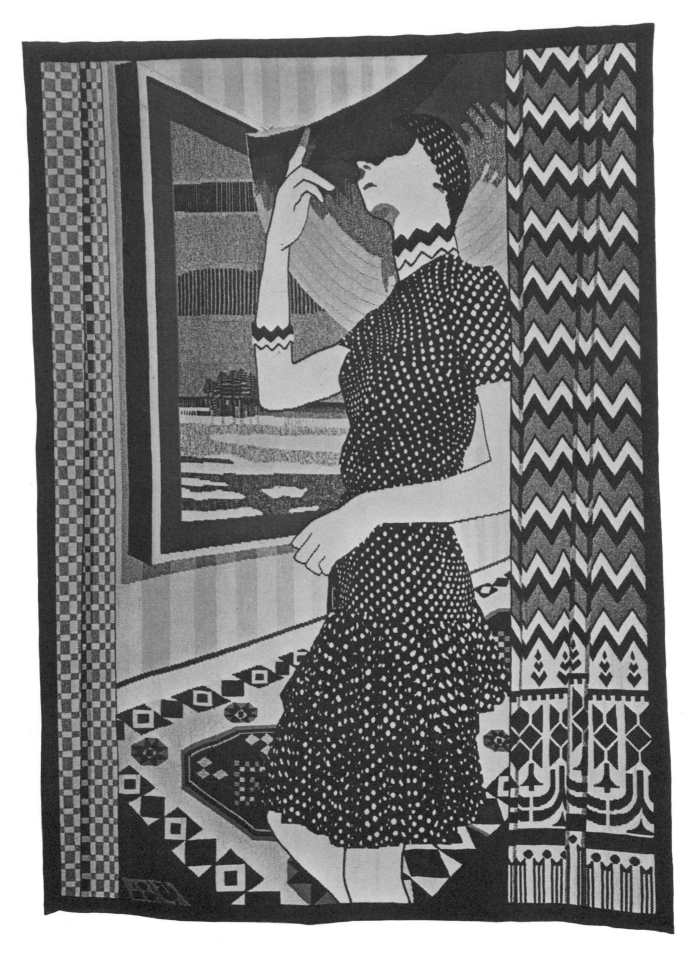

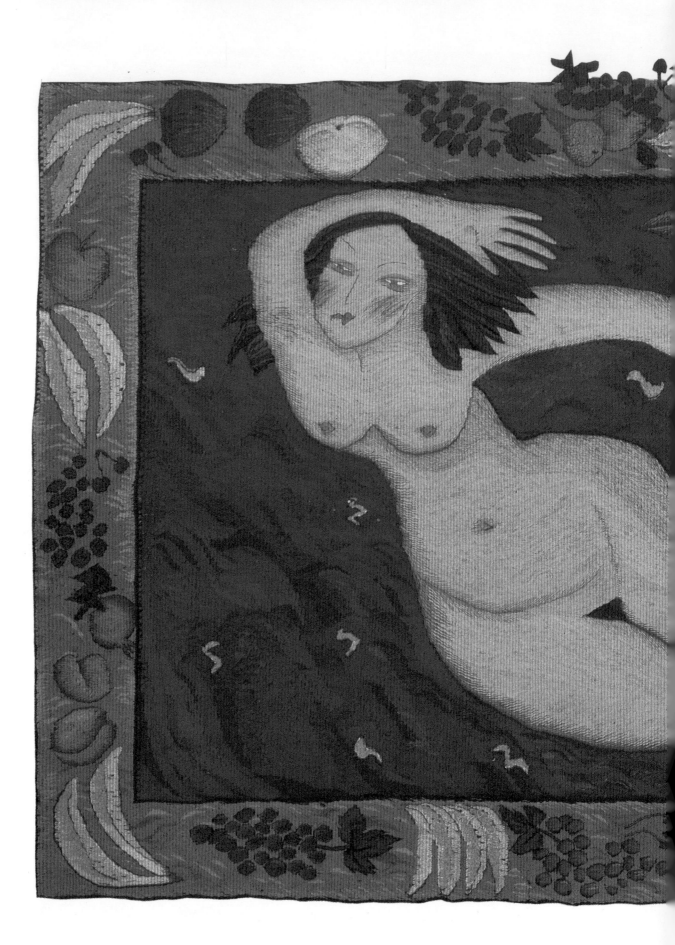

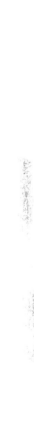

Keith Pattison

LYNNE CURRAN

b. 1954

Training
1973-7 Edinburgh College of Art (Tapestry)

Employment
Visiting lecturer at Sunderland Polytechnic, Cumbria College of Art, various colleges, galleries and summer schools. Artist/craftsman-in-residence in Caithness and Biddick Farm

Awards, etc.
1977 Andrew Grant Travelling Scholarship (France, Spain, Orkney, Ireland)
1979 Northern Arts/Crafts Council Bursary

Selected Exhibitions – Solo
1980 Third Eye Centre, Glasgow
1981 Gawthorpe Hall, Lancashire
1982 Crawford Centre for the Arts, St Andrews

Collections
All work is in public and private collections, UK and abroad

Commissions
1984 Victoria and Albert Museum, London

'My tapestries are reflections of my thoughts, my surroundings and my interests; a collection of china, a line in a song or a poem, a story, a place, a flower or a thing to do.

'All these are noted in my sketchbook until they distil and evolve into a tapestry.

'What could be better than to weave tapestries around my own thoughts and favourite things?

'It is important to me that the ideas are woven rather than painted. The time involved in the process of making helps distil the story. And the linens, silks, sewing cottons and fine wools give a density to the colours. This helps to evoke the intense moment I am commemorating. I like to work in a miniature scale as it suits the intimacy of the recalled experience; and I am content to explore a flat surface where the story, the colour and the imagery take priority.'

Previous page: LYNN CURRAN 'Take me to Bali', 42 inches × 65½ inches, wool, linen, cotton, silk, rags, cashmere, 1983-4

Opposite: LYNNE CURRAN 'Take me to the Dance', 7¼ inches × 5¼ inches, sylko, wool, cotton, cashmere, 1984

A page from one of LYNNE CURRAN's sketchbooks

David Cripps

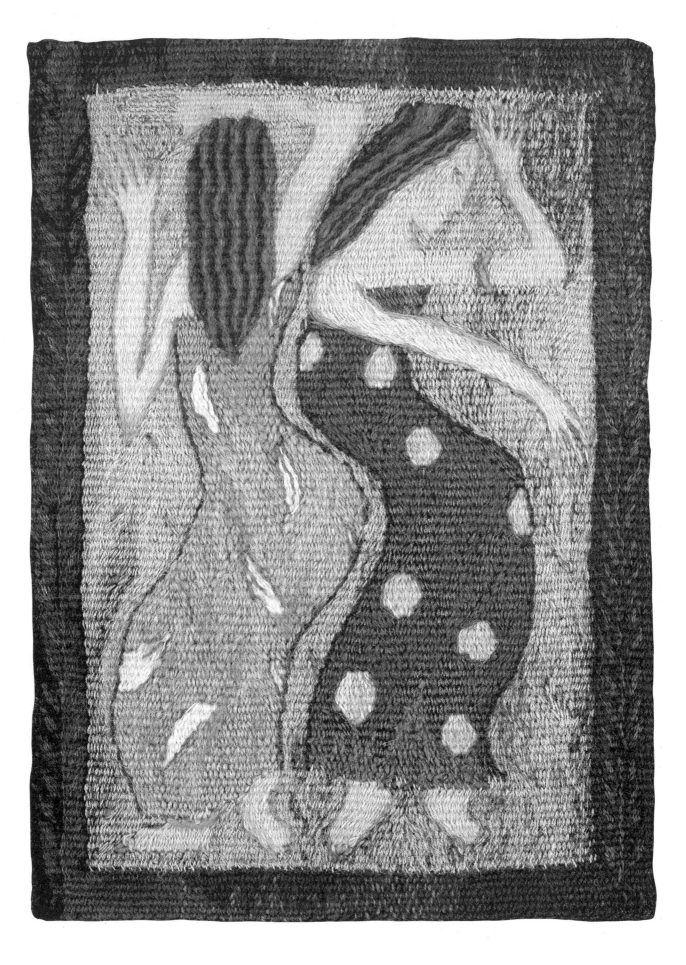

MAGGIE RIEGLER

b. 1944

Training
1962-7 Gray's School of Art, Aberdeen (Fine Art)
1967 Studied weaving in Finland

Employment
1967-75 Gray's School of Art, Aberdeen
1978 Teaching tapestry-weaving in Saudi Arabia; Visiting lecturer at Duncan of Jordanstone
College of Art, Dundee; Belfast College of Art, Ulster; and various summer schools

Selected Exhibitions
1973 'The Craftsman's Art', Crafts Council, Victoria and Albert Museum, London; 'Fifteen
Weavers', British Crafts Centre, London
1977 'Small Tapestries', Scottish Arts Council, touring Britain and Scandinavia
1978 'Scottish Tapestries', Villefort, France
1980 'Fabric of Nature', DLI Museum, Durham; 'The Craft of the Weaver', British Crafts Centre
1981 'Contemporary British Tapestry', Sainsbury Centre for the Visual Arts, Norwich

Collections
Arts Council of Great Britain; Royal Scottish Museum, Edinburgh; Department of the
Environment; for British Embassy, Cairo; Scottish Development Agency; Aberdeen Art Gallery;
Education authorities and private collections

Commissions
Chevron Petroleum (UK); The Bank of Scotland; St Martin's Property Corporation Ltd.; P & O
Shipping Company Ltd.

Maggie Riegler's tapestries incorporate a variety of weaving techniques in addition to
the traditional Gobelin, including wrapping, macramé, stitching and padding, and a
mixture of materials—feathers, and yarns of all fibres.

'I have no reverence for textile techniques *per se*, when the technique employed
becomes the main point of interest in a piece of work, that piece has, to my mind,
failed.'

Two small tapestries by MAGGIE
RIEGLER which include, as well
as woven tapestry, macramé,
braiding, fringing, wrapping,
tassels

Opposite: Detail of a tapestry
by MAGGIE RIEGLER showing a
rich mixture of materials and
techniques

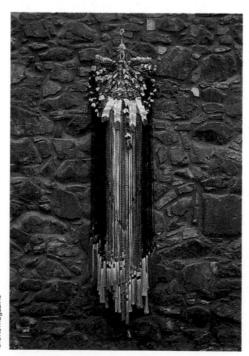

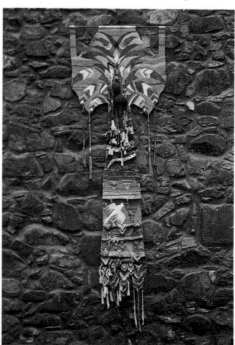

GRACE ERICKSON

Training
ending 1977 Illinois State University

Employment
1983-4 Artist-in-residence at Exeter Museum, Devon; Thornbury School, Plymouth, Devon; Ramada Hotel (Reading Festival), Berkshire; Plymouth Arts Centre, Devon; Burnley, Lancs; (all regional art associations)

Award
1983 South-West Arts

Selected Exhibitions – Solo
1983 Salisbury Arts Centre, Wiltshire
1984 Wetheriggs Gallery, Penrith, Cumbria; Plymouth City Museum, Devon

Selected Exhibitions – Group
1983 Galerie Velke, Kassel, W. Germany; English Wool Board, touring Japan
1984 'Makers '84', British Crafts Centre, London; 'Rugs and Hangings for Walls and Floors', Cirencester Workshops, Glos and touring; 'International Tapestries', Northampton, Mass., USA

Collections:
Illinois State University; John Winch Memorial, Maidstone, Kent; Private collections, UK, USA and Australia

Opposite: GRACE ERICKSON 'Art sleeps in Craft', 5 ft 7 inches × 3 ft 1 inch, wool on linen warp (the figure is painted on to the tapestry), 1983

GRACE ERICKSON 'Al Hocha', woven tapestry, 3 ft 6 inches × 3 ft 4 inches, wool on linen warp, 1984

Grace Erickson works in Gobelin tapestry technique, but adds padding to give form, and sometimes paints the surface of the tapestry with acrylic paints.

'Primarily, I make my tapestries for their images. Technique does not seem crucial, so I use whatever materials look helpful to realize my ideas. Building the image well in structural *and* pictorial terms does feel good though, so most of my work is tapestry woven.'

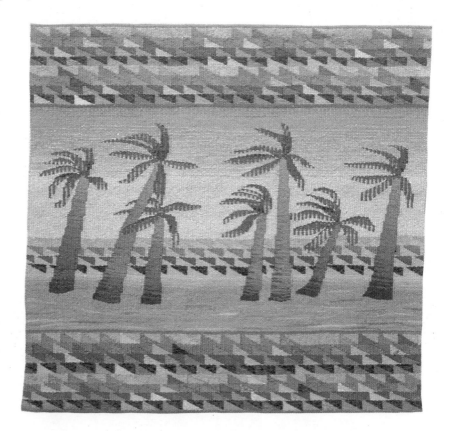

MARY FARMER 'Float 2',
33 inches × 33 inches, tapestry

MARY FARMER 'Interlock 1',
29 inches × 29 inches, tapestry

MARY FARMER

Opposite: MARY FARMER
at the loom

b. 1940

Training
1958-61 Beckenham School of Art (Fine Art)

Employment
currently Tapestry tutor, Royal College of Art, London

Awards
1979 South East Arts Major Award
1980 Crafts Council Bursary

Selected Exhibitions – Solo
1979 Newbury Spring Festival of the Arts; South Hill Park Arts Centre, Bracknell
1980 Oxford Gallery, Oxford

Selected Exhibitions – Group
1981 Kettles Yard, Cambridge
1981-2 Sainsbury Centre for the Visual Arts, Norwich (also in 1984); Cooper Lynn Gallery, New York, USA; Modern Master Tapestries, New York, USA, (also 1983-4); Helen Drutt Gallery, Philadelphia, USA
1983 John Hansard Gallery, Southampton; Southampton Art Gallery; Camden Arts Centre
1985 British Crafts Centre, London

Selected Collections
H.R.H. The Duke of Edinburgh; Victoria and Albert Museum, London; Crafts Council, London; Government Art Collection (for British Embassy, Los Angeles, USA); Ministry of Public Buildings and Works (for British Embassy, Paris); Contemporary Art Society; Channel 4 Television Company Ltd, London; Liverpool Cathedral (Anglican); Regional arts associations; National Bank of America, City of London

'Colour is to me the single most powerful and emotive visual sensation. My own commitment is to explore: spatial illusions and ambiguities; optical colour; colours which are constantly changing their definition or breaking out of their borders by their relationship to one another, to light, to surface, to form, to proportion, to scale; positives and negatives which exchange dominance; the extra heightening of a colour's particular quality by its counterpart; contradictions such as colour vibrations activating static forms; the evocation of what isn't actually there.

'I aim to achieve maximum strength by the limitation of means by minimizing the distractions; through spareness to increase the experience.

'I use wool for its incomparable intensity and saturation of colour; tapestry for its richness and for the personal control possible over its construction and substance, and both for their contribution and relationship to the imagery.'

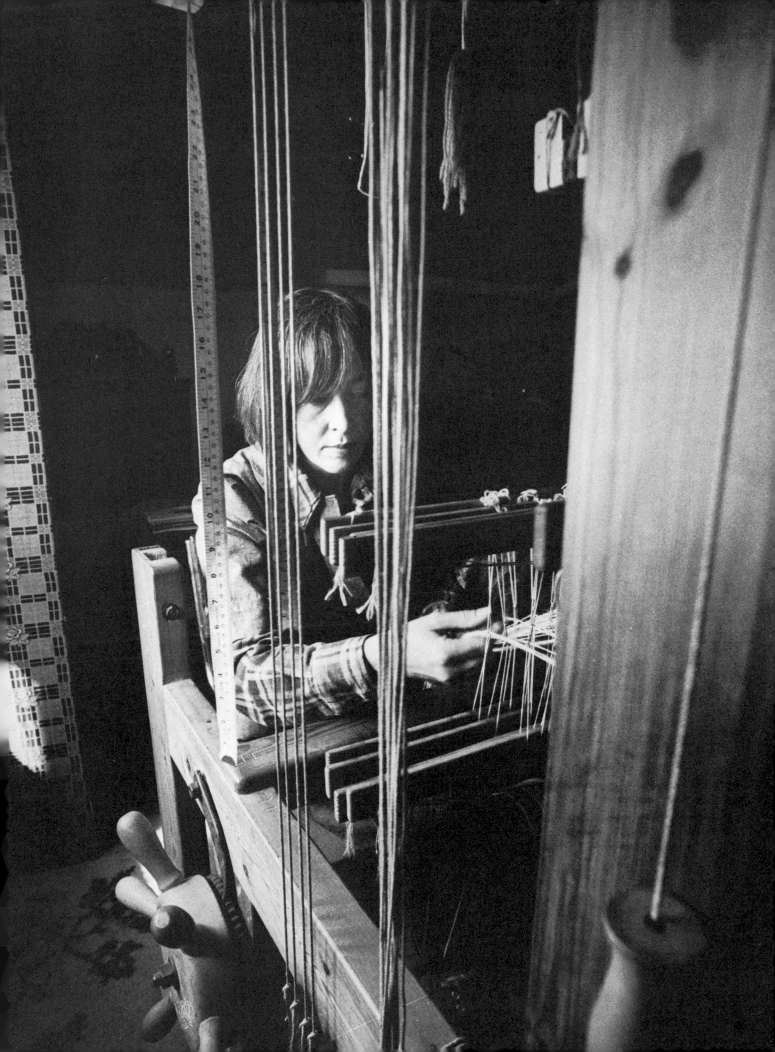

JOANNA BUXTON

b. 1945

Training
1967-70 Hornsey College of Art, London (now Middlesex Polytechnic) (Environmental Design)
1970-73 Royal College of Art, London (Tapestry)

Employment
1977-80 Central School of Art, London
1978-82 Middlesex Polytechnic
1980- Visiting lecturer, West Sussex College of Art and summer schools, etc.

Selected Exhibitions
1980 'Contemporary British Crafts,' Sothebys, London, Torquay, Munich
1981 'Contemporary British Tapestry', Sainsbury Centre for the Visual Arts, Norwich
1983 'Contemporary Cotton', Rufford Craft Centre, Notts; 'Attitudes to Tapestry', John Hansard Gallery, University of Southampton; Westminster Gallery, Boston, USA

Collections
Crafts Council, London; Private collections

Commissions
Gatwick Airport; Tower Hotel, London; National Motor Museum; Central Electricity Generating Board; De Beers Diamond Co., Antwerp; Greys Court, National Trust; Government of Qatar

Opposite: JOANNA BUXTON
'Gertrude Bell – Daughter of the Desert', 5 ft × 6 ft, tapestry shown on the loom, 1984. Part of the series 'Intrepid Women'

JOANNA BUXTON
'Amy, Wonderul Amy', 6 ft 6 inches × 5 ft, tapestry, 1983. Part of the series 'Intrepid Women'

'My imagery is, I think, very "English" and, I hope, very "weaverly". The woven element is extremely important to me. There must be present a certain quality that can only be achieved in this medium, in the way the final image presents itself in line, form, surface, and the ways that colour and shading should all be in methods particular to tapestry ... Drawing is important as a framework, but it is all done towards the ultimate weaving. (If these things worked as drawings or paintings I would be a painter – there would be no point in going through the slow and time-consuming process of weaving it.)'

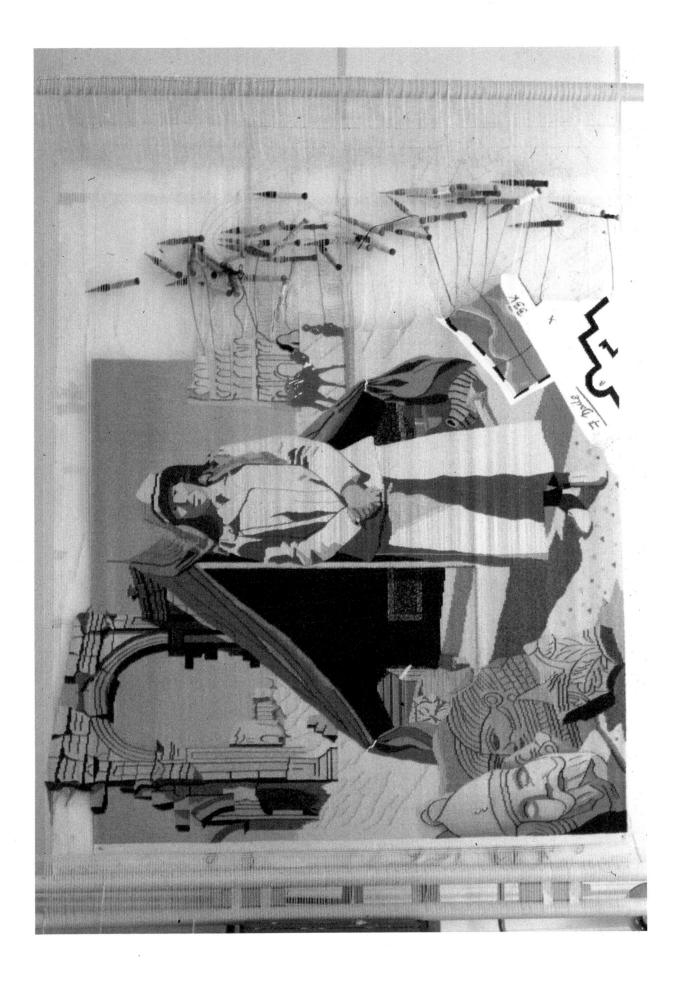

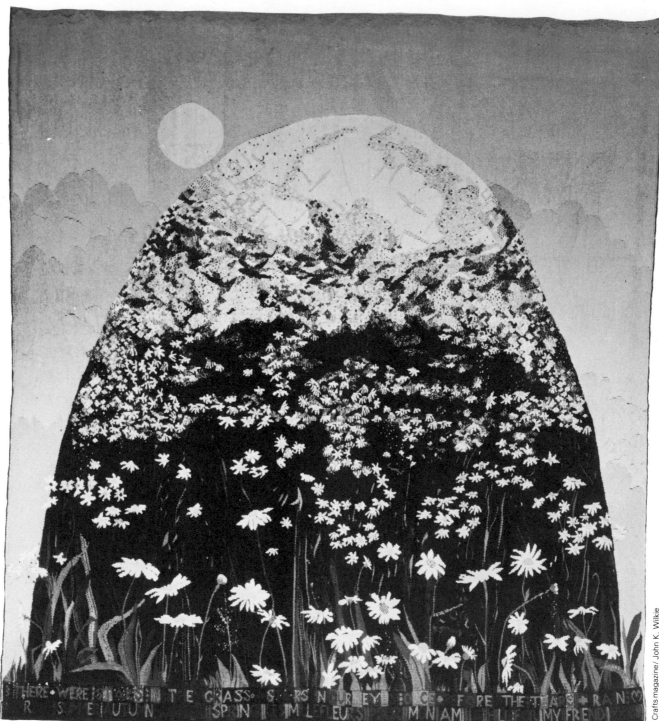

MAUREEN HODGE

b. 1941

Training
1959-64 Edinburgh College of Art (Stained Glass and Tapestry)

Employment
1964-5 Assistant to Archie Brennan
1965-73 Edinburgh Tapestry Co.; Assistant to Archie Brennan in Tapestry Department, Edinburgh College of Art
1973- Head of Tapestry Department, Edinburgh College of Art

Award
1969 Scottish Arts Council Award to Young Artists

Selected Exhibitions
1965 2nd International Tapestry Biennale, Lausanne; 'Weavers from Dovecot Studio, Edinburgh', Whitworth Gallery, Manchester
1967 3rd International Tapestry Biennale, Lausanne
1970 'Modern British Hangings', Scottish Arts Council, Edinburgh and touring
1971 'Experimental Textiles', Camden Arts Centre, London
1972 'Woven Structures', Camden Arts Centre, London
1973 'The Craftsman's Art', Crafts Council, Victoria and Albert Museum, London; 'Fifteen Weavers', British Crafts Centre, London
1974 'Tapestries from Edinburgh', British Crafts Centre, London
1975 1st Triennale of Textile Arts, Lodz, Poland
1976 2nd International Exhibition of Miniature Textiles, British Craft Centre, London and world tour
1977 'Masterpiece', Silver Jubilee Show, British Crafts Centre, London; 1st STAG Show, Glasgow, Edinburgh, London
1978 'Tapestries', Edinburgh, St Andrews, London and Inverness (with Fiona Mathison); 3rd International Exhibition of Miniature Textiles, British Crafts Centre and world tour; 3rd Triennale of Textile Arts, Lodz, Poland
1979 2nd STAG Show, Edinburgh and London; 'Star Quality', British Crafts Centre, London
1980 'The Craft of the Weaver', British Crafts Centre, London; 4th International Exhibition of Miniature Textiles, British Crafts Centre, London and world tour
1981 'Contemporary British Tapestry', Sainsbury Centre for the Visual Arts, Norwich and touring
1983 'Textiles Today', Southampton Museum; 'Attitudes to Tapestry', John Hansard Gallery, University of Southampton

Collections
Scottish Arts Council; Royal Scottish Museum, Edinburgh; University of Stirling; Crafts Council, London; Scottish Gallery of Modern Art; Contemporary Art Society; Scottish Development Agency; Private collections world-wide

Opposite: MAUREEN HODGE 'A Hill for my Friend', 6 ft 8 inches × 5 ft 10 inches, Gobelin tapestry, 1976 (in the collection of the Scottish National Gallery of Modern Art, Edinburgh)

'I believe that my work involves the act of construction in two ways. A tapestry is a construction of warp and weft where the image is not of the surface as in drawing and painting but exists from the front to the back of the structure.

'Construction is also involved in the act of organizing the ideas in the piece; the building up of the concept into a tangible image. These images are drawn from nature in terms of nature being the source of life. I am not trying to present the whole but rather various personal constructions or some possibilities from that whole as if I were trying to make images to find a model in scientific terms which would illuminate the truth or reality (i.e. the nature) of it all.'

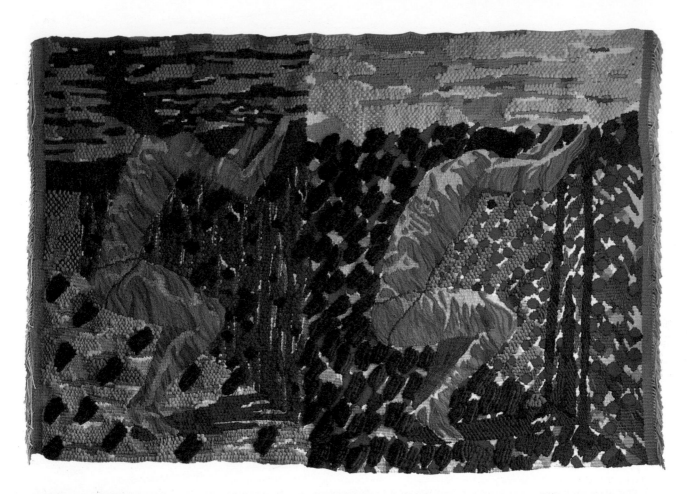

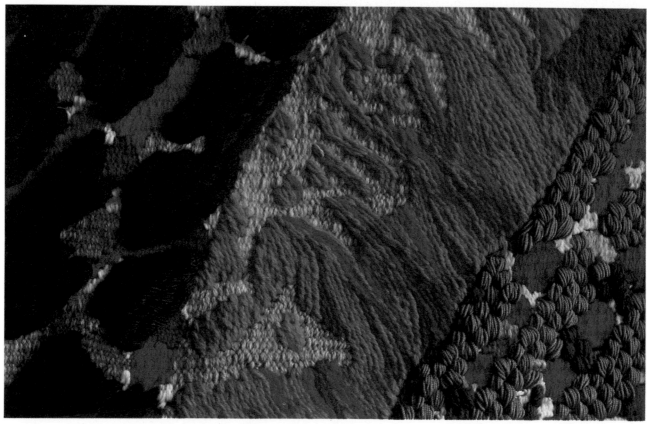

WILLIAM JEFFERIES

b. 1953

'Tapestry may be a sub-set of work in fibre but I find it a huge playground of interesting directions. The dignity of the laborious I certainly believe in, but I do enjoy the numerous small directions that piece together an area of tapestry weaving. The whole fabric must be read as a building, as a brave building phase continued with a faith in the ultimate idea.'

Opposite: WILLIAM JEFFERIES (*above*) 'Bobbing Boys', 168cm × 259cm, tapestry, 1980 (*below*) 'Bobbing Boys' (*detail*)

WILLIAM JEFFERIES in front of his tapestry 'Book of Dreams', 1984

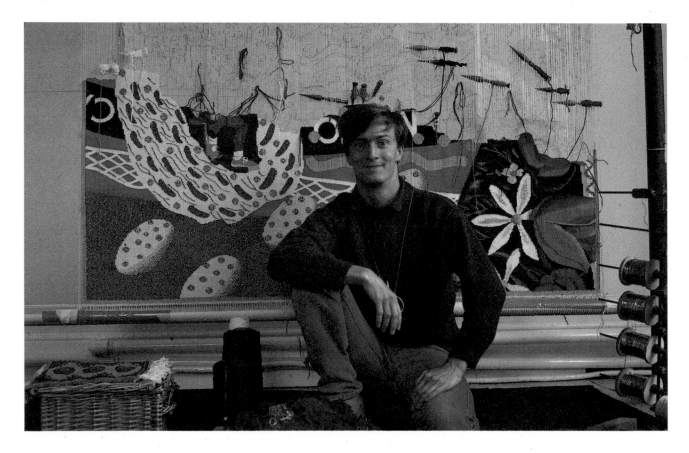

ALEC PEARSON

b. 1924

Training
Keighley School of Art, Keighley, Yorks; Leeds School of Art; Académie de la Grande Chaumière
(Life Drawing)

Employment
1947-74 Teaching at secondary level and at colleges of education

Recent Exhibitions
1978 Contemporary German and British Crafts, London and Frankfurt-am-Main
1979 Museum Schloss Rheydt, Münchengladbach, Germany
1980 British Ceramics and Textiles, Schloss Clemenswerth, Germany
1981 'Textiles Today', Kettle's Yard, Cambridge and touring; 'Contemporary British Tapestry',
Sainsbury Centre for the Visual Arts, Norwich and touring
1983 Oxford Gallery, Oxford

Selected Commissions
Guildhall School of Music and Drama, Barbican, London; IBM, Midlands Centre, Warwick;
Courtaulds, London; The University Church, Cambridge; British Embassy (new offices),
Khartoum, Sudan

ALEC PEARSON 'East Anglian
Landscape', 330cm × 180cm,
tapestry, 1984, wool on linen
warp (for the British Embassy,
Khartoum)

Alec Pearson's tapestries usually depict landscape: the horizontal is fundamental to
landscape, and integral in the tapestry-weaving process. He does not weave his
designs sideways but from bottom to top, so the weft is in sympathy with his theme.

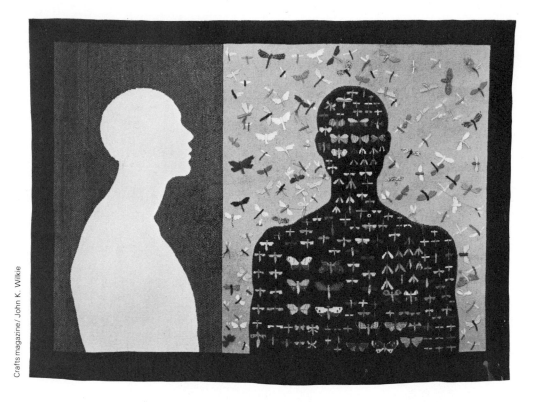

FIONA MATHISON

b. 1947

Training
1966-71 Edinburgh College of Art (Tapestry)
1970-74 Part-time weaver, Edinburgh Tapestry Co.
1971-3 Royal College of Art, London (Tapestry)

Employment
1973- Edinburgh College of Art
1978-82 Artistic Director, Edinburgh Tapestry Co.
1982- Artistic Consultant, Edinburgh Tapestry Co.

Selected Exhibitions
1981 'Textiles Today', Kettles Yard, Cambridge and touring; 'Contemporary British Tapestry', Sainsbury Centre for the Visual Arts, Norwich and touring
1982 'British Festival', Houston, Texas, USA
1983 'Attitudes to Tapestry', John Hansard Gallery, University of Southampton; TEAM Talbot Rice Arts Centre, Edinburgh
1984 'Rugs and Hangings for Walls and Floors', Cirencester Workshops, Glos and touring

Selected Collections
Scottish Arts Council; Royal Scottish Museum, Edinburgh; Private collections in UK, USA, Australia, Norway, and Canada

Selected Commissions
Sick Children's Hospital, Edinburgh; Tower Hotel, London; First National Bank of Chicago, Edinburgh

'I work almost entirely figuratively, often combining elements which are unexpected, humorous, sometimes even a little disturbing. The specific structure of the tapestry is in direct relationship to the subject and is used sometimes to heighten similarities or contrast between the subject and the object made. Tapestry for me has a spontaneity, it is possible to alter structure, texture, colour, shape and even dimension all at the time of making.'

FIONA MATHISON 'In the Shadow of Man', tapestry. Some of the insects in this work are three dimensional, woven with 'extra warps'

Overleaf: (*above*) FIONA MATHISON 'Collector's Item', 7 inches × 10 inches, tapestry. Metamorphosis from one item to another is a favourite theme of Fiona Mathison: in this case a blue bottle (Milk of Magnesia) becomes a bluebottle (fly)
(*below*) FIONA MATHISON 'A Clean Sheet', 4 ft × 9 ft, tapestry woven at the Edinburgh Tapestry Company (in the collection of the Scottish Development Agency)

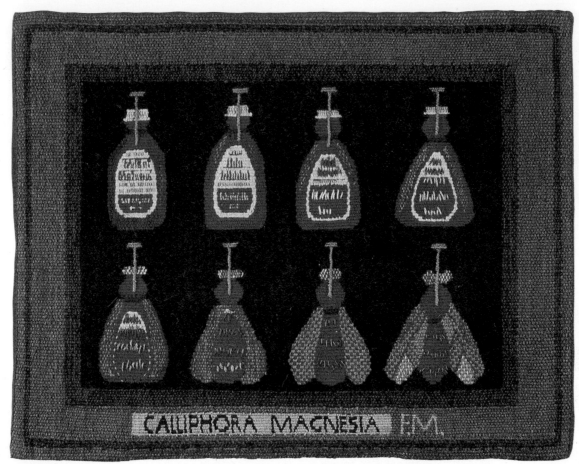

CALLIPHORA MAGNESIA P.M.

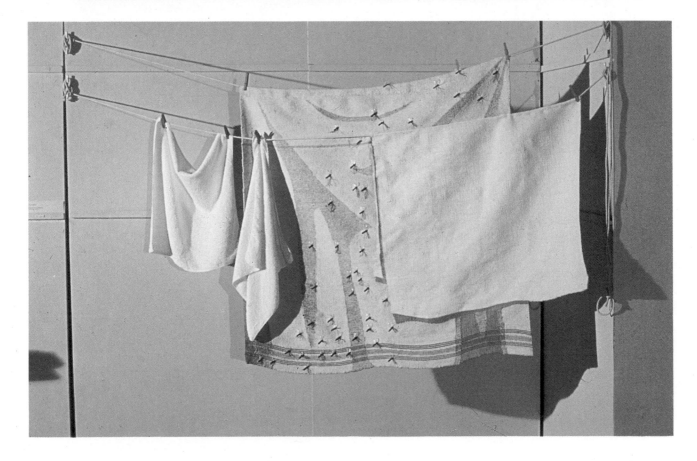

VALERIE KIRK

b. 1957

Training
1974-9 Edinburgh College of Art (Tapestry)
1979-80 Goldsmiths' College, London (Teacher Training)

Employment
1979 Tapestry weaver in the Victorian Tapestry Co., Melbourne, Australia
1984 Crafts Council of Australia: lecturing, workshops, etc. and with the Flying Art School;
Artist-in-residence, Busselton, Western Australia

Award
1981 Northern Arts Travel Award (Egypt)

Selected Exhibitions
1979-80 Scottish Tapestry Artists Group
1981 LYC Gallery, Cumbria; 'Textiles North', touring
1982 'Images in Weaving', British Crafts Centre, London; 'Making it', British Crafts Centre,
London
1983 'Attitudes to Tapestry', John Hansard Gallery, University of Southampton; 'Fibre Art',
touring
1984 'The Maker's Mark', Melbourne, Australia

Collections
The Shipley Museum and Art Gallery, Gateshead; Carlisle Art College; The Ararat Textile
Collection, Australia; Private collections

'My work is a composition of ideas brought together in the technique of woven
tapestry.

'The ideas are collected and begin in drawing, keeping cuttings, making collages
and taking photographs. From these many fragments, reflecting my interests and
experience, I compile new relationships. Eventually, I sketch out a cartoon for the
tapestry.

'In the image-making process of tapestry I can reduce and refine my ideas in one
complete picture.'

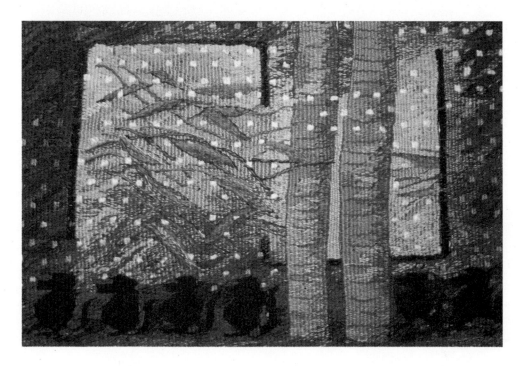

VALERIE KIRK 'Baboons, Pink
Dot Leaves, and Royal Palms',
17½ inches × 23½ inches,
tapestry, 1982 (in the
collection of North West Arts)

THE EDINBURGH TAPESTRY CO. (DOVECOT STUDIOS)

founded 1912

Tapestries woven include
1975 'Five Gates of London', John Piper
1976 'Form against Leaves', Graham Sutherland
1977 'Emblem on Red', Graham Sutherland
1977-80 'Nevelson Uniques, 1-7', Louise Nevelson
1977 'Emblem on Yellow', Graham Sutherland
1977-8 'Blue Guitar 1 and 2', David Hockney
1979 St Catharine's College, Oxford, (three panels), Tom Phillips
1980 'Eastern Still Life', Elizabeth Blackadder; 'Una Selva Oscura', Tom Phillips

Opposite: The Edinburgh Tapestry Company, 1984

Overleaf: The largest tapestry ever woven in the U.K. Commissioned from the Edinburgh Tapestry Co. by General Accident Insurance Co., Perth, Scotland. It was designed by Sam Ainsley, 1982

Below: Interior of the Dovecot studios – the looms are *'haute lisse'*

There are two major tapestry-weaving studios in Britain: West Dean Studios, Chichester (see pages 138-9) founded in 1976, and the Edinburgh Tapestry Co. (also known as Dovecot Studios) which was founded by the fourth Marquis of Bute in 1912, in the present studios at Corstorphine in Edinburgh. Weaving takes place on 'high warp' looms (as opposed to the 'low warp' method favoured by West Dean) and colour blending in the weft is achieved by combining eight fine worsted yarns into one. Thousands of colours are thus available from a standard range of about fifty held in stock. The years of Archie Brennan's directorship were very important and exciting for the studio: he established a unique rapport with the artists involved, and evolved a radically different approach to tapestry, compared with other studios abroad. This policy was continued by subsequent directors Maureen Hodge and Fiona Mathison, and by the studio's present artistic director, Joanne Soroka.

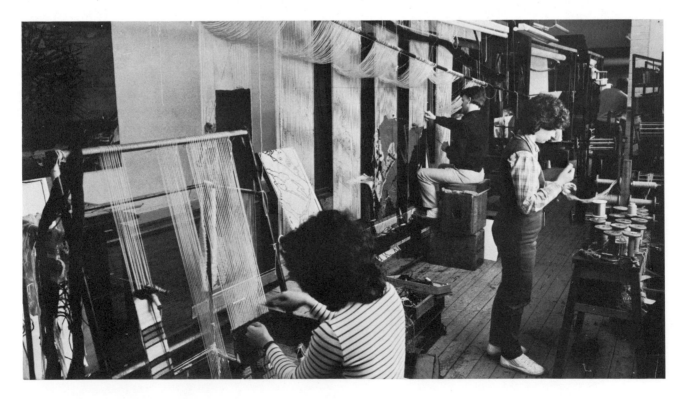

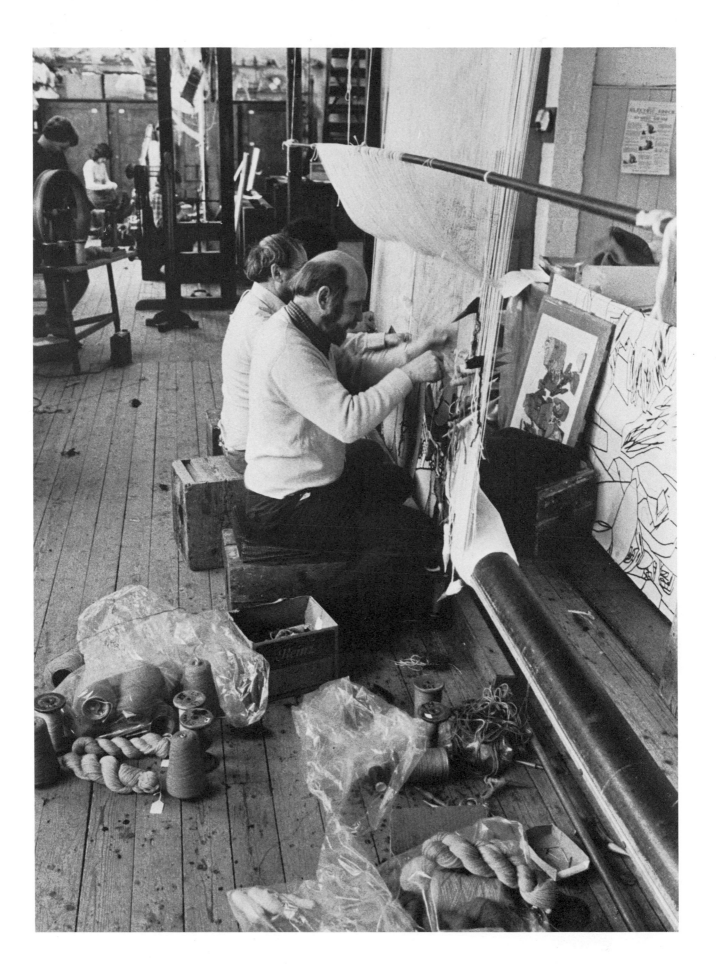

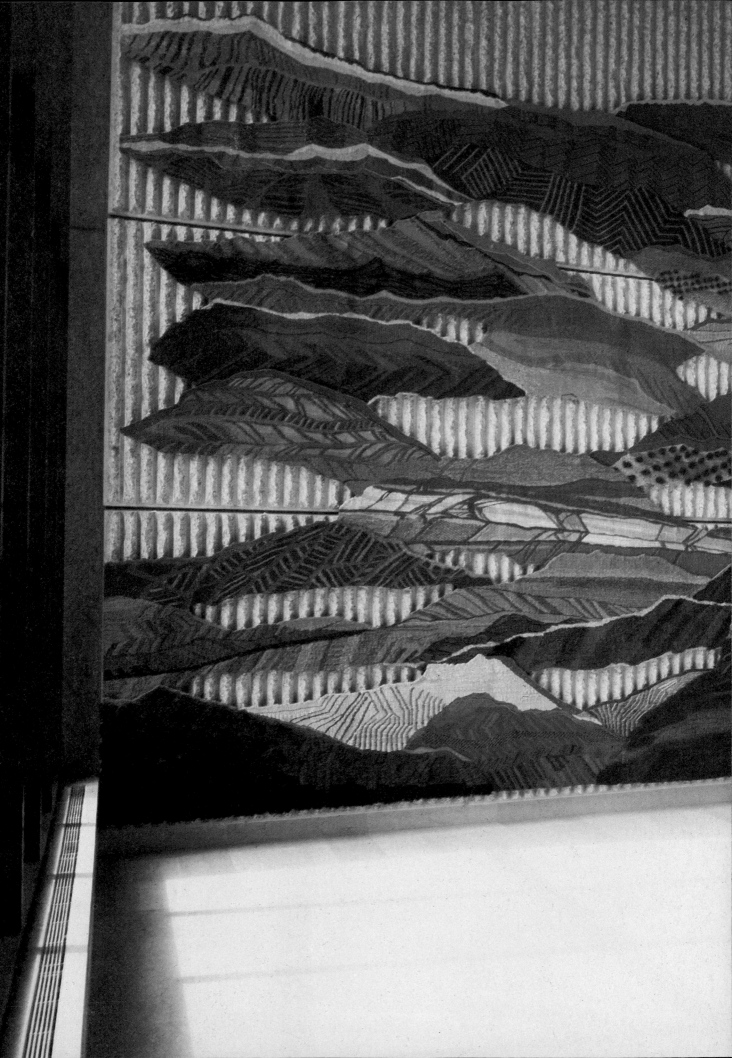

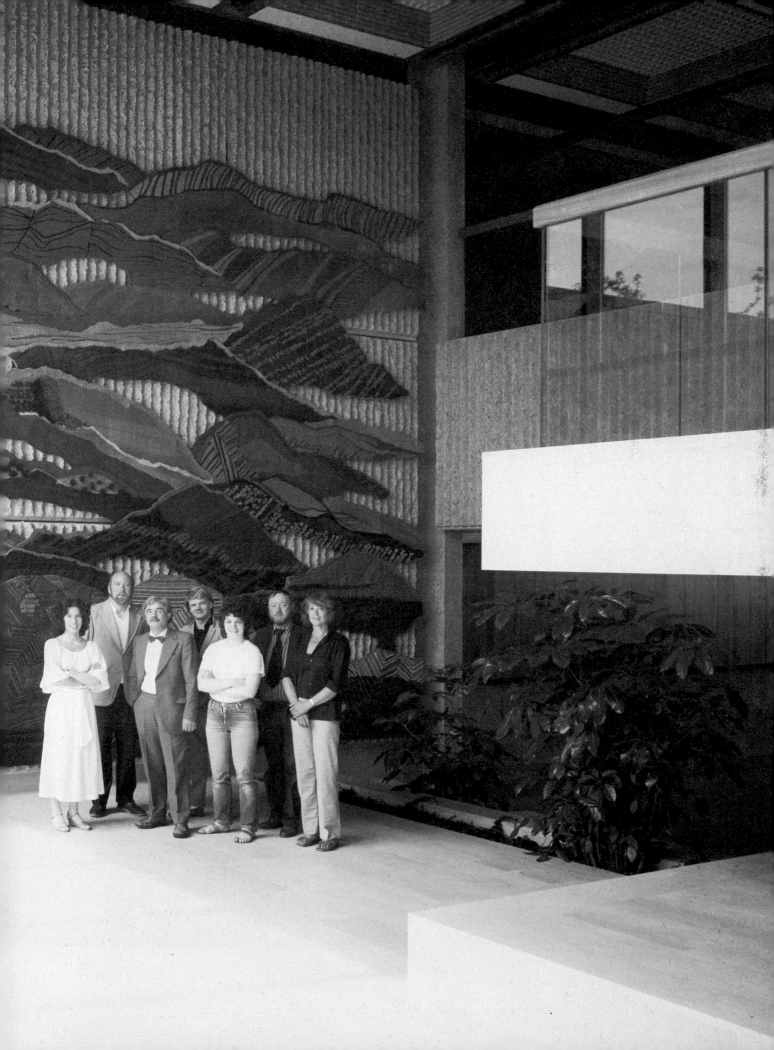

WEST DEAN
TAPESTRY STUDIO

founded 1976

Tapestries woven include
1976 'Seated Mother and Child', Henry Moore
1977 'Two Women and a Child', Henry Moore
1978 'Two Seated Women with Children', Henry Moore; 'Three Seated Women with a Child',
Henry Moore; 'Three Reclining Women, One with a Child', Henry Moore
1979 'Three Women in a Landscape', Henry Moore; 'Three Reclining Figures', Henry Moore;
'Circus Rider', Henry Moore

West Dean Tapestry Studios
in Sussex: the weaving here is
done on *'basse lisse'* looms

Overleaf:
'Moonlight', from the painting
by Howard Hodgkin, woven at
the West Dean Tapestry
Studios, 1982

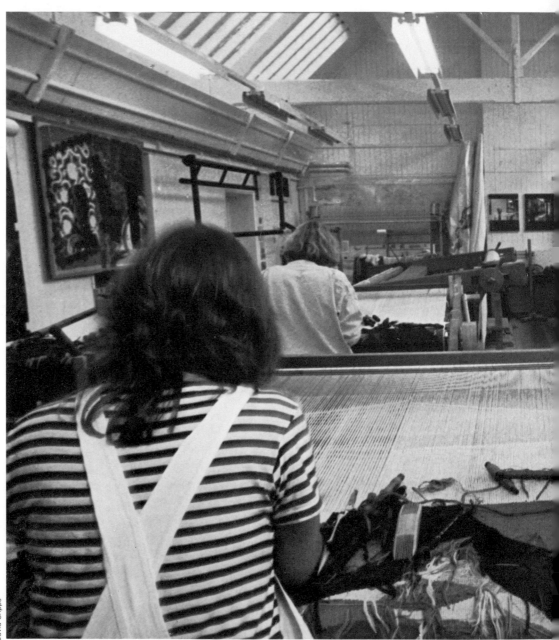

David Cripps

1980 'Gold-Crested Wave', Eva-Louise Svensson; 'Two Reclining Figures', Henry Moore; 'Two Standing Figures', Henry Moore

1981 'Three Seated Women', Henry Moore; 'Figure in a Lunar Landscape', Henry Moore; 'Tree', Henry Moore

1982 Centenary Tapestry, Donald Jackson; 'Quartet: Four Seated Women and Two Children', Henry Moore; 'Ventilator', Howard Hodgkin (twice); 'Moonlight', Howard Hodgkin (four versions)

1983 'Mother and Child', Henry Moore; 'Mother and Child', Henry Moore

1984 'Figures in a Garden', Eileen Agar; 'Oil Rig in the North Sea,' Philip Sutton; 'Three Fates', Henry Moore; 'Three Seated Figures', Henry Moore; Chichester Cathedral Tapestry, Ursula Benker

West Dean Tapestry Studios was founded in the magnificent setting of Edward James's West Dean House (now a college for the crafts). The tapestries are woven there on 'low warp' looms by a team of weavers. The foundation years of the workshop were directed by the Swedish weaver Eva-Louise Svensson, who established a policy of 'translation' by the weavers of original drawings or paintings submitted by artists.

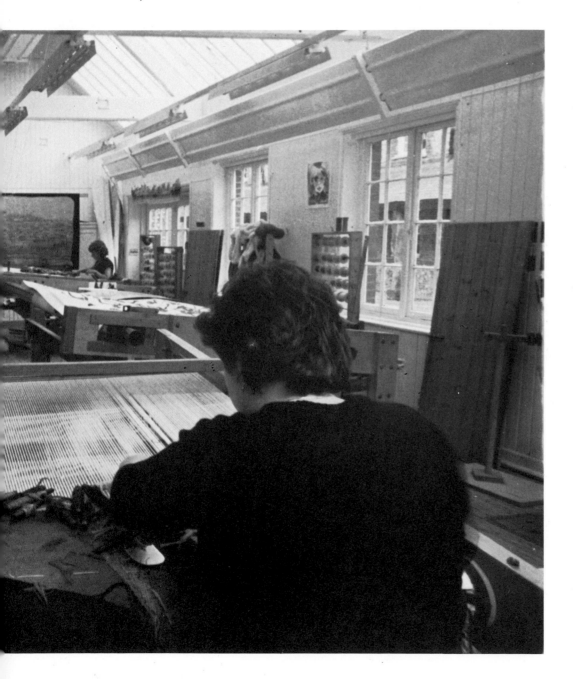

INGUNN SKOGHOLT

Crafts magazine

INGUNN SKOGHOLT 'Serse',
20cm × 15cm, 1980

b. 1952, Norway

Training
1969-73 Oslo Art School, Norway (Fine Art)
1973-4 Bratislava Art Academy, Yugoslavia
1975-6 Edinburgh College of Art (post-graduate)
1977-9 Royal College of Art, London

Exhibitions
1981 'New Classics', Midland Group, Nottingham; 'Textiles Today', Kettle's Yard, Cambridge;
'Contemporary British Tapestry', Sainsbury Centre for the Visual Arts, Norwich and touring
1982 'Fabric and Form', Crafts Council, London, Australia, New Zealand and Hong Kong
1983 'Sesjon', Kunstnerens Hus, Oslo

Collections
Crafts Council, London; Norsk Kulturrad, Norway; Oslo Kommunes Kunstsamlinger

Ingunn Skogholt is concerned with colour: until recently pastels (pinks, blues, yellows) or grey/blacks, and with 'planned randomness'. She dyes her yarns, wools usually, sometimes linen, to obtain the exact shades, and the endless variety of shades which she requires. Often the tapestry is overstitched in thin dark lines to accentuate an area. Recently, her work has become polychromatic, with clear colour areas on darker grounds, and figurative.

WEAVING

In this book a division has been made between 'weaving' and 'tapestry-weaving' which may puzzle some readers. Although both areas concern 'weaving', there the overlap stops. Few, if any, professional craftsmen practise both tapestry-weaving and loom-weaving. The attitudes needed are different: tapestry-weavers are concerned with the resulting image, and weave towards it with very simple equipment and a technique which takes only a short time to learn. Weavers, on the other hand, appear to be primarily concerned with the making process, with the structure, the cloth quality, and do not need the flexibility of imagery which is available to the tapestry-weaver. They are, on the whole, equipment and material orientated, and their images result in this way.

Handloom weavers have two paths open to them on leaving college – industrial designing, (which involves hand-weaving samples of small squares of cloth, with much design input and knowledge of technology) or weaving one-off pieces, which may be lengths, rugs, hangings, items of clothing or furnishing. Some people maintain both paths, moving from one to the other throughout their career, others set off firmly along one or the other. Both these paths then divide: interiors or fashion? It is rarely sensible to follow both of these ways.

The last decade has seen many changes and chances for weavers. The persistent maintaining of traditional standards by a number of admirable people over many years has ensured that when exciting works occur in the weaving world they are made well, and with an appreciation of materials. The groundwork of pure craftsmanship laid by Ella Macleod at West Surrey College of Art, Farnham, and continued by Margaret Bide and other ex-students now teaching there, ensures that it is no coincidence that in the following pages a high proportion of the craftsmen are seen to have trained there. The work of Morfudd Roberts (ensuring supplies of good wool yarn) and Roy Russell (introducing simple and subtle dyeing to all) must also be recognized as invaluable back-up support to the cloth-weaving craftsmen.

Hand-weaving suffers from being one of the slowest of the crafts, which makes it difficult for the practitioner to survive on craft alone. Those schools which teach that 'finest is best' inflict a burden on their students which causes much depression in later years, if they attempt to make a living outside teaching.

Museums are helping to maintain standards of craftsmanship by 'reminding'. The Crafts Study Centre in Bath, under the direction of Barley Roscoe, is hastily preserving what a generation or so had neglected to appreciate fully, and has gently pointed out, by exhibition, the fine linen of Rita Beales and the erratic but often innovative work and life of Ethel Mairet. The vast Quarry Bank Mill at Styal in Cheshire became, under the dynamic direction of David Sekers, 'Museum of the Year' (1984), and as a working museum of the cotton industry is now looking forwards, as well as to the past, by working with Kerry Snaylam as part of the Crafts Council's project 'Texstyles'.

Generally, though, public appreciation of weaving is slow. The BBC attempted to help with a television series, 'The Craft of the Weaver', which was painstakingly researched and directed by Anna Jackson in 1980, with repeats being shown up to four years later, and abroad. Valuable books on aspects of weaving have been written

by Irene Waller. Peter Collingwood has written unbelievably erudite (yet user-friendly) tomes sharing his researches into rug, sprang and tablet-weaving techniques. The ubiquitous Guilds of Weavers, Spinners and Dyers are ploughing a worthy furrow which is, sadly, disregarded by the colleges and polytechnics.

There has been enormous interest in spinning in the last few years. The idea of sitting peacefully, the silence broken only by the hum of the wheel and the hiss of wet logs on the fire, and *producing* something at the same time, appealed to many who would eschew Valium. Only a few of these born-again spinners wish to extend their knowledge, skill or creativity in the subject, however.

A strong branch of the professional weavers is formed by those who concentrate on rug-making. To these is added the challenge of the rug-tufters, who can out-tuft any hand-weaver with their compressors and guns, firing the wool at a rapid rate into stretched hessian. The two workshops of Ron Nixon and John French produce sophisticated and glorious products. Hand-weavers had, for some time, declared that tufted rugs (apart from Peter Collingwood's double corduroy innovation) were un-economic to weave. Roger Oates was quick to see the possibilities of such equipment to extend his repertoire of rugs. Flat-weave rugs are *still* best woven by hand, and one of the quiet, positive and confident flowerings in this area recently has been that of the work of Vanessa Robertson and Norman Young. From worthy, and well-made, block-weave rugs their combined talents have emerged with excitingly marked, essentially hand-woven rugs which are positively of today.

Peter Collingwood's single-minded, academic approach to his invented fabrics, such as the 'macrogauze', proves that endless delightful and mind-tickling variations can be obtained from just one basic idea, one technique. This mature thinking is also shown by other weavers working in this non-functional area: Bobbie Cox and her thick, handspun wool, 'turned furrows'; Mary Restieaux's fine silk ikat pieces; Ruth Harris's Soumak angles; Theo Moorman's inlay and ethereally tapered bands; John Hinchcliffe's glowing rag-pile rugs; Kathleen MacFarlane's semi-sexual sisal works; my own preoccupation with systems and the basic weave; Tadek Beutlich's wrapping and loopings; all the products of endless concentration and obsession on a theme, often lasting a lifetime.

In the colleges, the idea that a weaver should be self-employed on leaving is now regarded as the norm. Industry has, on the whole, been given up for dead. An interesting and recent revolution is now taking place, however, in that many weavers are considering the possibility of commissioning weaving (getting industry to work for *them*) and are not flinching from marketing the results. The super-efficient Morgan and Oates were early into this field and several other weavers (Wendy Jones, Kerry Snaylam, myself) are also working in this way. The recent 'Texstyles' project organized by the Crafts Council helped to boost this idea. The future may well see a new Industrial Revolution.

ANN SUTTON

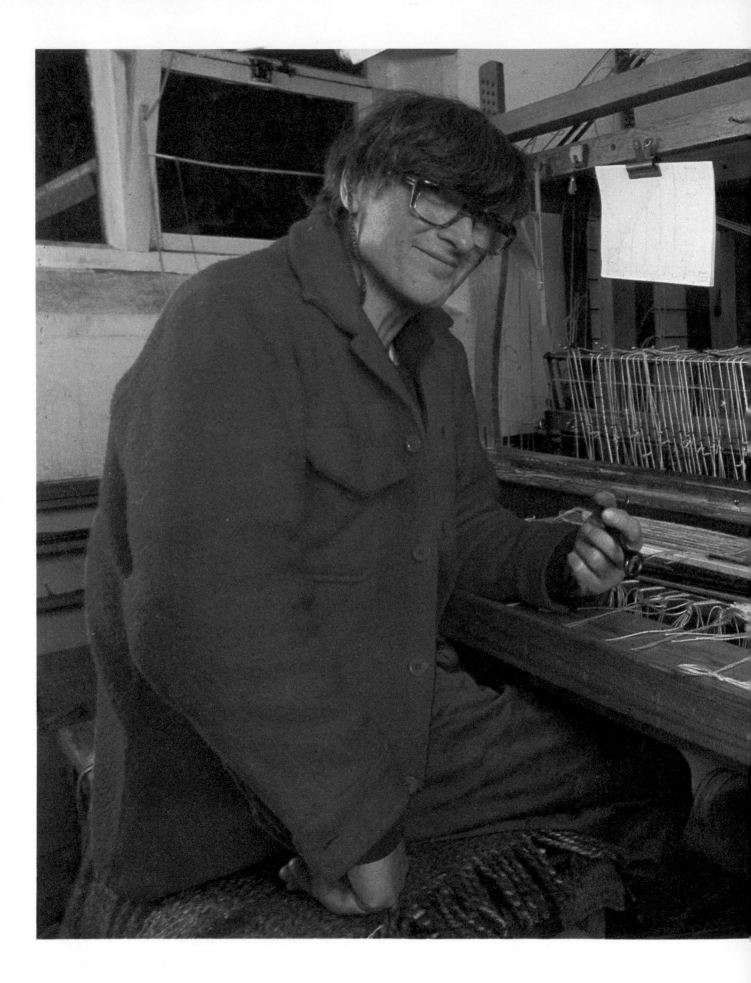

PETER COLLINGWOOD

b. 1922

Training
1946 Qualified in medicine, St Mary's Hospital Medical School, London
1950-52 In weaving studios of Ethel Mairet, Barbara Sawyer, Alastair Morton

Employment
Since 1964 Annual teaching/lecturing tours in USA
1972, 1976 Teaching in Switzerland and Holland

Awards, etc.
1963 Gold Medal: International Handicrafts Exhibition, Munich
1974 OBE

Selected Exhibitions – Solo
1977 Fiberworks, Berkeley, California
1978 Cider Press Centre, Dartington, Devon
1981 Crafts Council, London
1984 Kyoto and Tokyo, Japan; Touring exhibition, New Zealand; Also many group exhibitions, world-wide

Selected Collections
Victoria and Albert Museum, London; National Gallery of Melbourne, Australia; National Museum of Wales, Cardiff; Royal Scottish Museum, Edinburgh; Museum of Art, Philadelphia; Cooper Hewitt Museum of Design, New York; Stedelijk Museum, Amsterdam

Selected Commissions
New Zealand House, London; University of York; Metropolitan Cathedral, Liverpool; National Westminster Bank, Manchester; Kuwait Embassy, London; W. H. Smith and Son; BP, Britannic House, London; Wobarn, Mass., USA

Peter Collingwood is Britain's most respected and inventive weaver. One of very few weavers to live almost entirely from his workshop production, without regular teaching, he has written several books which are regarded as the definitive publications on the subject.

'I have always approached textiles from the technical side, liking to adapt old looms, or invent new ones, so that they produce fabrics either of a new type, or, of an old type but more easily and with more control. The design follows from the possibilities inherent in the structure being made.'

Previous page: PETER COLLINGWOOD in his workshop near Colchester

PETER COLLINGWOOD three 'Macrogauze' woven hangings

Opposite: PETER COLLINGWOOD three-dimensional 'Macrogauze' woven hanging, 26 ft × 16 ft, 1978. Commissioned for the Wellersley Park Offices, Boston, Mass. USA

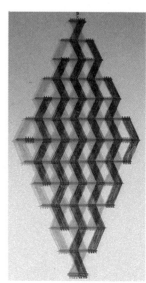

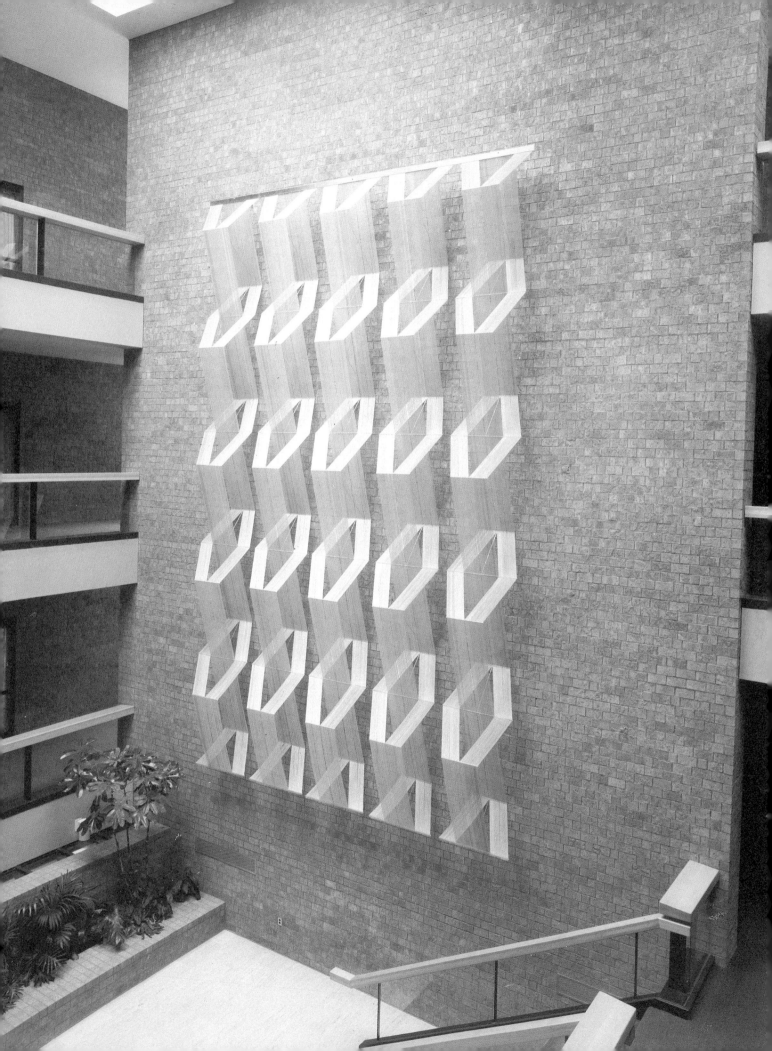

TADEK BEUTLICH

Opposite: TADEK BEUTLICH
hanging, wrapped form in sisal

b. 1922, Poland

Training
Studied in Poland, Germany, Italy and England

Employment
1951-74 Camberwell School of Art, London

Selected Exhibitions – Solo
1963, 1967, 1970, 1972, 1974 Grabowski Gallery, London
1971, 1973 Croneen Gallery, Sydney, Australia
1979 Peterloo Gallery, Manchester
1982 Oxford Gallery, Oxford
1983 St James's Gallery, Bath

Selected Exhibitions – Group
1967 3rd Tapestry Biennale, Lausanne
1969 4th Tapestry Biennale, Lausanne
1970 Smithsonian Institution, Washington DC, USA
1971 Scottish Arts Council, touring
1972 Denver Art Museum, USA
1973 'The Craftsman's Art', Crafts Council, Victoria and Albert Museum, London
1974, 1976, 1978, 1980 International Exhibition of Miniature Textiles, British Crafts Centre, London
1981 'Contemporary British Tapestry', Sainsbury Centre for the Visual Arts, Norwich and touring
1981 'Mainstream', touring USA
1982 'Fabric and Form', Crafts Council, London, Australia, New Zealand, Zimbabwe, Hong Kong
1983 'Four Weavers', Southampton Art Gallery

Tadek Beutlich's first textile work was in the traditional Gobelin tapestry technique. His book *The Technique of Woven Tapestry* (Batsford, 1969) is still the definitive work on the subject. Later work became transparent, ethereal, to be followed by heavy, looped, sisal pieces. For ten years he lived in Spain, where the materials and light were strong influences on his work.

'For the last ten years I have been interested in light falling on some textile materials, mainly in the form of dots and lines on different levels and at different angles. For this reason I am creating and searching for textile structures which enable me to obtain the best results in this three-dimensional pointillism effect. Most of my work is made without any equipment but I am also interested in partly weaving on a frame or loom – continuing and completing them afterwards.'

BOBBIE COX

b. 1930

Training
1948-51 Bath Academy of Art (Fine Art)

Employment
1951-72 Totnes High School, Devon; Bath Academy of Art, Avon; Dartington College of Arts, Devon
1972- Freelance teacher/lecturer/demonstrator; Part-time curator of ethnological collection for Dartington College of Arts, Devon

Award
1979 South West Arts Major Award

Selected Exhibitions – Solo
1978 No. 88 Gallery, Totnes; Prescote Gallery, Oxfordshire
1979 Plymouth Arts Centre, Devon
1980 Taunton Brewhouse, Devon
1983 St James's Gallery, Bath
1984 Cooper Art Gallery, Barnsley, Lancs; Salisbury Festival

Selected Exhibitions – Group
1973 'The Craftsman's Art', Crafts Council, Victoria and Albert Museum, London
1977 'New Faces', British Crafts Centre, London; 'Masterpieces', British Crafts Centre, London; 'Autumn Textiles', British Crafts Centre, London; 'Crafts in Question', Whitworth Art Gallery, Manchester
1980 'Crafts Southwest', South West Arts, touring; 'The Craft of the Weaver', British Crafts Centre, London
1981 'Contemporary British Tapestry', Sainsbury Centre for the Visual Arts, Norwich and touring
1984 'Rugs and Hangings for Walls and Floors', Cirencester Workshops, Glos and touring

Selected Commissions
Trust House Forte; IBM; Dartington Hall Trust

Bobbie Cox weaves large and small hangings, using wool which she processes in her workshop – dyeing and blending, spinning thick strong yarns to suit the work in progress. Becoming increasingly involved in photography, she is recording and responding to, in weaving, man-made landscapes in Devon and on Dartmoor.

'I think of the warp as the backbone from which my construction grows, and in this way cannot divorce the technique from my ideas. I am stimulated by working to commission. I see it as a service, and functional. Parallel to large-scale work, I also work very small; and it is through this scale that I have opportunities to explore new ideas and directions, to take risks, and to find the translation of my subject into the medium of weaving. Much of my weaving is presented as reliefs, using colour and texture in response to light. Some go further into three dimensions and use the weight, fall and form of the woven piece and its plasticity.'

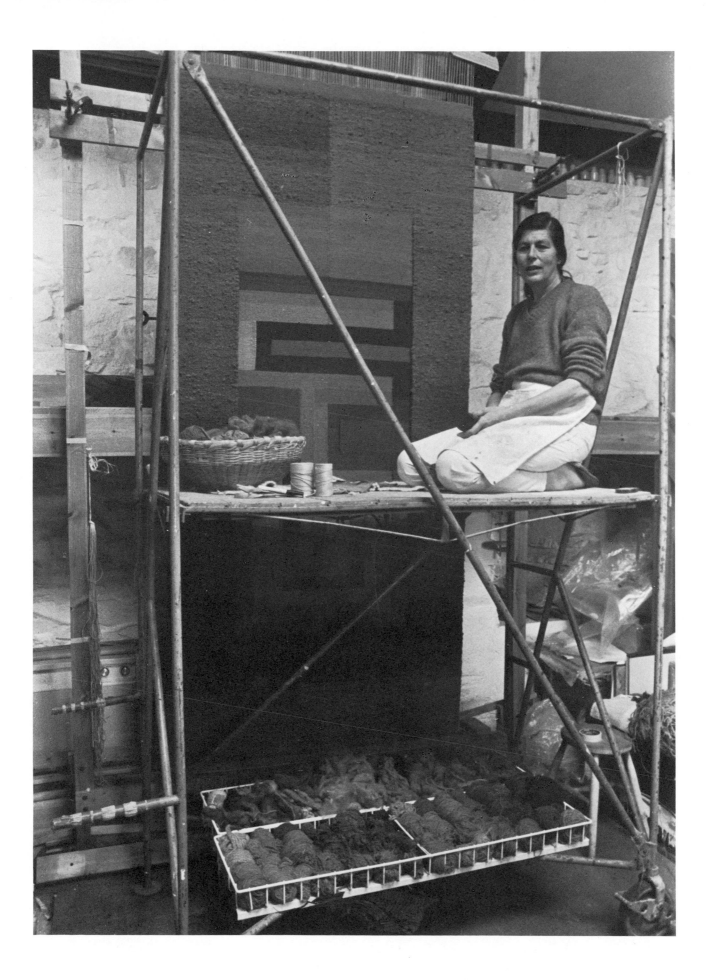

ANNA CADY

b. 1951

Training
1970-73 West Surrey College of Art and Design (Textiles)

Employment
1975-78 Cambridge College of Art
1980-81 Highland Craftpoint: survey of weaving in Scotland (consultant); Various short courses, lectures

ANNA CADY silk weaving patchwork strip jacket, spun silk warp, filament silk weft (*detail*)

Anna Cady is a meticulous weaver of fine cloths in lengths or as items:

'My main interest lies in fine natural yarns and cloths. The qualities I aim for are those of good cloth – drape, handle, practicality and especially exciting use of colour. In all the cloths I weave, different yarns and fibres are combined for diversity and richness.'

ANNA CADY silk
weaving, spun silk warp,
tussah silk weft

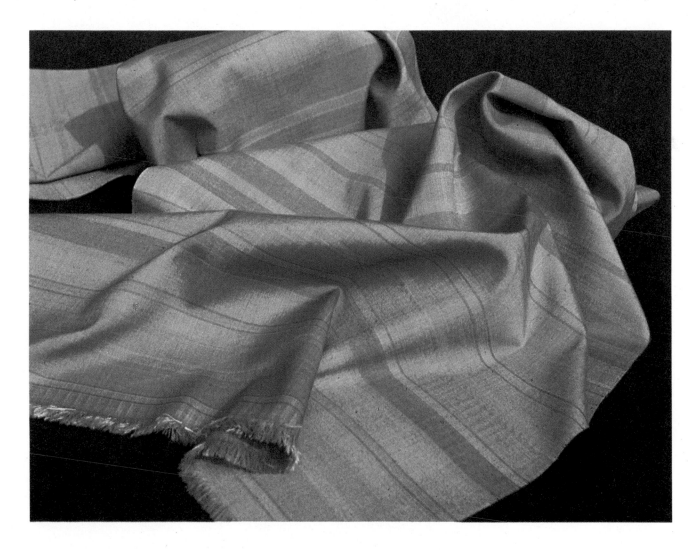

151

KATHLEEN
MCFARLANE

b. 1922

Training
As a librarian; Learnt to weave in a Norwegian studio; Part-time classes in painting and life drawing: University of Newcastle

Exhibitions – Solo
1973 Weavers' Workshop, Edinburgh
1974 Sunderland Civic Art Gallery
1976 British Crafts Centre, London
1977 Gardner Centre, University of Sussex
1980 Wells Centre, Norfolk
1981 Castle Museum, Norwich

Exhibitions – Group
1973 'The Craftsman's Art', Crafts Council, Victoria and Albert Museum, London; 'Fifteen Weavers', British Crafts Centre, London
1975 'Woven Works', Eastern Arts, touring
1976 'Three Tapestry Weavers', DLI Gallery, Durham
1977 Oxford Gallery, Oxford

Collections
Norwich Castle Museum; Leicestershire Education Authority; Blyth Jex School, Norwich; Private collections

Commissions
St Margaret's Priory, King's Lynn: altar frontal

Opposite: KATHLEEN MCFARLANE 'Black Embryo', 5 ft × 4 ft, woven fibre sculpture, sisal

Kathleen McFarlane learnt to weave household artifacts in Norway. Later, she became interested in painting and was deeply influenced by Victor Pasmore, leading to Munch, Arp and Moore. Working in paint, she began to use plaster, sand and sacking to build up textured surfaces. Tadek Beutlich's book introduced her to tapestry-weaving, and she was strongly inspired by his work, and by that of Magdalena Abakanowicz.

'Abakanowicz spoke in a new language, but one I felt I readily understood. I began working in sisal instead of wool and it was a revelation. I succumbed totally to the new material and exulted in the results I could get from it. The greatest excitement in the early stages came from the forms I could make in sisal with the familiar crochet hook. Forms that seemed to grow under my hands as if obeying some inner law struck such a chord in me that my hands trembled as I worked. I had clearly stumbled on something which had a profound meaning for me.'

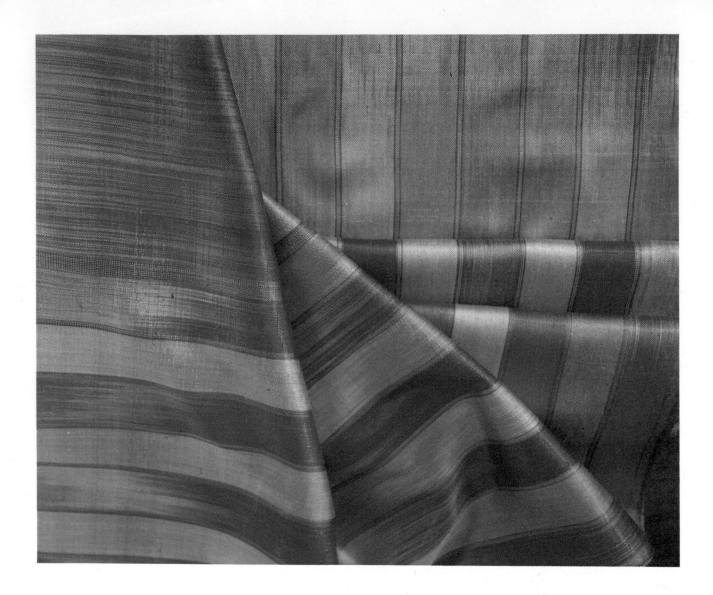

LUCY COLTMAN

LUCY COLTMAN fine silk and lurex cloth with space-dyed warp

Training
1977-80 West Surrey College of Art and Design (Textiles)
1980-81 Manchester Polytechnic (Textiles)

Employment
1981 Jack Lenor Larsen Design Studio, New York
1982 Jim Thompson Thai Silk Company, Bangkok (as designer, and setting up a design studio)

Awards, etc.
1980 Awarded stand at INDIGO in the 'Nouveaux Talents' competition, Lille Textile Fair

'My work is designing and weaving small quantities of special cloth, for soft furnishings and fashion accessories. I try to produce fabrics with special qualities of colour, light and luminosity, working with silk and lurex to achieve sheens and shot effects. The silk warps are often ikat or space-dyed so that the different coloured areas offset the lurex weft in different ways creating illusions in the reflective surface. The hand-dyeing and hand-weaving combine to produce a soft, light fabric with a unique texture and colouring.'

JULIA FORD

Training
1975-8 Loughborough College of Art (Woven Textiles)
1985 University of Kansas, USA (Textiles)

Employment
1978-81 Derby Lonsdale College of Higher Education, Derby
1982, 1983, 1984 Gallery assistant: Californian art galleries; Freelance designer for Deryck
Healey International; 3 Suisses (France); Creation Baumann (Switzerland); Cavendish Textiles
(London), etc.; Freelance lecturer

Award
1985 University of Kansas Professional Terminal Masters Fellowship

Exhibitions – Solo
1983 Woven Works, University of California, Santa Barbara, USA
1984 Bartoli and Ashton Gallery, Santa Barbara, USA

Julia Ford's woven textiles are inventive in structure, subtle and 'modern' in texture,
and with total control over colour. She is currently investigating the computerized
loom at the University of Kansas, USA.

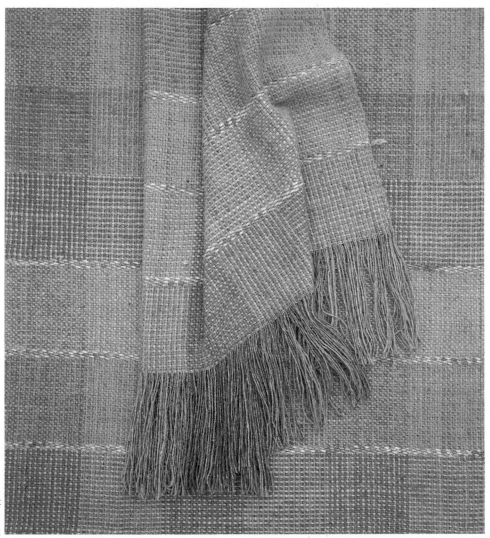

JULIA FORD, tussah silk scarf,
handwoven and dyed

David Cripps

KERRY SNAYLAM

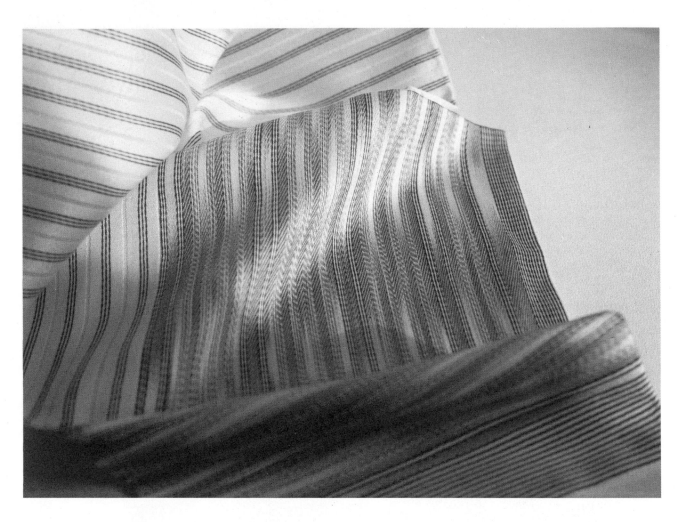

KERRY SNAYLAM hand-woven fine cotton cravats, with tie-dyed weft

b. 1957

Training
1976-9 Loughborough College of Art (Woven Textiles)
1979-81 Royal College of Art, London

Employment
1981- Leicester Polytechnic

Award
1984 Crafts Council award to participate in 'Texstyles' project

Kerry Snaylam, in common with many other weavers, spends part of her time designing for industry. In her case these are mainly fashion fabrics. She also produces a range of hand-woven items for exhibition and sale (scarves, cravats, wraps).

'My most recent work has been the involvement with the "Texstyles" project, organized by the Crafts Council. I have developed a range of fabrics for interiors, and with the help of Quarry Bank Mill at Styal (a working museum of the cotton industry) I have started to put these ideas into power-loom production.
 'I work, almost exclusively, with fine cotton yarns: dyed, space-dyed, and tie-dyed to produce interesting pattern effects in satin, sateen and plain weaves.'

MARGARET SMITTEN

(also known as Margaret Windsor-Stevens)

b. 1951

Training
1970-73 Loughborough College of Art (Weaving)
1973-4 Brighton Polytechnic (Teacher Training)

Employment
1974-5 Ware College of Further Education, Herts
1975-6 North Herts College of Further Education; Own workshop summer school: Digswell House

Awards, etc.
1977 Eastern Arts Minor Award
1978 Lincolnshire and Humberside Arts Association Award

Exhibitions – Solo
1979 Doncaster College of Art

Margaret Smitten uses a dobby loom for many of the repeated elements on her hangings of houses and gardens. She programmes the loom to weave rows of windows, roof tiles, and trees in orchards, which she then assembles into the large buildings with their formal grounds which constitute one of her favourite themes. This technique is ideally suited to the dobby loom, which is designed to produce repeats of weaves and is generally used for industrial designing. Margaret Smitten is one of only a few weavers to use it in this way to produce hangings.

MARGARET SMITTEN 'House Portrait' in dobby woven bands, with inlay

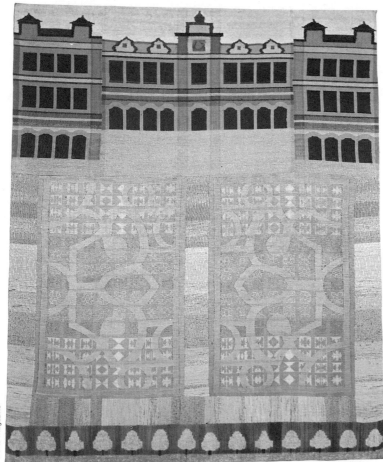

Crafts Magazine

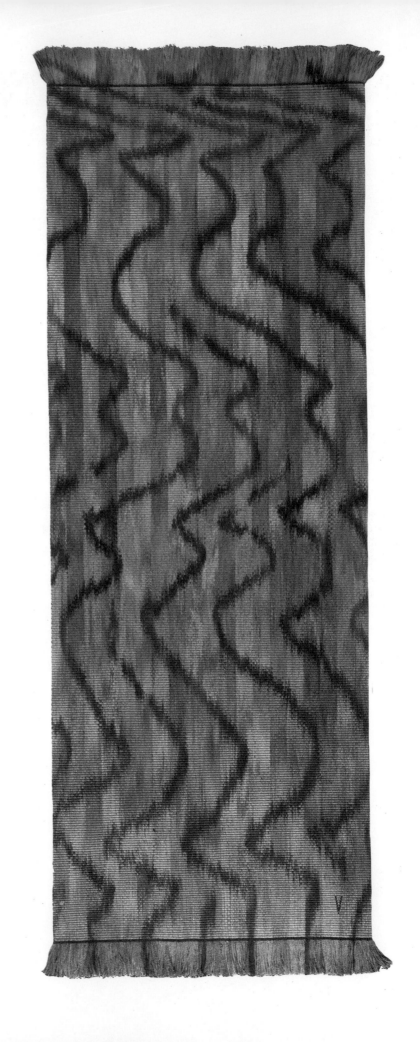

VANESSA ROBERTSON and NORMAN YOUNG

joint workshop started 1972

Training
Nottingham College of Art; Dartington College of Arts, Devon; Largely self-taught in weaving

Awards
1978 Winston Churchill Memorial Trust travelling fellowship (to study ikat weaving in Switzerland and Mallorca)

Selected Exhibitions – Solo
1973 Cider Press, Dartington
1982 Formatera, Zurich, Switzerland

Selected Exhibitions – Group
1979 Rugs used as backdrops for Jean Muir's exhibition, touring
1983 'Rugs and Throws', British Crafts Centre, London; 'A Closer Look: at Rugs', Crafts Council, London and touring
1984 Summer Exhibition, Crafts Council

Selected Commissions
Jean Muir; David Mellor; The President of Nigeria; Miss Bridget D'Oyly Carte; City of Leeds Museums, Lotherton Hall; Imperial College of Science and Technology, London; Unilever House, London

'On setting up the workshop in 1972 a ten-year period of self-apprenticeship was forecast. During that period looms were built and adapted, dye techniques and equipment devised and developed, and the weave structure improved. Designing took on a new freedom with the change from geometric three-end block-draft rugs to warp-face ikat rugs. Our own ikat technique allows freedom for any shapes, figurative or abstract, and any number and combination of colours. We make rugs and wall-hangings for corporate and private clients, aiming to design them with empathy towards both client and interior.'

Opposite: VANESSA ROBERTSON and NORMAN YOUNG ikat-dyed warp-face rug

VANESSA ROBERTSON and NORMAN YOUNG ikat-dyed warp-face rug

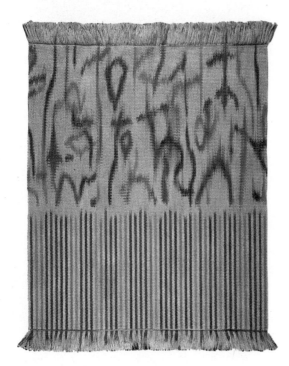

159

GWEN MULLINS

Training
Began to weave shortly after marriage. During Second World War, set up looms at the local hospital in Epsom
1952 Started the Graffham Craft Centre, teaching a variety of crafts

Award
OBE

Selected Exhibitions
Two exhibitions per year in the Graffham Weavers Workshop
1970 British Crafts Centre, London
1972 Craftwork, Guildford

Collections
Victoria and Albert Museum, London; Royal Scottish Museum, Edinburgh; Crafts Council, London

Gwen Mullins weaves rugs, dyeing the yarn in the workshop, mostly with natural dyes. Her work is 'inspired and developed from sketches or photos brought back from walks and travels. I use a pile technique as this gives much freedom for design and makes a good heavy rug.'

Gwen Mullins is much respected, not only for her weaving, but for her work with the weavers' guilds and her influence through teaching. During its existence, 'The Gwen Mullins Trust' provided much-needed assistance for craft projects in the years before other grant sources were in operation.

GWEN MULLINS hand-woven pile rug

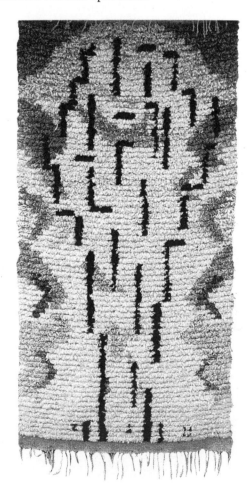

BARBARA MULLINS

Training
Trained as a primary school teacher and taught for several years
1957 Became full-time weaver, and joined her mother Gwen Mullins (see opposite page) at the Graffham Crafts Centre, later the Graffham Weavers Workshop; Attended short courses, also Farnham School of Art (part-time)

Employment
1962 Horsham School of Art
1964-69 Part-time lecturer at a London training college; Now teaches short courses at West Dean College, Chichester and in own workshop

Award
1969 Leverhulme Research Fellowship (to research natural dyes in Peru)

Exhibitions
Two exhibitions per year in the Graffham Weavers Workshop
1965 Ceylon Tea Centre, London
1967, 1969 The Clarkson Gallery, Edinburgh
1970 British Crafts Centre, London
1972 Craftwork, Guildford

Barbara Mullins's weaving includes rugs, 'mostly the Kehlim technique but also different threadings—inspiration comes from life, and the countryside around the home and workshop'. She also weaves cushions, hangings, bags and other articles; the yarn is usually dyed with natural dyes.

BARBARA MULLINS hand-woven rug

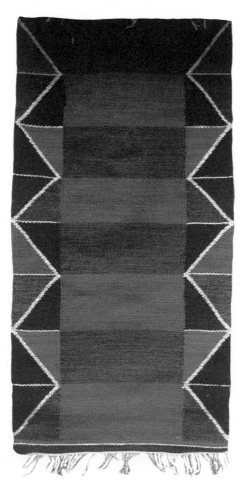

HILARY AUDEN

Training
1970-72 Brighton Polytechnic (Textiles)
1972-4 Royal College of Art, London (Textiles)

Employment
1974-5 Workroom assistant and pattern cutter for INEGA
1975-7 In partnership with two fashion designers, using hand-woven fabric
1980- Central School of Art, London

Exhibitions
1980 'The Craft of the Weaver', British Crafts Centre, London

Opposite: 'Comfortable Chair', designed and made by Fred Baier with cotton upholstery fabric designed and hand-woven by HILARY AUDEN, 1984

Below left: HILARY AUDEN wool and silk blanket, with brocaded patterning
Below right: HILARY AUDEN upholstery fabric woven in cotton (*detail*)

Hilary Auden designs and weaves rugs and upholstery fabrics in cotton and wool, and sometimes silk, using inlay and tufts to form small areas of colour interest:

'I like to design fabric for specific furniture, such as Fred Baier's "Comfortable Chair". Other than that I weave complete articles, with as little finishing or shaping off the loom as possible. Everything I weave must be practical and useful, not "precious". At the moment I am influenced by Romanian textiles, fabrics of the 1950s, and early American weaving.'

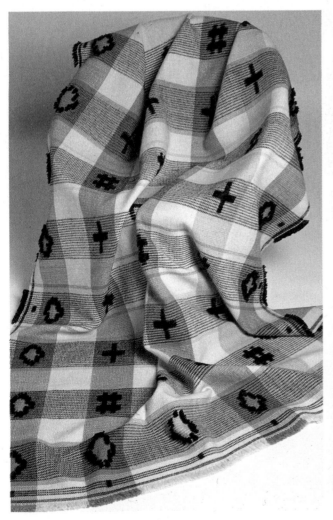

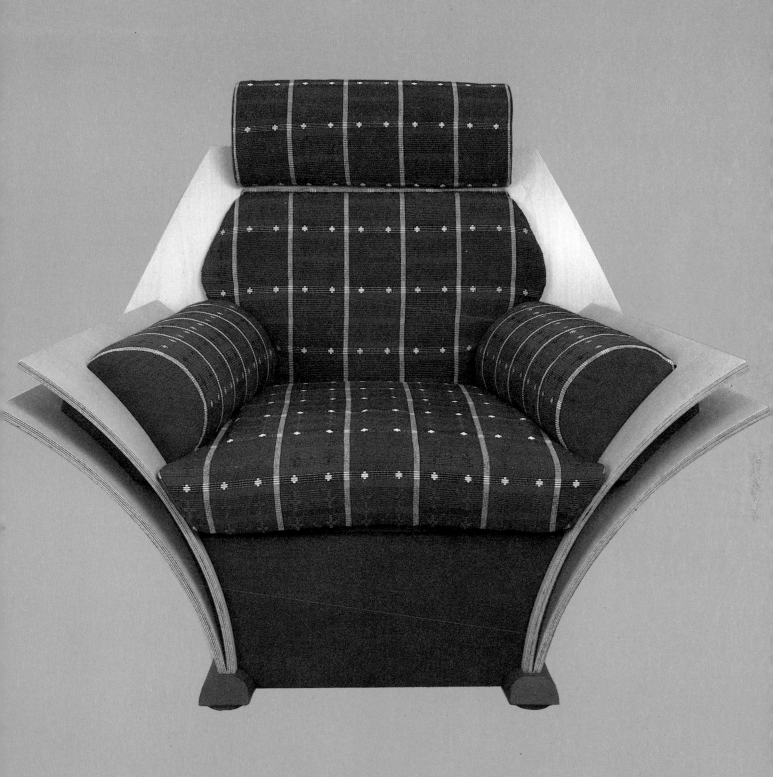

WENDY JONES

b. 1947

Training
1966-9 Middlesex Polytechnic (Fashion/Textiles)
1969-71 Royal College of Art, London (Woven Textiles)

Employment
1971-3 Set up and ran Craftworkshop, Penshurst, Kent
1971-4 Croydon College of Art
1974- West Surrey College of Art, Farnham
1978 Crafts Survey for South East Arts and Crafts Council on the state of the crafts in South East England
1981- Joint organizer and lecturer: Annual Textile Summer School at West Surrey College of Art
1982- Part-time lecturer, Camberwell School of Art, London
1983 Occasional lecturer, Royal College of Art, London

Selected Exhibitions
since 1981 'Makers', British Crafts Centre, London
1983 'Quilting Patchwork and Appliqué 1700-1982', Minories, Colchester, and Crafts Centre, London; 'Rugs and Woodworks', Gardner Centre, Sussex and touring; 'A Closer Look: at Rugs', Crafts Council, London and touring; 'Rugs and Throws', British Crafts Centre, London
1984 'Rugs and Hangings for Walls and Floors', Cirencester Workshops, Glos and touring; 'Black and White', British Crafts Centre

Collections
Reading University; Crafts Council, London; South East Arts

Opposite: WENDY JONES, Double-cloth throw in black, white and grey wool

WENDY JONES, Throw showing the use of both sides of an unbalanced twill, wool

'I continue to make individual rugs, but that is only one aspect of my work. I am currently designing and making co-ordinating furnishing textiles including blankets/throws, etc.

'I have always been interested in both sides of the fabric and so a lot of my rugs and fabrics use double-cloth techniques.'

David Cripps

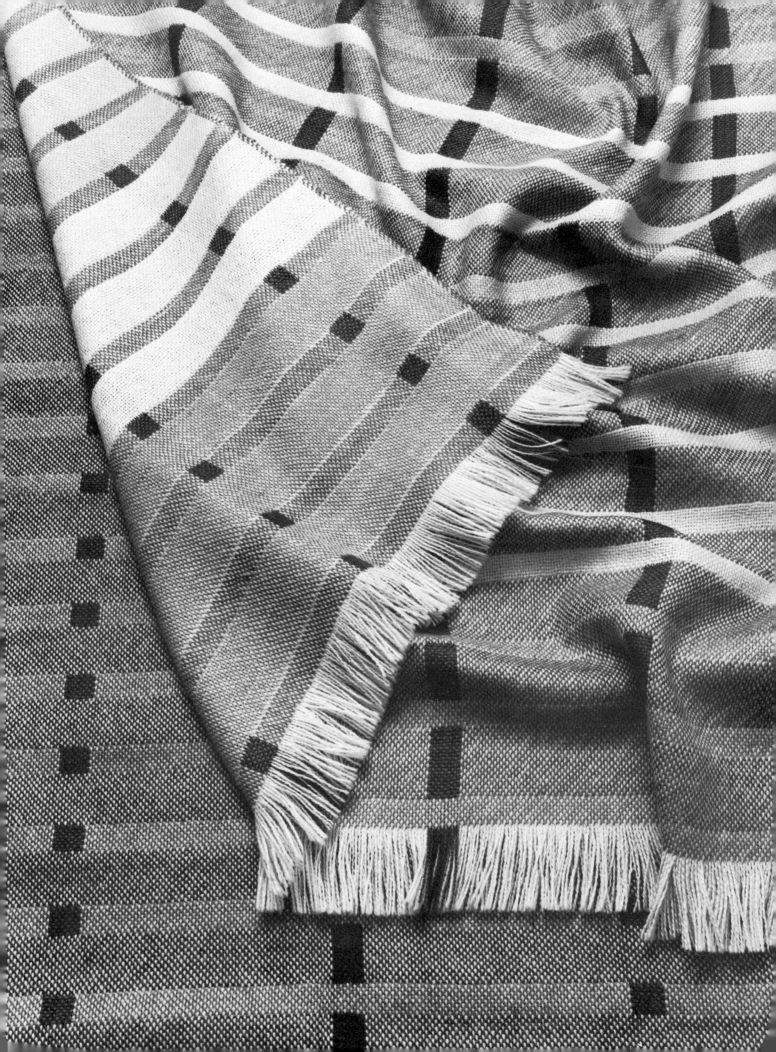

THEO MOORMAN

Opposite: THEO MOORMAN woven hanging with shaped bottom edge, and tapering woven bands, weighted with slate pebbles

b. 1907

Training
1925-8 Central School of Art, London (Handweaving with Walter Taylor)

Employment
1928-30 Weaving rugs at Heal and Sons Ltd, London
1930-32 Freelance
1933-8 Designing at Warner and Sons Ltd, modern furnishing fabrics
1939-43 Developing fabrics for armaments
1944-53 Organizer for the Council for the Encouragement of Music and the Arts, Yorkshire
1953 Started to handweave full-time; Annual lecture/workshop tour in USA

Award
1977 MBE

Selected Exhibitions – Solo
1963 'Theo Moorman: Tapestries and Church Fabrics', The Manor House, Ilkley, Yorks
1967 Queen Square Gallery, Leeds, Yorks
1972, 1975, 1985 Oxford Gallery, Oxford
1975 Royal Northern College of Music, Manchester
1976 Kettle's Yard, Cambridge; Art Alliance, Philadelphia, USA

Selected Exhibitions – Group
1965 'Weaving for Walls', Victoria and Albert Museum, London
1968 'Woven Textiles '68', Building Centre, London

Selected Commissions
1956 Wakefield Cathedral
1957, 1968, 1970 Manchester Cathedral
1968 Agnes Stewart School, Leeds
1969 Cooper-Hewitt Museum of Design, New York
1975 Fitzwilliam College, Cambridge

Theo Moorman has developed an inlay weaving technique so that she can produce free imagery in a way which is quicker and lighter in weight than traditional tapestry: 'I am concerned with producing woven abstractions from my visual experiences. They may deviate so far from the original literal image as to be unrecognizable but I hope that they retain much of the primary vision and impulse.' Many of her larger works have been commissions for churches, and she also weaves smaller works, hangings for domestic environments.

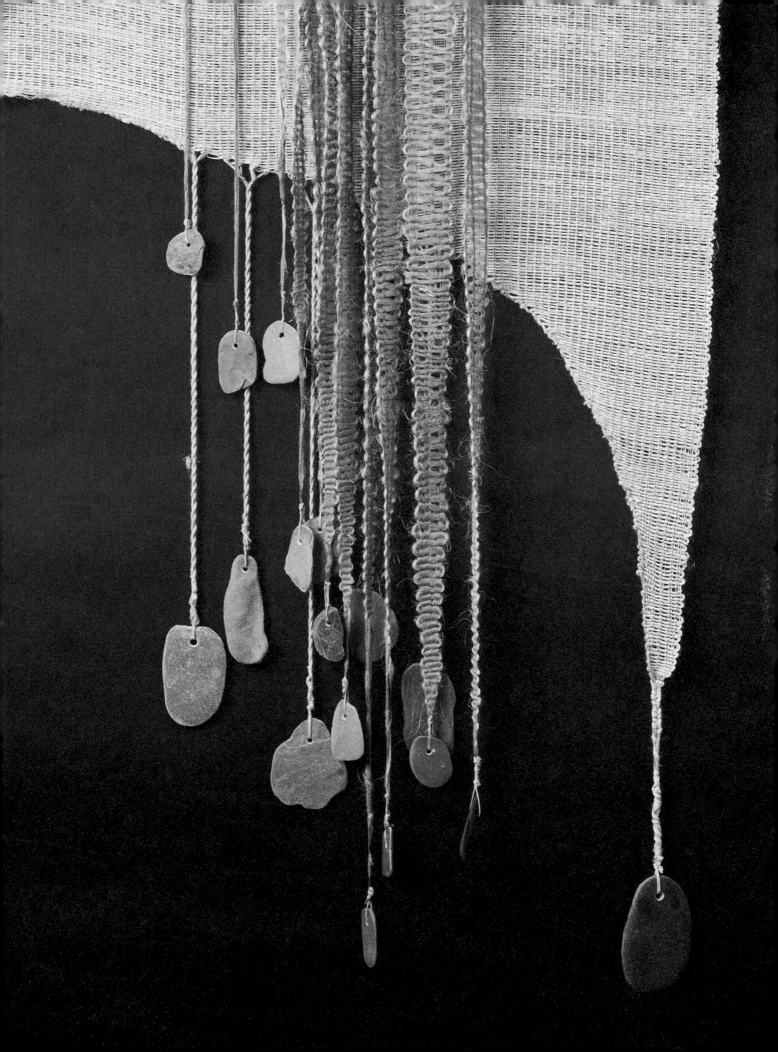

FAY MORGAN
and ROGER OATES

(known as Morgan and Oates)

Opposite: MORGAN and OATES
woven wool rug

ROGER OATES and FAY MORGAN in
their studio in Ledbury
Herefordshire

FAY MORGAN

ROGER OATES

Training

Hornsey College of Art, London
Royal College of Art, London

West Surrey College of Art
Kidderminster College of F.E.

Employment

Goldsmiths' College, London
and visiting lecturer to
various other colleges

Various colleges of art

Award
1975 Joint: Welsh Arts Council Bursary – to produce first collection

Selected Exhibitions
1973 'The Craftsman's Art', Crafts
Council, Victoria and Albert Museum,
London
1977 'Flavour of the Seventies',
Southampton

1973 'The Craftsman's Art', Crafts
Council, Victoria and Albert Museum
1975 'The Camera and the Craftsman',
Crafts Council, London and touring
1977 'Rugs for Churches', Crafts Council,
London; 'Textiles and Ceramics', British
Council touring

1978 Fay Morgan and Roger Oates, Welsh Arts Council, Cardiff and touring
1983 'A Closer Look at Rugs', Crafts Council, London and touring
1984 'Texstyles', Crafts Council Gallery, London and touring

Fay Morgan develops hand-weaving for the purposes of industrial production. Roger
Oates's early rugs (and some in current production) are essentially one-off, hand-
woven works. On their marriage in 1976 they formed the partnership 'Morgan and
Oates' which 'designs and makes woven textiles where skill and craft are used to
enhance the concept. Raw materials and good design are related to function and
visual enjoyment.' Their production is now totally in the field of interior
furnishings – tufted and woven rugs, in cotton rag or fine wools, furnishing fabrics
and table linens.

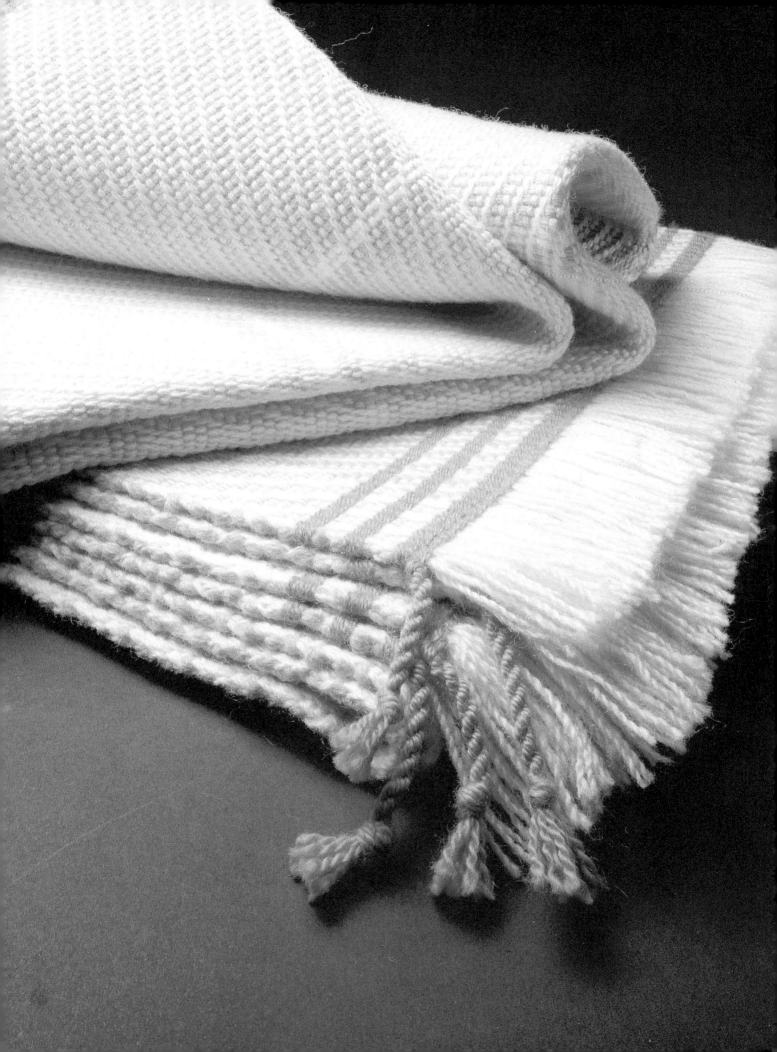

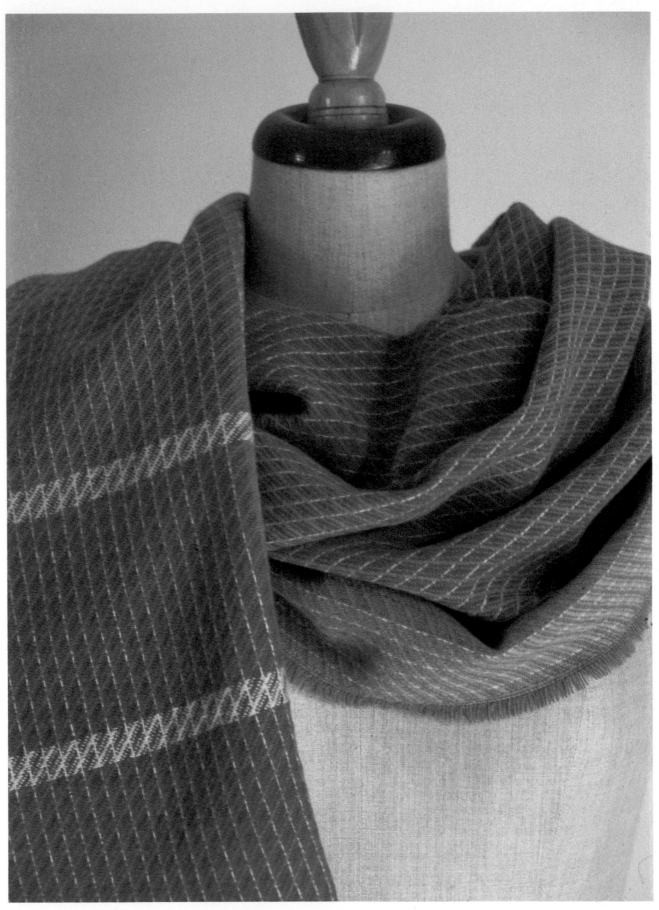

FAY MORGAN woven scarf

Opposite: ROGER OATES weft
face twill rug

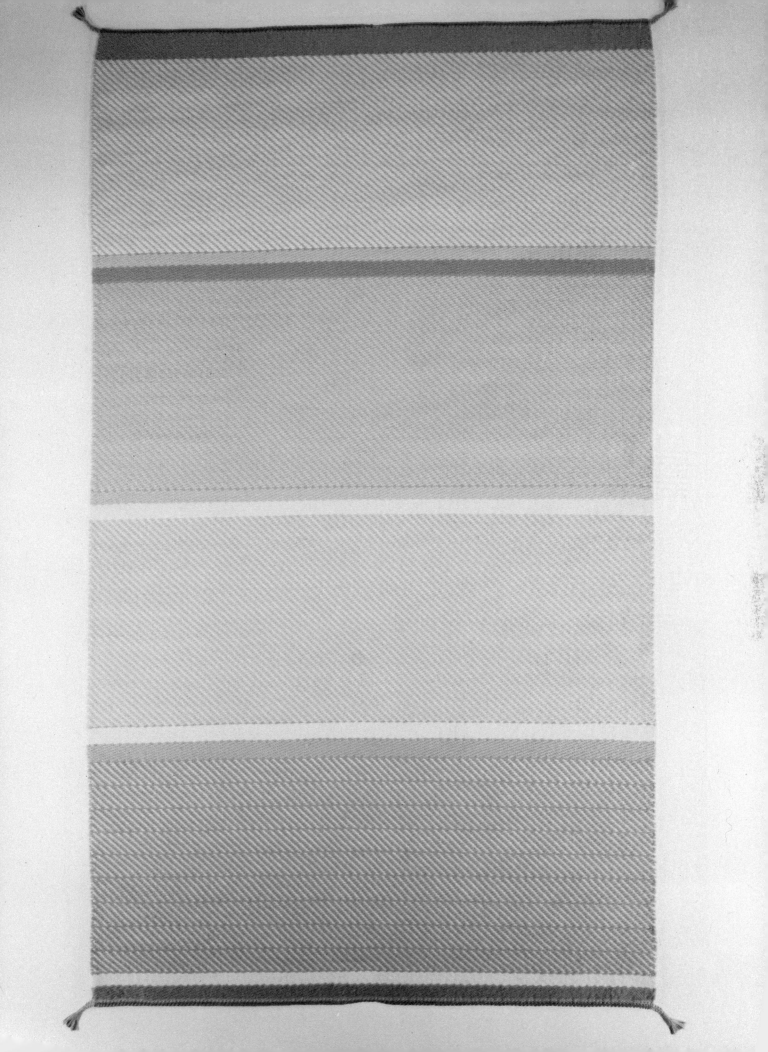

ANN SUTTON

Training
1951-6 Cardiff College of Art (Embroidery and Weaving)

Employment
1956-63 West Sussex College of Art, Worthing
1967-74 North Oxfordshire College of Art, Banbury; Several years teaching short courses at Barry Summer School, Wales
1967-78 Consultant to various mills in Wales
1962- Freelance designing, lecturing, weaving
1983- Consultant designer to Welsh Woollen Association
1970- External assessor to BA/MA courses

Awards, etc.
1970 Welsh Arts Council sculpture competition (commission award)
1971 Worshipful Company of Weavers Travel Scholarship (Nigeria and Morocco)
1978 Crafts Council Bursary
1984 Southern Arts, Major Bursary

Selected Exhibitions – Solo
1969 British Crafts Centre, London; 'Textile Images on Paper', Victoria and Albert Museum, London
1974 'Sutton/Treen: Textiles and Jewellery', (with Gunilla Treen), Crafts Council, touring
1975 British Crafts Centre, London
1976 Dodson Bull Interiors, Barbican, London
1979 Work in Progress: Crafts Council (one section of four)
1984 Anatol Orient Gallery, London
1985 Major exhibition, Norrköpings Museum in Sweden, also Boras

Selected Exhibitions – Group
1973 'The Craftsman's Art', Crafts Council, Victoria and Albert Museum, London
1978 International Tapestry Triennale, Lodz, Poland
1981 International Tapestry Triennale, Lodz, Poland; 'British Ceramics and Textiles', British Council/Crafts Council, Knokke-Heist, Belgium and many others

Exhibitions Instigated
1974, 1976, 1978, 1980 International Exhibitions of Miniature Textiles, London and world tour
1977 Enid Marx R.D.I. – retrospective, Camden Art Centre, London
1983 'Attitudes to Tapestry', John Hansard Gallery, University of Southampton

ANN SUTTON 'Honeycomb', and 'Herringbone', 30 inches × 30 inches, cotton cloth/acrylic paint woven panels, 1982

Frank Youngs

Frank Youngs

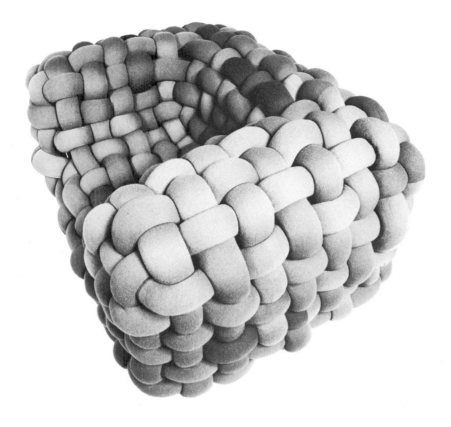

Sam Sawdon

Collections
The Crown Prince of Qatar; Victoria and Albert Museum, London; National Museum of Wales;
Oxford City and County Museum; City of Leeds Museum and Art Gallery, Lotherton Hall

Selected Commissions
1973 Crafts Council: 'Floor Pad' for exhibition in 'The Craftsman's Art', Victoria and Albert
Museum (also textile foreword in catalogue)
1975 Liberty & Co.: a 'Loveseat' for centenary celebrations
1976 Companies Registration Office, Cardiff (Department of the Environment): two hangings
1980 Mercantile and General Reassurance, Moorgate, London: three hangings
1983 Crafts Council Gallery, London: two flags

Ann Sutton presented the five part BBC television series 'The Craft of the Weaver' in 1980. She is
the author of *Tablet Weaving* (Batsford, 1973); *The Craft of the Weaver* (BBC Publications, 1980);
The Structure of Weaving (Hutchinson, 1982); *Tartans* (Bellew, 1984); *Colour-and-Weave* (Bellew,
1984).

'I enjoy the logical structure and thinking inherent in weaving, and work with
this in simple systems, usually to do with colour and number. The work is often
composed of simple, direct units, joined together to form a whole. The structure is
sometimes traditional, sometimes invented. Selvedges on all four sides are a
constant fascination, produced in all ways: from darning on nails in a board to a
foot-loom version of back-strap four-selvedge weaving.
 'Technique is of little importance: it is evolved as an efficient way of producing
the required result, and often changes with each piece. Conversely, all the
imagery is the result of technique, and of the way in which colour can be located
in a particular structure. Craftsmanship is important to me only in a negative
way: the lack of it detracts from the concept of the piece.'

JOHN HINCHCLIFFE

Training
1968-71 Camberwell School of Art, London
1971-3 Royal College of Art, London

Employment
Camberwell School of Art; West Sussex College of Art; Middlesex Polytechnic

Awards, etc.
1970 Travel Scholarship to Konstfachskolan, Stockholm
1977 *Daily Telegraph* Magazine British Craft Award: textiles
1980 Southern Arts Bursary
1982 South West Arts Major Bursary

Selected Exhibitions
1977 'Crafts of the Seventies', Whitworth Gallery, Manchester; 'Rugs for Churches', Crafts Council, London; 'Masterpiece', British Crafts Centre, London
1981 'Textiles Today', Kettle's Yard, Cambridge and touring; 'British Ceramics and Textiles', British Council, Belgium
1983 'A Closer Look at Rugs', Crafts Council, London and touring

Collections
Crafts Council, London; Victoria and Albert Museum, London; Southern Arts; American Crafts Council; Romsey Abbey; Ulster Museum, Belfast

John Hinchcliffe's rag-pile rugs were woven in a double-corduroy technique with rags dyed, and over-dyed, in rich colours. Although intended and practical for the floor, they were usually hung on walls by their owners. They were rich and valuable contributions to the textile arts of the 1970s. Hinchcliffe has now moved to another area of the decorative arts, and is making decorated ceramics.

JOHN HINCHCLIFFE woven rag pile rug

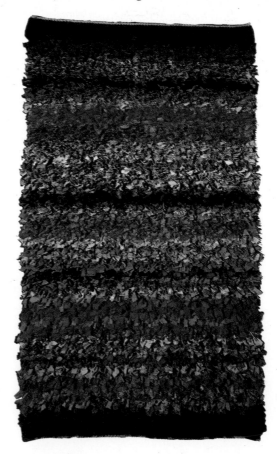

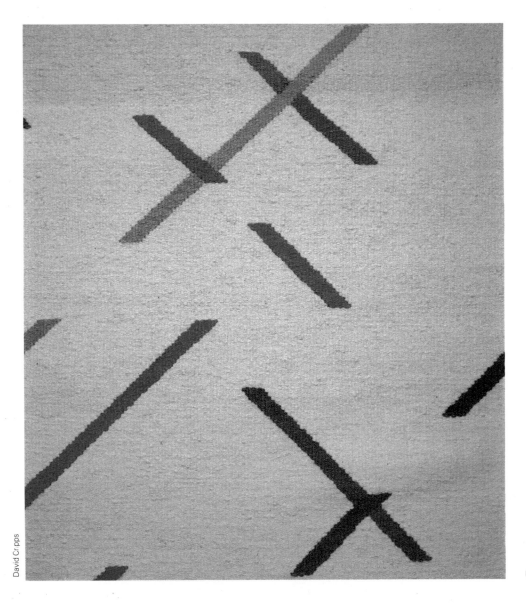

LESLEY MILLAR, rug (detail)

LESLEY MILLAR

Training
1972-5 Hammersmith College of Art
In the workshop of Gwen and Barbara Mullins

Selected Exhibitions
1979 'Ten Years of 401½', Commonwealth Institute, London
1981 'Making Good', South East Arts, touring
1983 'Rugs and Throws', British Crafts Centre, London; 'A Closer Look at Rugs', Crafts Council, London and touring

'Most of my work is made to commission. I enjoy the challenge of meeting the requirements of the client within my own design preoccupations. There is such a variety of mass-produced textiles available that I must offer something tailored uniquely to each customer. I dye all the wool myself so that a rug will match the colour-scheme of a room. For some time I have been interested in the movement of shapes across the surface of the rug and am now using pattern as well as colour to define these areas.'

NORMAN SCOTT

Training
1963-7 Concordia University, Montreal, Canada (Fine Art)
1968-70 Goldsmiths' College, London
1975-6 Central School of Art (Textiles)

Exhibitions – Solo
1972 401½ Workshops, London; Galerie Soleil, Montreal, Canada
1978 Embankment Gallery, London
1980 Hamiltons, London; Smedbyn Gallery, Huskrana, Sweden (with Tessa Fuchs)
1984 Lammards Gallery, Billingshurst, Sussex

Exhibitions – Group
1971 Chenille Galleries, London
1974 Textural Art Gallery, London; '62 Group, Commonwealth Institute, London; 'British Crafts', Reykjavik, Iceland
1975 'Designers at 401½ Workshop', Ashgate Gallery, Farnham
1978 '62 Group, Commonwealth Institute, London

Norman Scott's weaving concentrates on two fundamental qualities of the medium – structure and texture. His carpets and hangings are geometric, with the addition of embroidered or tapestry areas which he uses to counteract the repetitive nature of a shaft-woven fabric.

NORMAN SCOTT, woven hanging showing embroidered area (detail)

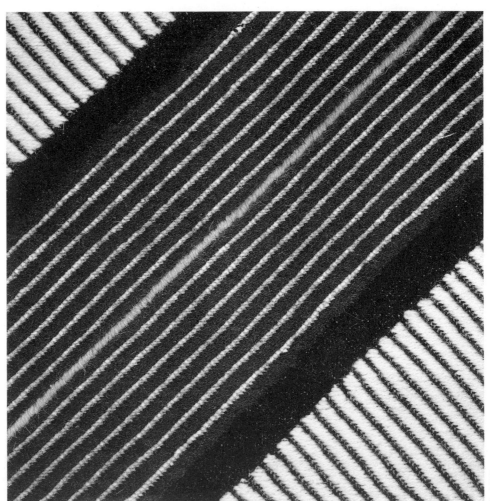

David Cripps

RUTH HARRIS

Training
1953-6 Central School of Art, London

Award
1980 Crafts Council Bursary (research into Soumak weaving)

Selected Exhibitions – Solo
1981 'Ruth Harris', British Crafts Centre, London

Selected Exhibitions – Group
1973 'The Craftsman's Art', Crafts Council, Victoria and Albert Museum, London
1974 'Fifteen Weavers', British Crafts Centre, London; Grabowski Gallery, London
1981 'Contemporary British Tapestry', Sainsbury Centre for the Visual Arts, Norfolk
1982 'The Maker's Eye', Crafts Council Gallery, London

Collections
Victoria and Albert Museum, London; Private collections in UK, USA and West Germany

'These tapestries are my responses to the landscape in which I live – the northern part of Essex. It is an intensively cultivated arable landscape, open, bold, rich in patterning and colour. Acres of rolling cornfields intersected by ditches. There is nothing cosy or romantic about this landscape: it is the result of intensive farming by giant agricultural machines. The marks made by these machines, combined with the seasons and the rapid light changes fascinate me. I make innumerable drawings, and then designs (one-quarter or one-third the size of the finished tapestry). At this stage one becomes instinctively aware how to weave the tapestry: which areas should be woven in flat gobelins technique and which in raised soumak weave. I have a particular interest in the interplay and the contrast between flat and raised surfaces which give the tapestry a rich tactile quality as well as a slightly, three-dimensional effect. Soumak is a very ancient technique in which an extra weft thread encircles one or more warp threads producing an angled, raised line. To the best of my knowledge, I am the only artist weaving tapestries using soumak techniques as a major element of the work.'

RUTH HARRIS 'Zig Zag I', 66 inches × 98 inches, woven in Soumak weave

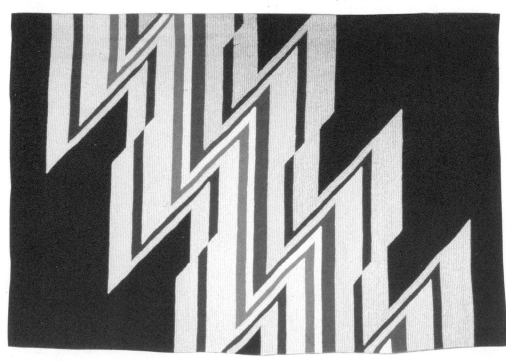

177

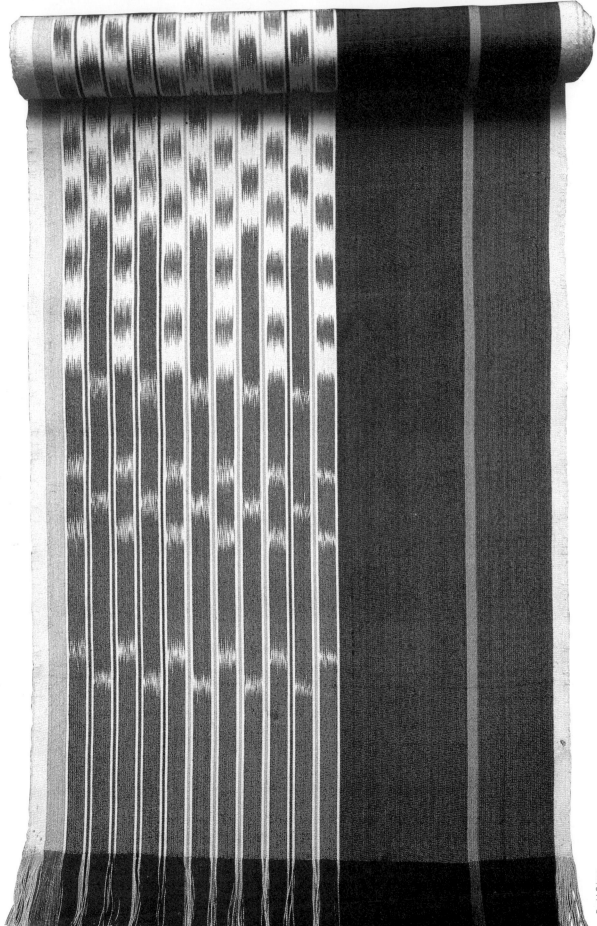

MARY RESTIEAUX

Training
1964-7 Cambridge College of Art and Technology (BA General Subjects)
1969-72 Hammersmith School of Art, London (Textiles)
1972-4 Royal College of Art, London (Textiles)

Employment
1974-80 Royal College of Art
1974-9 Freelance designer
1977 Worked in Hong Kong
1974- Part-time lecturer: Chelsea College of Art; Central School of Art; Camberwell School of Art; Goldsmiths' College; West Surrey College of Art

Selected Exhibitions
1979 'Press View', Crafts Council Gallery, London
1980 Oxford Gallery, Oxford; 'Gaudy Ladies', Royal College of Art, London
1981 'Textiles Today', Kettle's Yard, Cambridge and touring
1982 'Fabric and Form', Crafts Council, London, Australia, New Zealand, Zimbabwe, Hong Kong; 'Approach to Collecting', American Craft Museum, New York
1984 Craft Shop, Victoria and Albert Museum (two-man)

Collections
Victoria and Albert Museum, London; Eastern Arts; Southern Arts; Crafts Council, London; Craft Study Centre, Bath

Mary Restieaux weaves fine silk, narrow-width cloths with ikat patterning in brilliant colours – as scarves, belts or hangings. Using a dip-dye method, with acid dyes, she aims for 'layers of pattern, forms appearing and disappearing, creating space and depth, and, very important that a closer look reveals lots of fine detail of subtle colour and weave effects. I use bright and clashing colour (influenced by Itten's Seven Colour Contrasts) to give a sense of movement.'

Opposite: MARY RESTIEAUX three silk scarves, dip-dyed, ikat dyed and hand-woven

MARY RESTIEAUX hangings, dip-dyed, ikat-dyed and hand-woven

GERALDINE ST AUBYN HUBBARD

b. 1946

Training
1965-8 West Surrey College of Art (Woven Textiles) (including a study visit to Iran)

Employment
1969 Dartington College of Arts
1970-76 West Surrey College of Art
1976-7 Advisor and teacher: Harris Looms, Hawkhurst, Kent
1980-82 BBC television 'The Craft of the Weaver', parts 1 and 2 with Ann Sutton (and book);
Occasional lecturing/teaching at West Surrey College of Art; West Dean College, etc.

Award
1979 Southern Arts Bursary

GERALDINE ST AUBYN
HUBBARD, two scarves in
wool, silk and cashmere

Selected Exhibitions
1978 'New Faces', British Crafts Centre, London
1981 'The Golden Fleece', Rufford Craft Centre, Notts
1982 'The Craft of the Weaver', British Crafts Centre, London; 'Fashion as Art', Boston, Mass. USA
1983 'Wood and Weaving', Southern Arts, touring
1984 'Empathy', Clarendon Gallery, London; 'Black and White', British Crafts Centre, London

Geraldine St Aubyn Hubbard weaves fine cloth from natural fibres—silk, wool and cashmere. The cloth is made into 'simple unstructured clothes: tunics, T-shirts, kimono-style wraps, skirts, kaftans, shawls, scarves, ties. Most of the cloth is designed for specific garments, with borders or stripes suitably placed.

'I like to use contrasting matt and lustrous fibres. Colour, proportion, texture, rhythm and balance are all very important, as is the handle of the cloth. All the fabrics are woven to be worn, and I hope that they will transcend swift fashion changes.'

David Cripps

RICHARD WOMERSLEY

b. 1945

Training
Studied weaving with Lore Youngmark and Mike Halsey; Has worked closely with Kaffe Fassett for several years

Exhibitions
1983 'Rugs and Throws', British Crafts Centre, London
1984 'Maker/Designers Today', Camden Arts Centre, London; Numerous exhibitions in UK, Switzerland, USA and Japan

Collection
Victoria and Albert Museum, London

Commissions
British Wool Marketing Board; Bill Gibb; Designers' Guild; Missoni

'My blankets can be used as blankets, or wall hangings, or worn, or anything a piece of fabric can be used for. I use a variety of materials, lots of wool and silk, and a variety of techniques including tapestry-weaving and special ways of dyeing.'

RICHARD WOMERSLEY, blanket in interlocked weft technique (detail)

Opposite: RICHARD WOMERSLEY, Blankets showing the use of warp-and weft-face weaves with interlocked weft areas (details)

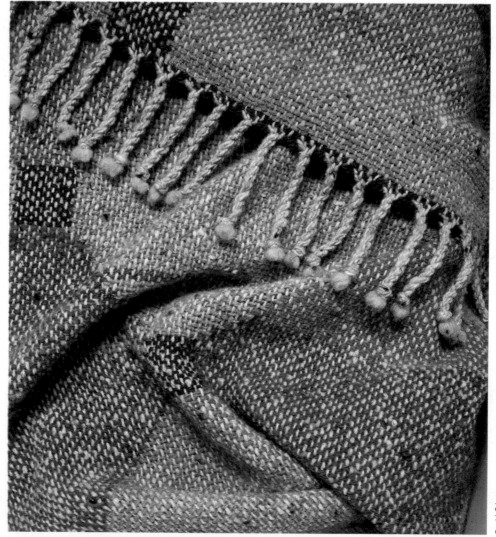

David Cripps

182

MARIANNE STRAUB

b. 1909 Switzerland

Training
Kunstgewerbeschule der Stadt, Zurich
1932 Bradford Technical College

Employment
1933 Designing at 'Gospels' (Ethel Mairet's studio)
1934-7 Designing for the Welsh Woollen mills (Rural Industries Bureau)
1937 Designer, Helios Fabrics
1947 Managing Director, Helios Fabrics
1950 Designer, Warner and Sons
1964-75 Designing for Tamesa Fabrics
1956-64 Head of Woven Textiles, Central School of Art, London
1964-8 Lecturer, Hornsey School of Art, London
1968-74 Part-time lecturer, Royal College of Art
1974- Adviser to Combined Course at Huddersfield Polytechnic

Awards, etc.
1972 Royal Designer for Industry
1984 OBE

Exhibition
1984 'Marianne Straub: 50 years as Woven Textile Designer', Royal Society of Arts, London and
touring

Commissions
1971 Gwent Police headquarters (architects, Robert Matthey, Johnson, Marshall): hanging
1977 Huddersfield Polytechnic (architects, Wilson and Womersley): hanging
1981 University of Newcastle: two reproduction Roman cloaks, spun, dyed, woven, for
Housesteads Site Museum, Northumberland and Colebridge Museum

Marianne Straub's work, in industry, teaching, and the craft of weaving, is decribed
fully in the book *Marianne Straub* by Mary Schoeser (Design Council, 1984). In the
foreword, Donald Tomlinson writes, 'She misses nothing of importance which is
going on – not only in the area of industrial design but in the increasingly significant
world of education and textile crafts, which she has done so much to foster in recent
years.'

Marianne Straub herself, in her book *Handweaving and Cloth Design* (Pelham
Books, 1976) says: 'I believe that by thoroughly comprehending the methods by
which weave constructions are evolved, the traditional theories of cloth design can
constantly be reassessed in the light of a more adventurous attitude to fabrics and the
availability of a changing range of yarns.'

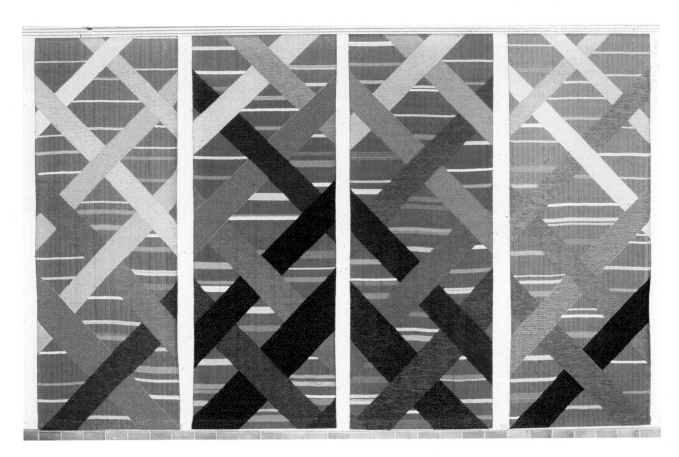

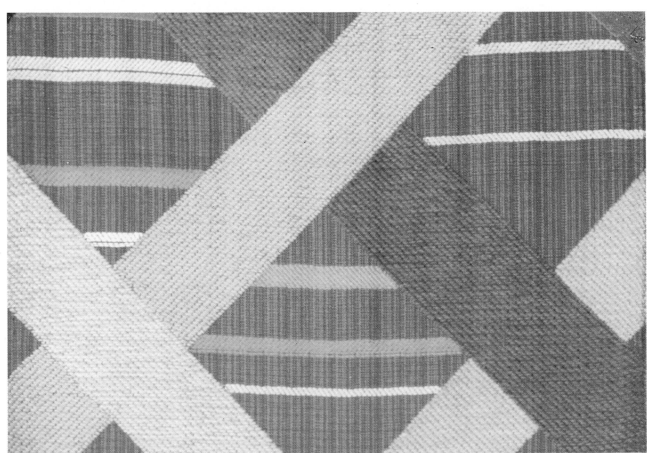

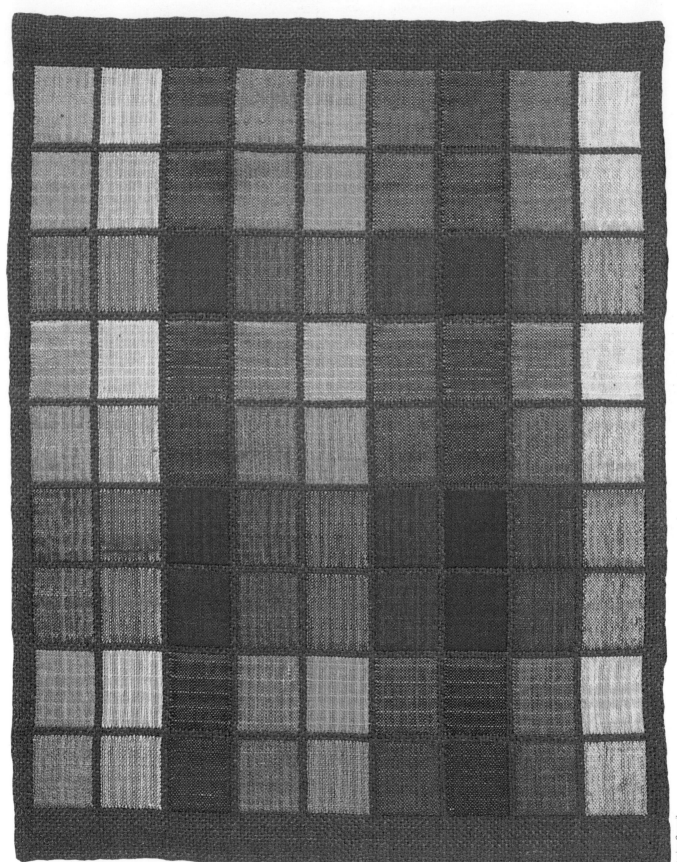

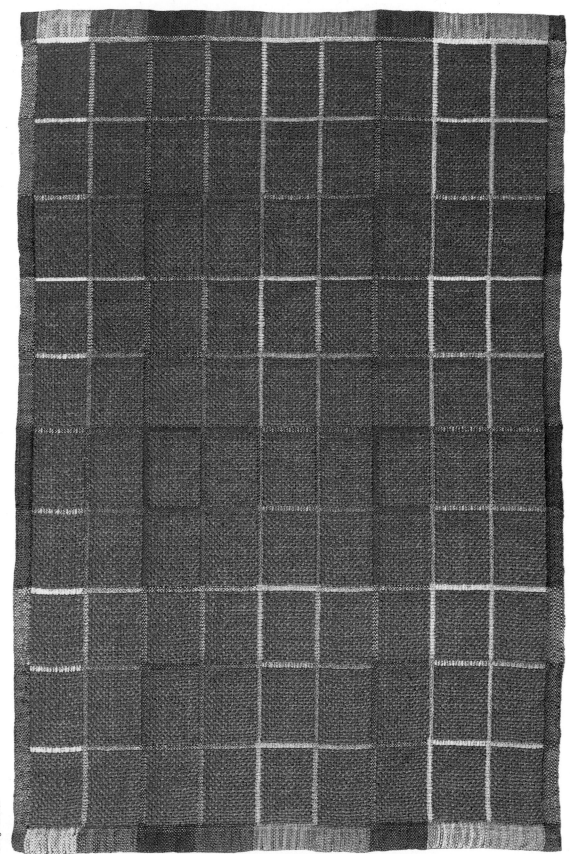

ADDRESS BOOK/INDEX

Curran, Lynne 112
c/o Crafts Council, 12 Waterloo Place, London SW1Y 4AU
Her work is also sold by: Victoria and Albert Museum Crafts Shop, London; British Crafts Centre, London; Guild of Lakeland Craftsmen Shop, Sheepskin Centre, Lake Road, Keswick.

Dyrenforth, Noel 10
11 Shepherds Hill, London N6
tel: 01-348 0956 (visitors by appointment only)

The Edinburgh Tapestry Co. 132
Contact: Joanne Soroka, The Edinburgh Tapestry Company Ltd, Dovecot Studios, Dovecot Road, Edinburgh EH12 7LE
tel: 031 334 4118 (visitors by appointment only)

Erickson, Grace 116
c/o Crafts Council, 12 Waterloo Place, London SW1Y 4AU

Farmer, Mary 118
50 High Street, Boston, Lincolnshire
tel: 0205 64614 (visitors by appointment only)
Her work is also sold by the British Crafts Centre, London

Fassett, Kaffe 34
tel: 01-452 3786
His work is sold through Beatrice Bellini Handknits, 74 Pimlico Road, London SW1

Fewlass, Annie 50
27 Tabley Road, Islington, London N7
tel: 01-607 6882 (visitors by appointment only)

Floyd, Rosalind 67
c/o School of Textiles, Goldsmiths' College, Cormont Road, London SE5

Ford, Julia 155
Department of Art and Design, University of Kansas, Lawrence, KS 66045, USA
Her European representative is Sarah Field, The Old School, Belton, Loughborough, Leicestershire LE12 9TU (visitors by appointment only)

Freeman, Susie 36
c/o Crafts Council, 12 Waterloo Place, London SW1Y 4AU (wholesale enquiries only)
Her work is sold by: Aspects, London; Victoria and Albert Museum Craft Shop, London; British Crafts Centre, London

Giddings, Robin 97
24 Rivington Street, London EC2A 3DU
tel: 01-729 1767 (visitors by appointment only)

Goetzee, Monique 22
c/o Hambledon House, Woodlands Road, Hambledon, Nr Godalming, Surrey GU8 4HW
tel: (042879) 4620
Her work is also sold by: British Crafts Centre, London; Royal Exchange Theatre Craft Shop, Manchester; Abbot Hall Art Gallery, Kendal, Cumbria

Goffin, Lucy 68
c/o Crafts Council, 12 Waterloo Place, London SW1Y 4AU

Graham, Victor Stuart 38
c/o Crafts Council, Waterloo Place, London SW1Y 4AU
His work is sold by: Detail, London; Strangeways, London; Crolla, London; 'Vicki Schofield', Trafalgar Street, Brighton; 'Pullies and Kangaroo', Sydney Street, Brighton and various craft shops

Greaves-Lord, Sally 28
c/o Crafts Council, 12 Waterloo Place, London SW1Y 4AU

Harris, Ruth 177
c/o Crafts Council, 12 Waterloo Place, London SW1Y 4AU

Harrison, Diana 20
36 Bramfield Road, London SW11 (visitors by appointment only)

Hinchcliffe, John 174
c/o Crafts Council, 12 Waterloo Place, London SW1Y 4AU

Hodge, Maureen 100, 124
c/o Crafts Council, 12 Waterloo Place, London SW1Y 4AU

Hope, Polly 54
Lindos, Rhodes, Greece
tel: 0244 31429
5a Heneage Street, London E1 5LJ
tel: 01-247 3450 (visitors by appointment only)

Jefferies, William 127
Cumbria Craft Residency, Cumbria College of Art and Design, Brampton Road, Carlisle, Cumbria CA3 9AY (visitors by appointment only) (or c/o Crafts Council, 12 Waterloo Place, London SW1Y 4AU)

Jones, Wendy 164
2 Brook Cottages, Brook Lane, Plaxtol, Kent TN15 0RF
tel: 0732 810520 (visitors by appointment only)
Her work is also sold by: British Crafts Centre, London: Designers Guild, London; Art for Offices, Wapping, London

Kagan, Sasha 48
Lower White House, Llanidloes, Powys, Wales SY18 6AD (visitors by appointment for commissions only)
Her work is sold by: The Scottish Merchant, 16 New Row, London WC2; Anthony Sheppard, 37 Heol Maengwyn, Machynlleth, Wales

Kirk, Valerie 131
c/o The Craft Officer, Northern Arts, 10 Osborne Terrace, Jesmond, Newcastle-on-Tyne
Her work is sold through current exhibitions, and by: The Guild of Lakeland Craftsmen, Sheepskin Centre, Kendal, Cumbria; The Bond Street Gallery, Decorative Arts Plaza, 4001 N.E. 2nd Avenue, Miami, Florida, USA

McFarlane, Kathleen 153
The Croft, Stody, Melton Constable, Norfolk NR24 2EE
tel: 0263 860505 (visitors by appointment only)

Mathison, Fiona 129
21 Dudley Terrace, Edinburgh EH6 4QQ
tel: 031 554 1732 (visitors by appointment only)

Millar, Lesley 175
110/116 Kingsgate Road, London NW6
tel: 01-328 2328 (visitors by appointment only)

Mills, Eleri 61
2-4 Oxford Road, Manchester M1 5QA
tel: 061 236 5707 (visitors by appointment only)

Moorman, Theo 166
Flat 3, New Street House, Painswick, Glos GL6 6UN
tel: 0452 812035 (visitors by appointment only)
His work is also sold by: Oxford Gallery, Oxford; 'Peter Dingley', Stratford-on-Avon; British Crafts Centre, London

Morgan and Oates 168
The House in the Yard, Church Lane, Ledbury, Herefordshire HR8 1DW
tel: 0531 2718 (visitors by appointment only)

Morrell, Anne 76
c/o Crafts Council, 12 Waterloo Place, London SW1Y 4AU
Her work is sold by: Yew Tree Gallery, Ellastone, Ashbourne, Derbyshire

Mullins, Barbara 161
Graffham Weavers, Graffham Petworth, Sussex
tel: 079 86 260 (visitors by appointment only)

Mullins, Gwen 160
Graffham Weavers, Graffham, Petworth, Sussex
tel: 079 86 260 (visitors by appointment only)

Pearson, Alec 128
18 Greenlands, Cambridge CB2 2QY
tel: 0223 246315 (visitors by appointment only)

Rangeley, Sue 74
11 Market Street, Charlbury, Oxfordshire
tel: 0608 810079 (visitors by appointment only)
Her work is also sold by: Smiths, Beaufort Square, Bath, Somerset; Charles de Temple, Jermyn Street, London

Restieaux, Mary 178
19 Rollscourt Avenue, London SE24
tel: 01-733 3637 (visitors by appointment only)
Her work is also sold by: British Crafts Centre, London; Victoria and Albert Museum Craft Shop, London; The Hand and the Spirit Gallery, 4222 North Marshall Way, Scottsdale, Arizona, USA

Riegler, Maggie 114
Dess Station House, Aboyne, Aberdeenshire AB3 5BD
tel: 033 984 254 (visitors by appointment only)

Riley, Catherine 73
c/o Crafts Council, 12 Waterloo Place, London SW1Y 1AU

Risley, Christine 58
16 Baizdon Road, Blackheath, London SE3 0UJ
tel: 01-852 2533 (visitors by appointment only)

Roberts, Patricia 41
Retail Shops at: 31 James Street, Covent Garden, London WC2; 60 Kinnerton Street, London SW1;

24 Toorak Road, South Yarra, Melbourne, Australia; D14 Queensway Plaza, Queensway Central, Hong Kong

Robertson, Vanessa and Norman Young 159
Apple Barn, Week, Dartington, Totnes, Devon TQ9 6JP
tel: 0803 865027 (visitors by appointment only)

Rogoyska, Marta 104
61b Downs Park Road, Hackney, London E8 2HY
tel: 01-241 6739 (visitors by appointment only)
Her work is also sold by: Anne Berthoud Gallery, London; Aspects Gallery, London; British Crafts Centre, London

Ross, Phyllis 81
The Warehouse, 51 Hambury Street, London E1 (visitors by appointment only)

St Aubyn Hubbard, Geraldine 180
2 Charlton Court Cottages, Mouse Lane, Steyning, West Sussex
tel: 0903 814204 (visitors by appointment only)
Her work is also sold by: Victoria and Albert Museum Craft Shop; Dartington Cider Press, Totnes, Devon

Scott, Norman 176

Sharifi, Pury 43
27 Fortismere Avenue, London N10 3BN
tel: 01-444 8234 (visitors by appointment only)
Her work is also sold by: Piega, Muswell Hill, London N10; Edwina Carroll, Covent Garden, London; Primavera, Cambridge; Country Fare, Winchester, Hants

Sherbourne, Annie 83
c/o Crafts Council, 12 Waterloo Place, London SW1Y 4AU

Short, Eirian 89
c/o Crafts Council, 12 Waterloo Place, London SW1Y 4AU

Sicher, Anne 30
Noah's Ark Studio, Mousehole, Cornwall TR19 6PQ
tel: 0736 731686 (visitors by appointment only)

Skogholt, Ingunn 139
Fossveien 12, 0551 – Oslo 5, Norway (visitors by appointment only))

Snaylam, Kerry 156
Unit 301, 73-75 Curtain Road, London EC2 (visitors by appointment only)

Smitten, Margaret 157
20 Melmore Gardens, Cirencester, Glos
tel: 0285 66073 (visitors by appointment only)

Starszakowna, Norma 17
12 Jedburgh Road, Dundee, Tayside, Scotland DD2 1SS
tel: 0382 644654 (visitors by appointment only)
Her work can also be seen at: Aspects Gallery, London; Anatol Orient Gallery, London; Compass Gallery, Glasgow

Stevenson, Connie 45
26 Rivington Street, London EC2 (visitors by appointment only)
Her work is sold by: Harvey Nichols, Knightsbridge, London; Paul Smith, Covent Garden, London; Darla Jane Gilroy, Kings Road, London; Swanky Modes, Camden Town, London

Straub, Marianne 184
c/o Crafts Council, 12 Waterloo Place, London SW1Y 4AU

Sunderland, Lesley 79
Heale Hall, School Bank, Montgomery, Powys
tel: 068 681 430 (visitors by appointment only)

Sutton, Ann 140, 172
c/o Crafts Council, 12 Waterloo Place, London SW1Y 4AU
Her work is also sold by the Anatol Orient Gallery, London

Eng Tow 84
210-D, Sembawang Road, Singapore 2677, Singapore
tel: 2571896/4662417 (visitors by appointment only)
Her work is also sold by the Anatol Orient Gallery, London

Tucker, Sian 27
346 Old Street, London EC2 (visitors by appointment only)
Her work is also sold by: Victoria and Albert Museum Craft Shop, London; British Crafts Centre, London

Virgils, Katherine 86
24 St Luke's Mews, Notting Hill, London W11
(visitors by appointment only)
Her work is also sold by: British Crafts Centre, London; Royal Academy Business Galleries, London; Anderson O'Day Gallery, London

The Crafts Council keep a selected slide index of textile makers which members of the
public may consult by appointment.

The Crafts Council, 12 Waterloo Place, London SW1Y 4AU.

The details in this Address Book were correct at the time of going to press, but the publishers can
take no responsibility for any changes.